# TEXAS BOOTS

**SHARON DeLANO** and **DAVID RIEFF** are editors who live and work in New York and collect boots in Texas. **STAR BLACK** is a widely published photographer of Southeast Asian and American subjects.

A Studio/Penguin Book

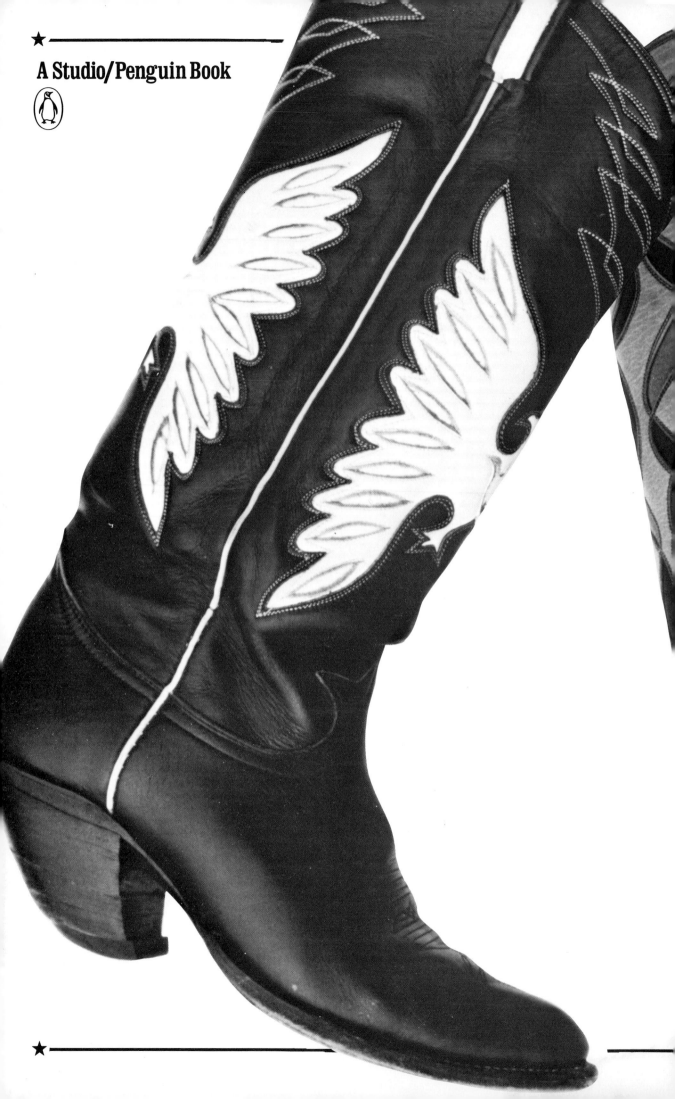

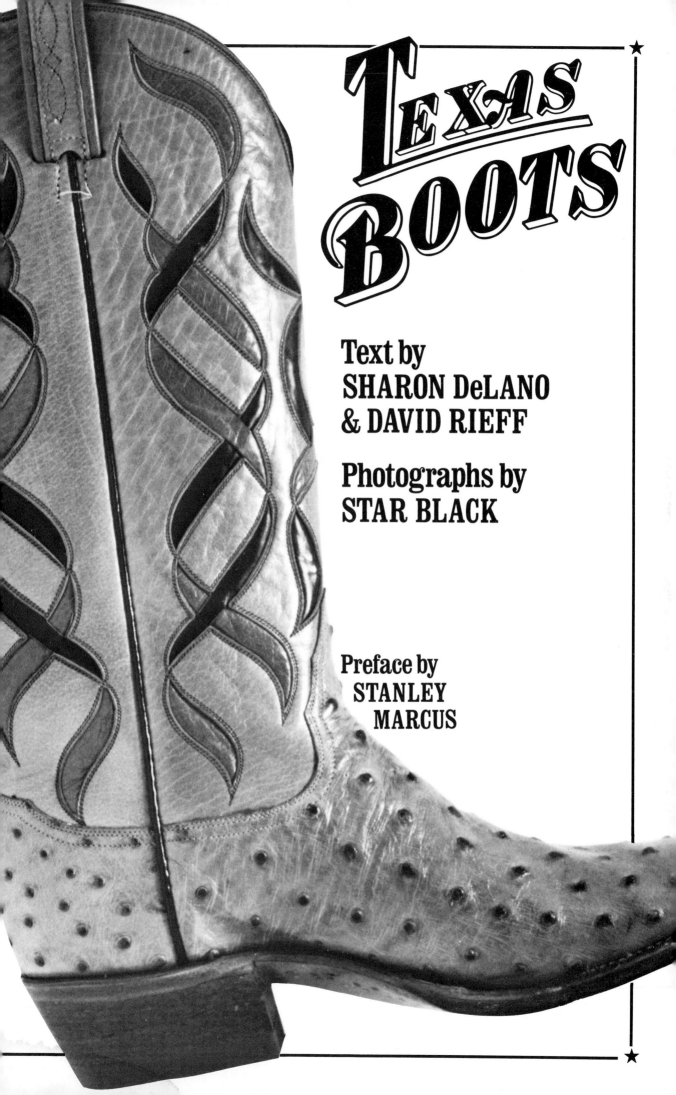

# TEXAS
# BOOTS

**Text by
SHARON DeLANO
& DAVID RIEFF**

**Photographs by
STAR BLACK**

**Preface by
STANLEY
MARCUS**

Penguin Books Ltd, Harmondsworth,
Middlesex, England
Penguin Books, 625 Madison Avenue,
New York, New York 10022, U.S.A.
Penguin Books Australia Ltd, Ringwood,
Victoria, Australia
Penguin Books Canada Limited, 2801 John Street,
Markham, Ontario, Canada L3R 1B4
Penguin Books (N.Z.) Ltd, 182–190 Wairau Road,
Auckland 10, New Zealand

First published in the United States of America in
simultaneous hardcover and paperback editions by
The Viking Press (A Studio Book) and Penguin Books 1981

Library of Congress Cataloging in Publication Data
DeLano, Sharon.
    Texas boots.
    1.  Boots and shoes—Trade and manufacture—Texas.
2.  Cowboy boots.    I.  Rieff, David.    II.  Black, Star.
III. Title.
HD9787.U5T44    338.4'768731'009764    81-2514
ISBN 0 14 00.5883 4                        AACR2

Printed in the United States of America by
Rae Publishing Co., Inc., Cedar Grove, New Jersey, and
Alithochrome Corporation, Springfield, Massachusetts
Set in Memphis Light

*Designed by Gael Towey Dillon*

## CREDITS

The photographs on pages 12–13, 14–15, 18, 19, and 20
are from the Erwin E. Smith Collection of Range Life
Photographs in the Library of Congress, Washington,
D.C. Used by permission of Mrs. L. M. Pettis.

The photographs on pages 14, 15, 24–25, and 155–59
are by Russell Lee and are from the Farm Security
Administration Collection of the Library of Congress,
Washington, D.C.

The photograph on pages 16–17 is from *Red River*,
copyright 1948 by Monterey Productions. Copyright ©
renewed 1975 by United Artists Corporation. All rights
reserved. Used by permission.

The map on page 18 is from *The Chisholm Trail* by
Wayne Gard, copyright 1954 by the University of
Oklahoma Press. Used by permission.

The photographs on pages 21, 25, and 27 (2) are from
The Museum of Modern Art/Film Stills Archive. Used by
permission of The Museum of Modern Art.

The photographs on pages 22–23, 32–33, and 34 are
from the collection of the Library of Congress,
Washington, D.C.

The photograph on page 24 is from the Western History
Collections, the University of Oklahoma Library. Used
by permission.

The photographs on pages 29 and 30 are from the
collection of John Cocchi. Used by permission.

The photograph on page 39 is by Paul Hosefros/*The
New York Times*. Used by permission.

The photograph on page 101 is by Nicholas deVore III.
Used by permission.

We set out
to write *Texas Boots*
because we love the boots
and admire the people who
make them. Not surprisingly,
it is the bootmakers them-
selves to whom we owe the
greatest debt. Their generosity
and advice made everything
else possible. Many others
in Texas provided valuable
assistance, but we would
particularly like to thank
Armando Romero in El Paso,
Bernie Cohen in San Antonio,
and Jim Foley in Fort Worth.
In New York, Joseph Oliver
and Thomas Doty at the Judi Buie
Bootshop, Texas at Serendipity,
and the staff of Blacksmith
were endlessly patient. Robert
Cornfield was a good and encourag-
ing friend from the outset and Martha
Kinney an enthusiastic supporter. At Viking, the
designer Gael Towey Dillon became our collaborator,
and in fact *Texas Boots* is as much her book as ours. The
photographer wishes to thank Michael Mertz   and Tom Mac-
Donald for their valuable technical               assistance
and Bill Pierce for his lighting               suggestions.

# CONTENTS

## PREFACE by STANLEY MARCUS

PAGE : 10

## H★I★S★T★O★R★Y of the C★O★W★B★O★Y ★ B★O★O★T

PAGE : 12

## PARTS of a BOOT ★ MAP OF TEXAS

PAGE : 41                    PAGE : 42

## T★H★E B★O★O★T★M★A★K★E★R★S

PAGE : 43

## COLOR PLATES

PAGE : 49

Tony Lama ☆ 82, Justin Boot Company ☆ 88, The Nocona Boot Company ☆ 95, Larry Mahan ☆ 101, Lucchese Boot Company ☆ 104, Rios Boot Company ☆ 108, Rios of Mercedes ☆ 108, M. L. Leddy & Sons ☆ 109, Olsen-Stelzer Boot and Saddlery ☆ 114, Dixon Boots ☆ 115, Mercer's Boot Shop ☆ 115, Henry Leopold ☆ 116, Charlie Dunn ☆ 120, Ray Jones ☆ 125, Paul Wheeler ☆ 128, Dave Little ☆ 134, James Leddy ☆ 138, Tex Robin ☆ 140, Alan Bell ☆ 143, Carlos Hernandez, Jr. ☆ 145, Larry Jackson ☆ 146, The Galvans ☆ 150, Elmer Tomlinson ☆ 152, J.E. Turnipseede ☆ 152, Capitol Saddlery ☆ 152

## H★O★W a B★O★O★T I★S P★U★T T★O★G★E★T★H★E★R

PAGE : 154

## C★O★N★S★U★M★E★R G★U★I★D★E

Leather ☆ 159, What to Look For ☆ 164, Proper Fit ☆ 166, Care of Your Boots ☆ 167, Where to Buy Boots ☆ 168

## GLOSSARY

PAGE : 170

★

# PREFACE

**W**ith the Texas Centennial celebration in 1936, America discovered Texas and became entranced with the legends of the West and its folk heroes—the cowboys. Distinguished visitors at Texas public functions submitted to the ritual of being "hatted" with a ten-gallon hat that they took home as a souvenir of their trip to the Wild West. However, except for West Texans, who habitually wore boots, ranch clothes, and sheriffs' hats, most native sons were somewhat disdainful of western attire. The fashion stores didn't deign to carry such clothes and referred the occasional interested customer to the western specialty shops.

Western wear, from Levi's to cowboy boots, has undoubtedly been America's single greatest contribution to world fashion. There is scarcely a country in the world where young people do not wear blue jeans. In some of the Eastern European countries, travelers have been besieged by offers from native residents who want to buy western jeans—at prices triple the original value.

I believe that it was Jacques Fath, the French couturier, who was the first European designer to discover western clothes and to use them as source material for fashion adaptation. On his

visit to Texas in 1949 to receive the Neiman-Marcus Award for Distinguished Service in the Field of Fashion, he was so impressed by the boots, shirts, and pants worn by the participants in a square dance staged for his entertainment that he ordered outfits for his wife and himself, which they wore at a square dance he gave at his château the following summer. In his couture collection of August 1950, he introduced his version of a cowboy shirt, made in satin with rhinestone buttons. In successive years, other Paris designers showed western pants in fur, jackets fringed in suede, bandana-decorated necklines, and satin cowboy boots.

Eventually American manufacturers followed the French lead and recognized the validity of western clothes for women as well as for men. In the mid-sixties, Levi's became popular with children, teenagers, and later with young adults. The blue-jean phenomenon started when many younger people adopted blue jeans as a symbol of revolt against the older generation; the fad gained momentum when inflation made such money-saving ways of dressing popular. As young people became ardent devotees of jeans, they began to buy the traditional accessories—cowboy boots, shirts, and hats. What began as a rebellious fad grew into a major international fashion. Both movies and television, which had been responsible for the public's perception of the cowboy as a hero, documented the wearing of jeans and boots by a significant proportion of the population under thirty.

The term "drug-store cowboy" was formerly used to describe those who dressed up "western"; today that bit of derision has disappeared. It's smart to dress "western," and it will continue to be so until some other major fashion movement reflecting a change in life-style displaces western wear. When this occurs, it will happen so gradually that we won't notice that one era has ended and another begun. But by that time, those who have found cowboy boots practical for work and leisure wear will surely refuse to give them up.

It is highly unlikely that this history of the cowboy boot and its manufacturing process will inspire any readers to become bootmakers, but it will make every owner of cowboy boots more appreciative of the superb craftsmanship that goes into making a fine pair of handmade boots.

STANLEY MARCUS
*December 1980*

# H★I★S★T★O★R★Y of the C★O★W★B★O★Y B★O★O★T

**C**owboy boots are at once fanciful objects and practical pieces of working gear, perfect emblems for the cowboy hero. A cowboy's outfit is a resplendent concoction of scarves and big hats and fringed leather ornamented with silver disks. Each element is chosen for its usefulness—a scarf protects his neck from rain and wind and can be used as a mask against dust clouds, a broad-brimmed hat shields his face from the sun, leather clothes defend against brush and cow horns— but the costume is nevertheless a stylish display, a projection of a romantic image.

The cowboy boot has endured as a vehicle for that image more successfully than any other piece of western costume except perhaps Levi's. And unlike Levi's the cowboy boot has no other associations. It is purer. It was not worn by farmers or miners or lumberjacks. The classic cowboy boot was designed especially for a man who rode all day on

horseback. The narrow toe of the boot made it easier for him to locate the stirrup quickly when he mounted, and a reinforced steel arch braced him while he rode and roped standing up. The high, underslung heel kept his foot from slipping through the stirrup when his horse stopped or turned abruptly. Tall leather boot tops protected his legs from the chafing and gouging inherent in rough work in the saddle, and stitching on the boots reinforced the leather and prevented it from sagging.

Such practical considerations no doubt led to the development of the typical cowboy boot, but its ornateness and extremity, the sleekness and elevation it lends to those who wear it, transcend the realm of utility, and cowboy boots were not to be possessed exclusively by the working cowboy for very long. They were appropriated by others as accoutrements of their own fantasies. The source of the fantasy, the cowboy on horseback,

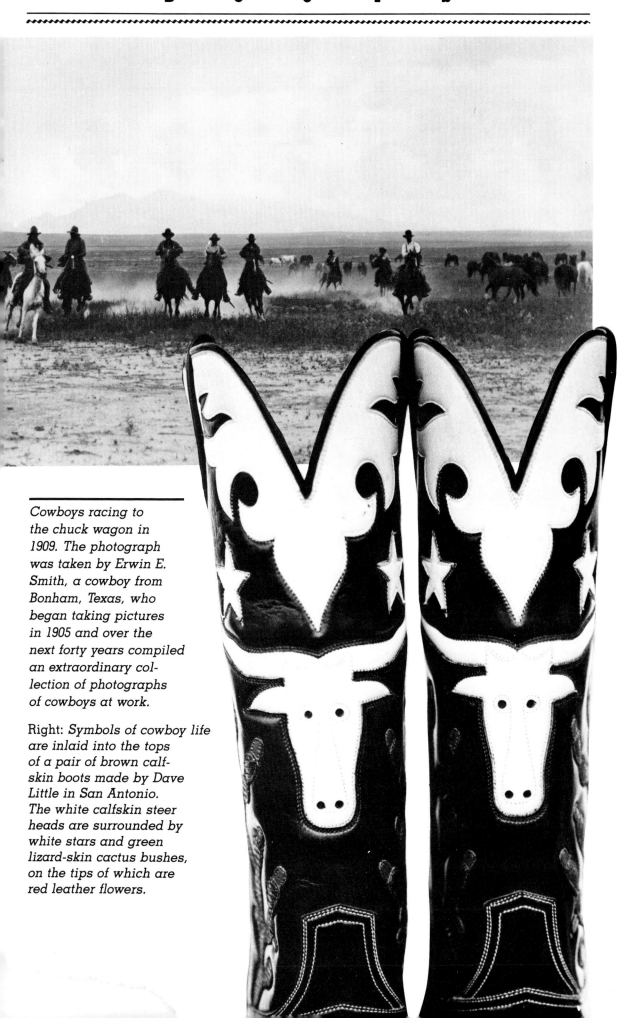

*Cowboys racing to the chuck wagon in 1909. The photograph was taken by Erwin E. Smith, a cowboy from Bonham, Texas, who began taking pictures in 1905 and over the next forty years compiled an extraordinary collection of photographs of cowboys at work.*

Right: *Symbols of cowboy life are inlaid into the tops of a pair of brown calfskin boots made by Dave Little in San Antonio. The white calfskin steer heads are surrounded by white stars and green lizard-skin cactus bushes, on the tips of which are red leather flowers.*

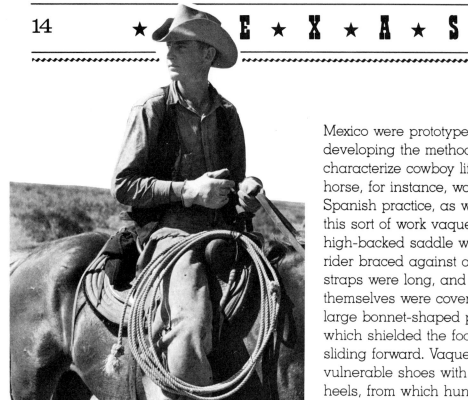

Mexico were prototypes of the cowboy, developing the methods that would characterize cowboy life. Roping from a horse, for instance, was a common Spanish practice, as was branding. For this sort of work vaqueros used a high-backed saddle which supported a rider braced against a taut rope. Stirrup straps were long, and the stirrups themselves were covered with tapaderas, large bonnet-shaped pieces of leather which shielded the foot and kept it from sliding forward. Vaqueros wore rather vulnerable shoes with short tops and flat heels, from which hung heavy Spanish

Left: *A young cowboy in well-worn work clothes on the SMS ranch near Spur, Texas, in 1939. The photograph was taken by Russell Lee for the Farm Security Administration.*

Below: *Fred "Kid" Bomar posing in front of his horse at the Turkey Tracks Ranch, Texas, in 1910. Photograph by Erwin E. Smith.*

continued to exist, but the conditions of his life were progressively circumscribed, and his own style was influenced by that of the admirers who thought to imitate him. Cowboy boots are still worn by cowboys, but increasingly they are also worn by those for whom they are chiefly ornaments, emblems of a style that is at once a pose and the consequence of a great adventure.

**T**he protagonist of that adventure emerged as a distinctive American type in the middle of the nineteenth century. His precursors were mountain men, Virginia planters, cavalrymen, but he was influenced most of all by the Mexican vaquero.

In 1800 thousands of longhorn cattle roamed free on the year-round grass of the plains north of the Rio Grande. The vaqueros who worked among these herds and on the huge ranches of northern

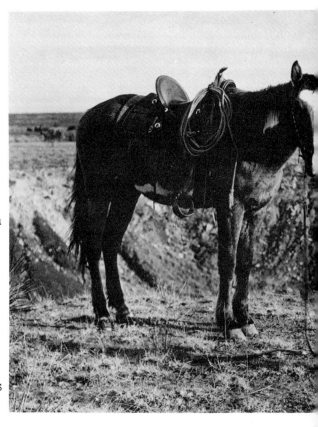

spurs that had to be removed if one tried to walk.

Vaqueros supplied almost everything to the culture of the cowboy except the cowboy boot. Anglo-American range workers were even called vaqueros until late in the nineteenth century because the word "cowboy" was a disparagement. (It had been first used in America during the Revolutionary War as a name for the Tory cattle thieves who supplied the British army with meat. When Texas revolted against Mexico in the 1830s, "cow boys" were sent out to steal cattle from the Mexican ranchers for Texan soldiers.) The Anglo vaqueros of the Republic of Texas who supplanted the Spanish were men with northern European roots. Many of them came to Texas from the South, and were seasoned horsemen who brought with them the riding gear of planters and cavalrymen, gear that included a plain leather, high-topped boot.

*The boots and spurs of a working cowboy in Texas in 1940. Photograph by Russell Lee.*

The new Texans modified Spanish ranching equipment and methods. They rode on Spanish saddles, but the heavy wood-block stirrups were replaced by light bentwood designs with leather treads, and tapaderas were made smaller and finally dispensed with altogether as being too cumbersome and not necessary, since boots took their place as protection. American cowboys wore spurs—marks of a Southern gentleman or a cavalry officer—but they altered the heavy Spanish spur. Spur wheels, or rowels, were made smaller and the spurs themselves were attached so that just the tips touched the ground and it was possible to walk without removing them. They were most often strapped to a cavalry boot with low, flat heels, square toes, and high tops that were slightly fuller in the leg than modern boots are. In the middle 1800s the regulation boot for cavalry officers reached just under the bend of the knee in back and arched over the kneecap in front. Ordinary troopers' boots were cut straight across just below the knee. This sort of boot was preferred by cowboys before 1870,

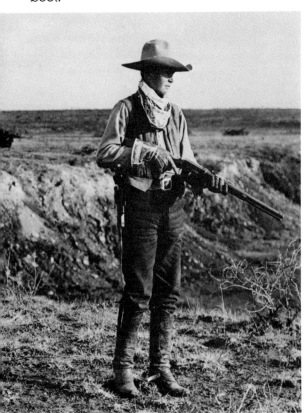

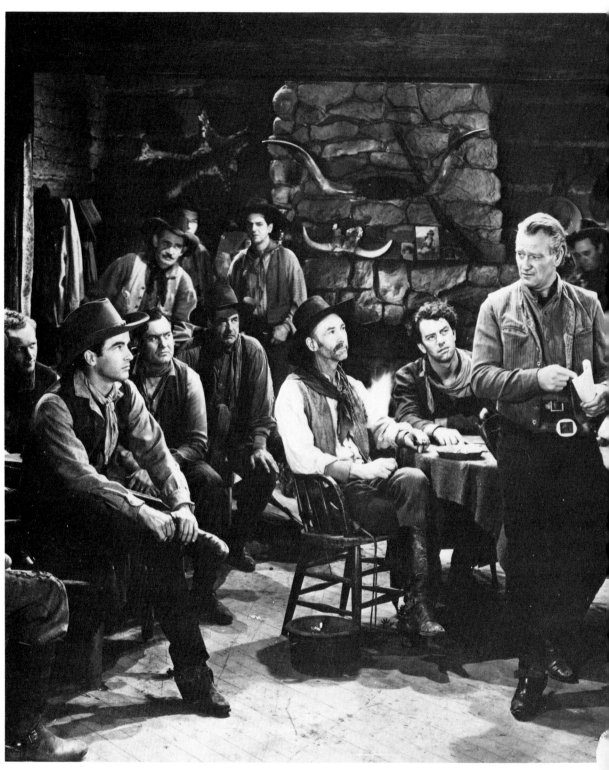

although they wore whatever was
available—often plain, lace-up farmers'
boots, or eastern riding boots, or low
Spanish-style boots.

Cowboys adopted the equipment and
working methods of vaqueros and
planters and cavalrymen, but they

developed a distinctive style, particularly
in the decade following the Civil War.
Texas was the only Confederate state that
had not been overrun by Union troops,
but it had been cut off from its markets
early in the war, when the Union took
control of the Mississippi, and its economy

was destroyed. Ranches were abandoned by men who became soldiers, and whole herds of cattle wandered off untended. In 1866 there were perhaps three million Texan cattle roaming loose. Rounding up these herds and driving them to northern markets was the great enterprise that created the cowboy hero—the adventurer who because of his special skills and audacity could carry out these risky missions. Before the 1800s, cattle had been raised in Texas mostly for their hides and tallow, and although some herds had been trailed to New Orleans or California, there had been nothing on the scale of the long drives of the two decades following the Civil War.

The first important cattle drive, the one that marked the beginning of the western cattle kingdoms and the apotheosis of the cowboy, took place in the fall of 1867 up the Chisholm Trail from Texas to Abilene, Kansas. In Howard Hawks's movie *Red River*, the herd that makes this auspicious journey is owned by John Wayne, an old cattle baron from southern Texas, and his young companion Montgomery Clift, just

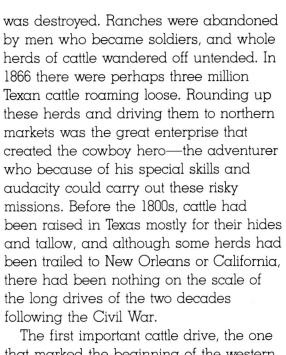

*John Wayne and Montgomery Clift in* Red River, *1948.*

*Kelly-green cowhide boots with white inlays, made in the 1950s by The Nocona Boot Company for the Chisholm Trail Round-up.*

The Chisholm Trail
in earlier years, 1867-75

back from the war. In the film the details of the early drives through Oklahoma Indian Territory to Abilene are cleaned up for the Hollywood movie audiences of the late Forties, but the perils and violence of the real cattle drives are touched on in the spectacular stampede sequences. An average trail herd consisted of between two thousand and twenty-five hundred cattle tended by nine or ten cowboys who lived and slept outdoors in all kinds of weather for the three to six months it took to get the herd to market. A cowboy worked in long shifts, with only short breaks for eating and sleeping. He was always on horseback, riding through dust clouds kicked up by the cattle, and facing the possibility that he could be crushed if his horse fell in a hole, drowned in one of

*Two cowboys trying to subdue a rearing horse at the LS Ranch, 1908. Photograph by Erwin E. Smith.*

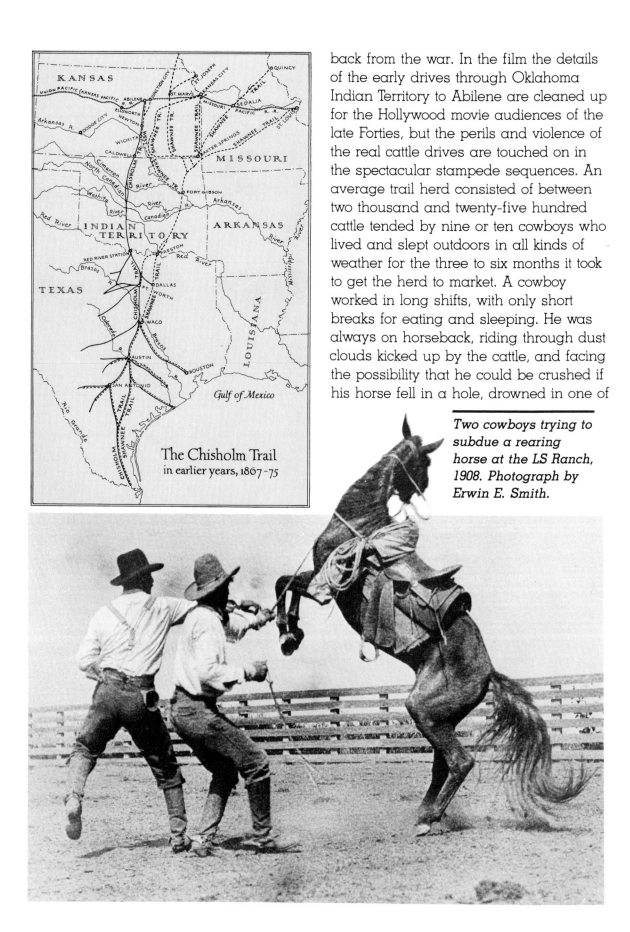

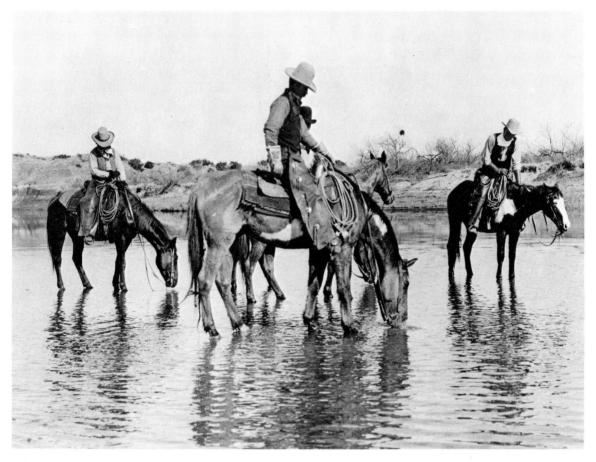

the numerous rivers that had to be crossed, poisoned by a rattlesnake, run over in a stampede (drovers assumed they would lose 10 percent of the herd in stampedes), or murdered by understandably hostile Indians as the huge herds traveled over their land.

**T**he classic cowboy costume of Texas comes from the period of the long drives: a wide-brimmed gray felt hat with a high crown, often decorated with a band of silver conchos or rattlesnake skin; a bandana of cotton or silk hung loosely over a collarless checked shirt; dark wool or leather pants; a vest with pockets for keeping tobacco. Gloves with wide cuffs, often fringed, were worn for roping. Chaps made of cowhide or calfskin with the hair side out were attached at the waist by a wide leather band.

*Cowboys from the Turkey Tracks Ranch letting their horses drink while they cross the Wichita River, 1910. Photograph by Erwin E. Smith.*

By the late 1870s the distinctive cowboy boot had been added to the cowboy outfit. There were bootmakers in many of the towns along the cattle trails, and it is impossible to say which one of them "invented" the cowboy boot, but in any case the style became popular very quickly. Henry Leopold, a seventy-eight-year-old bootmaker in Garland, Texas, remembers his father telling him about a large shop in Coffeeville, Kansas, in the late 1860s. Several bootmakers, among them Henry's father, worked there making boots with high slanted heels for cowboys. In 1876 C. H. Hyer, who had learned shoemaking from his father in Illinois, opened a small

shop in Olathe, Kansas, and soon had hundreds of cowboy customers. There was an enormous demand for the special boots among the drovers who had just been paid at the Kansas railheads. In Spanish Fort, a little town in northern Texas near Red River Station, where the Chisholm Trail crossed into Indian Territory, H. J. Justin, who did handy work around the local barbershop and repaired boots for the cowboys who passed through town, began putting together complete boots in the cowboy style. He took orders as the cowboys went north and had their boots ready when they came back through Spanish Fort on their way home.

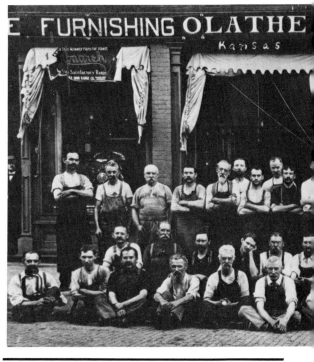

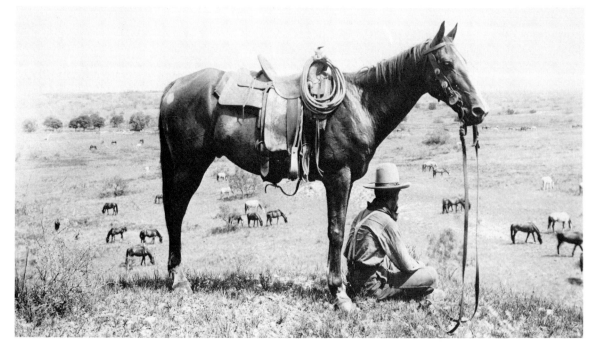

Above: *Bootmakers in Olathe, Kansas, at the turn of the century.*

Left: *Frederick William Leopold and Herman Heistermann, bootmakers in Odessa, Texas, in 1913.*

Below: *A wrangler watching over grazing horses on the SMS range in 1906. Photograph by Erwin E. Smith.*

Justin, C. H. Hyer, Frederick Leopold, and most of the other early bootmakers were sons of German settlers. Since the early nineteenth century, Europeans, particularly Germans, had been fascinated by Texas and the romantic characters living in its vast, wild space. The Mainzer Adelsverein, or German Emigration Company, sponsored German colonies in Texas in the 1840s and 1850s, and accounts of life in the American West provided material for a large body of popular German fiction. Some of the stories were based on reports by visitors to Texas and some arose from wild speculation about plainsmen and Indians.

Many German settlements in Texas retained their German identity until well into the twentieth century. Several of the towns in northern Texas through which the trail drives passed had German-language newspapers, and German was often the first language of the townspeople. For these immigrants, Texas was the new world of the free spirit, the land in which the cowboy-knight could work out his destiny. The boot invented by Hyer and Justin and the other bootmakers of German ancestry was a sort of northern European riding boot, close-fitting and high-topped, modified to accommodate the needs of American cowboys. The two-inch underslung heels,

*Errol Flynn in* Virginia City, *1939.*

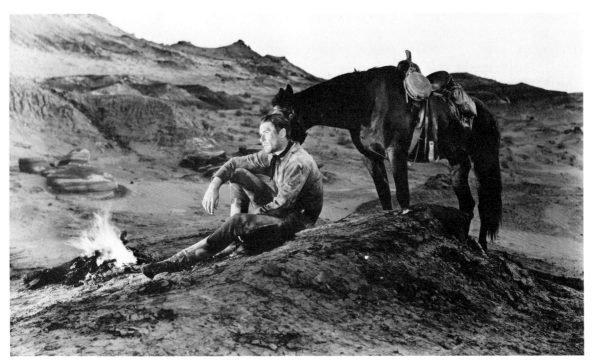

high reinforced arches, and narrow toes were designed for riding in a western saddle, but they also encouraged the cowboy's sense of himself as an exceptional character, a hero set off from other, more ordinary folk.

The earliest cowboy boots were not fancy. They were made of black or dark brown cowhide, with little ornamentation. Uppers were cut off square on top and a single row of swirled stitching was sewn across them. Cutout leather designs, often in a star pattern, were sometimes overlaid around the collars of the boot tops, but intricate stitching patterns and carved leather symbols didn't appear until later. The lower part of the boot was also plain and fitted tightly over the foot. The fit was in fact so tight and the heels so high that the boots were not comfortable for walking, but cowboys thought of themselves as complete horsemen who never walked, and were concerned mostly that their feet look fashionably small and thin. (It is said that some of the early boots were made with the same last for both the right and left boot so that they could be made to fit only by putting them on and standing in a trough of water until

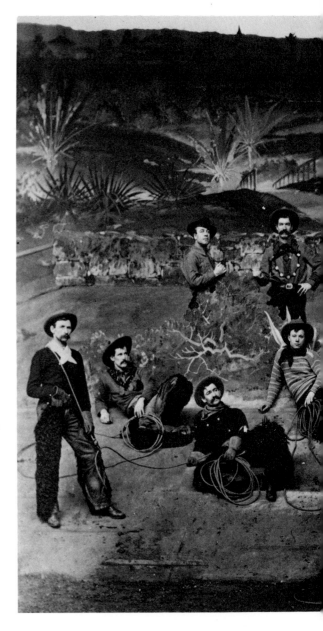

the boots were soaked through. They would then dry to the shape of the wearer's feet. This frequently repeated story suggests that early cowboy boots caused a certain amount of discomfort.) Heavy spurs were usually attached to the boots with a large crescent-shaped piece of leather strapped over the instep. When a cowboy walked his spurs rolled noisily along the ground—a jangling that was increased when "danglers," inch-long pear-shaped pendants, were hung from the axle of the spur wheels.

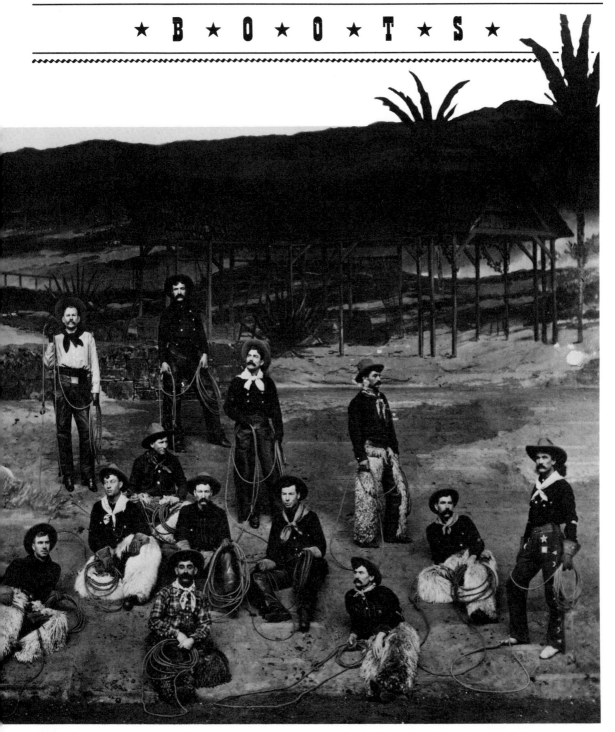

**T**he way of life that fostered cowboy culture—ranching on vast unfenced land and driving huge herds up the cattle trails—didn't last long. By the 1890s the long drives had all but ended and much of the plains was divided up with barbed wire fences. The classic age of the cowboy had in fact lasted only about twenty years. From the beginning the cattle drives had threatened the livestock of farmers in Kansas and Missouri because Texan cattle carried with them a variety of tick to which they were immune

*Cowboys from Buffalo Bill's Wild West Show posed in front of a painted curtain at the Olympia Theatre, London, 1903.*

but which caused midwestern cattle to become sick and die. Large sections of the northern plains had been quarantined to ward off "Texas fever." Cattlemen were also consistently harassed by small settlers on land the ranchers considered theirs by tradition but which newcomers thought could be legally settled under the terms of the Homestead Act of 1862.

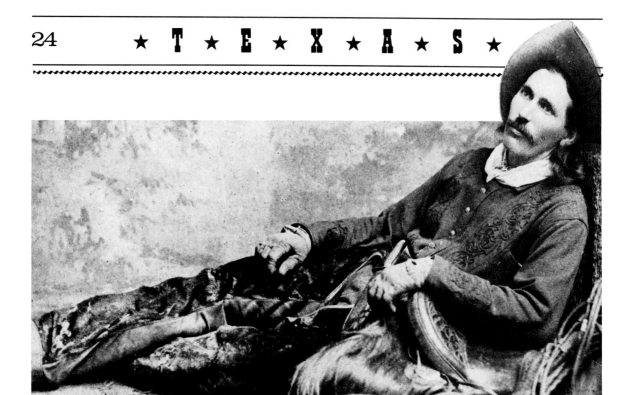

Buck Taylor, "The King of the Cowboys," in
Buffalo Bill's Wild West Show.

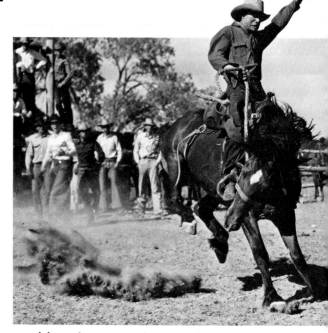

The beleaguered cattle industry was
finally done in by the disastrous winter of
1886–1887 when overstocked herds
weakened by a dry summer were
decimated in the worst blizzard in the
history of the plains. Many ranchers were
ruined, and the ones who survived were
forced to cut down the size of their land
and modernize their operations. Hence
the cowboy's work changed. He was no
longer the centaur of the range, never
separated from his horse, never on foot.
Now he had to build and repair fences,
harvest hay, feed cattle in the winter.

The decline of the cowboy as a real
figure in a working world was paralleled
by the rise of the stage cowboy. Buffalo
Bill's Wild West show opened in 1883 and
was a great hit with eastern audiences.
The first shows were exhibitions of
cowboy skills—riding, roping,
shooting—that soon were combined with
"reenactments" of incidents from western
history—the ride of the Deadwood
stagecoach, or an Indian attack on a
settler's cabin. One of the most popular
characters in the show was Buck Taylor,
King of the Cowboys. Taylor was young

and handsome and very tall. He could
throw steers and break wild horses yet
was (according to the show's publicity
handouts) just a sweet and genial boy
who had overcome the privations of an
orphaned childhood in postwar Texas.
Photographs show him wearing hairy
goatskin chaps with excessively long
fringe, an embroidered jacket, shiny black
boots with high slanted heels, and a
large pistol.

Taylor was probably the first person to
be lionized as a cowboy hero. Since 1903,

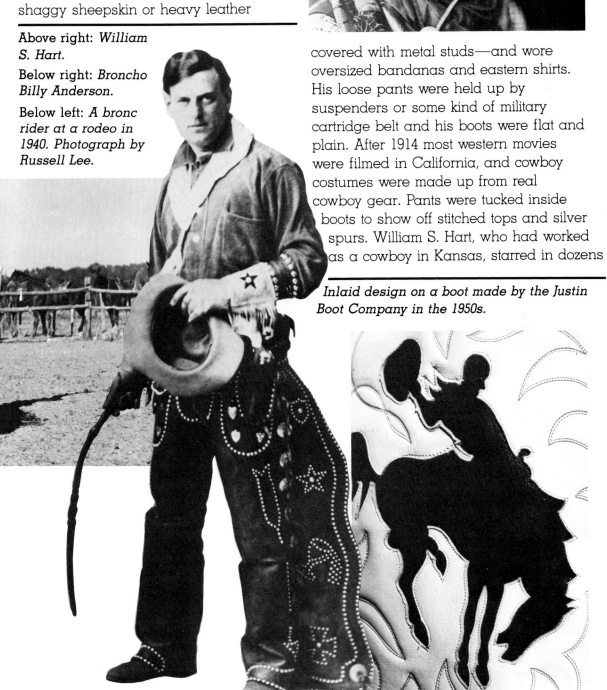

however, when Edwin S. Porter made *The Great Train Robbery* in a field in New Jersey, western movies have produced hundreds of cowboy heroes, usually expressions of easterners' fantasies about the West. Broncho Billy Anderson, the major cowboy movie star before 1914, dressed in huge, unwieldy chaps—of shaggy sheepskin or heavy leather

**Above right:** *William S. Hart.*

**Below right:** *Broncho Billy Anderson.*

**Below left:** *A bronc rider at a rodeo in 1940. Photograph by Russell Lee.*

covered with metal studs—and wore oversized bandanas and eastern shirts. His loose pants were held up by suspenders or some kind of military cartridge belt and his boots were flat and plain. After 1914 most western movies were filmed in California, and cowboy costumes were made up from real cowboy gear. Pants were tucked inside boots to show off stitched tops and silver spurs. William S. Hart, who had worked as a cowboy in Kansas, starred in dozens

*Inlaid design on a boot made by the Justin Boot Company in the 1950s.*

of Westerns between 1914 and 1925, movies that depict a dusty West in which Hart's typical hero finds redemption from a life of some kind of outlawry through inspired acts of goodness. Hart's costumes were not especially gaudy, but he wore big hats and checked shirts and tied a Mexican sash under his gun belt. His boots were very tall, with pitched heels and deeply notched tops covered with elaborate leaf-patterned stitching.

Tom Mix, the biggest western star of the Twenties, had a much flashier style. His costume was concocted from what was more or less a real cowboy outfit embellished with extra buckles and straps and ornamental buttons. His shirts were often fantastically embroidered and his boots were decorated with inlaid leather designs and many rows of stitching. Large silver spurs were fastened to his ankles with concho-covered strips of

**RUTH ROLAND**
*Famous Screen Star*
—has worn HYER BOOTS for years
◄ HYER ►

[6]

leather. Mix had a great influence on boot fashions. The 1923 catalog for the Justin Boot Company offers a "Tom Mix" boot and informs customers that the Justins supply Mix himself with "many pairs of ultra fancy numbers for special wear." The Tom Mix boot in stock has black kangaroo vamps with a wrinkled and stitched toe and kidskin uppers inlaid with white tulips. Long cloth pulls emerge from the top of the boot, which is deeply notched and encircled with chain stitching.

From the Twenties on, movies provided the images on which cowboy gear was

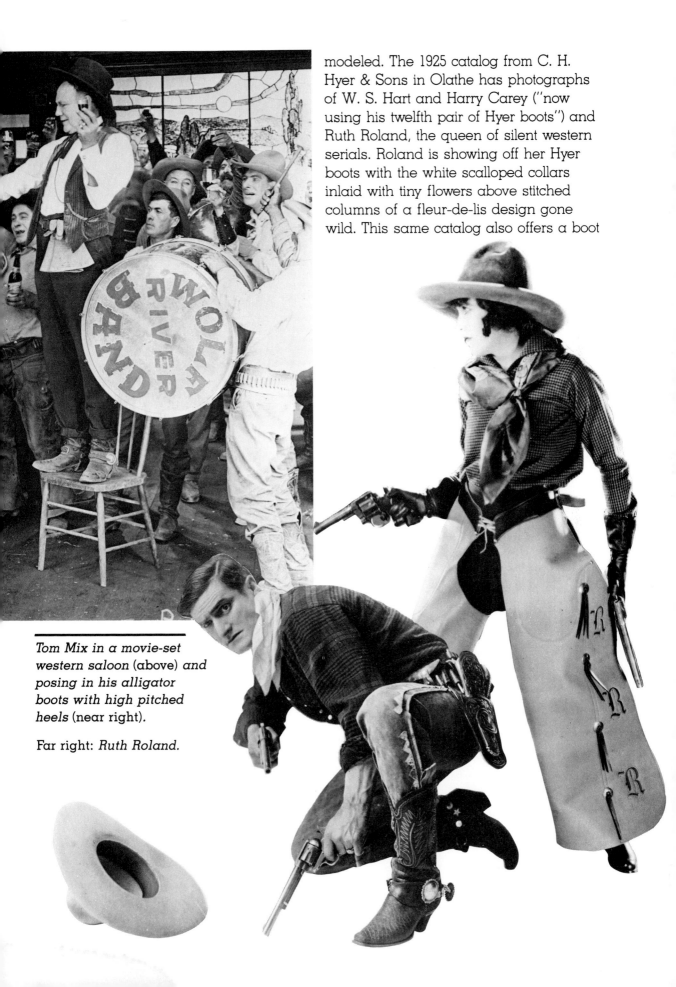

modeled. The 1925 catalog from C. H. Hyer & Sons in Olathe has photographs of W. S. Hart and Harry Carey ("now using his twelfth pair of Hyer boots") and Ruth Roland, the queen of silent western serials. Roland is showing off her Hyer boots with the white scalloped collars inlaid with tiny flowers above stitched columns of a fleur-de-lis design gone wild. This same catalog also offers a boot

*Tom Mix in a movie-set western saloon* (above) *and posing in his alligator boots with high pitched heels* (near right).

Far right: *Ruth Roland.*

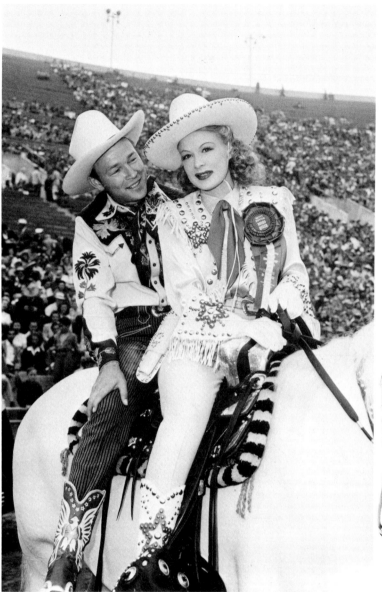

Left: *Roy Rogers with Betty Hutton, who had been named queen of a huge rodeo in Los Angeles in 1944. Rogers is wearing the distinctive inlaid eagle boots that were the emblems of his movie and television career. Betty Hutton is wearing a white satin and silver-studded fringed-leather outfit appropriate for a Hollywood star appearing at a rodeo in the Forties.*

Opposite page: *Dale Evans in* Along the Navajo Trail, *1945. Her short boots with wide tops were a typical Forties style.*

designed for one of Hyer's "very particular" customers. On each top a huge eagle with outspread wings clutches a red, white, and blue shield. The wings extend from just below the perforated white collar of the boot down past the tongue, and three white stars arch over its head. The vamps of the boot are sleek and unwrinkled, above two-inch underslung heels.

The other boots in the 1925 Hyer catalog are much plainer than the extraordinary eagle boot. Most of them are of black or tan French calf and have

modest, single-row stitching patterns under deep-notched tops with no collars. Heels are nearly two inches high and toes are rounded. By the Thirties, however, styles for regular customers were similar to those worn by the movie cowboys. Inlaid butterflies and stars, steer heads, half moons, hearts, dice, and flowers decorated the tops of stock boots. There were usually four rows of stitching, which sometimes snaked down to the vamp or covered the toe and counter.

The decorated boots of the Thirties and Forties reflected the kitsch glamour of the

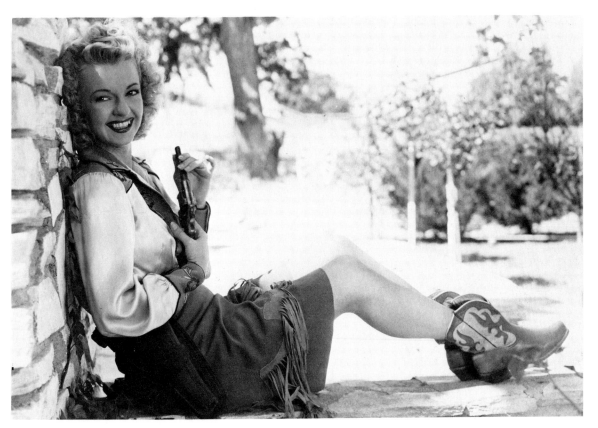

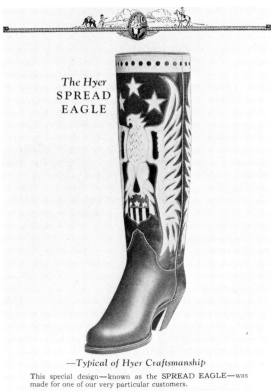

The Hyer
SPREAD
EAGLE

*—Typical of Hyer Craftsmanship*

This special design—known as the SPREAD EAGLE—was made for one of our very particular customers.

This beautiful boot is shown here, primarily, to illustrate the extraordinary craftsmanship and striking originality shown by our workmen in producing this peer of all fine boots. Price $85.00.

*See Back Inside Cover Page for World's Rodeo Records*

[ 12 ]

films of the period. The enormously popular cowboy musicals of Gene Autry, Roy Rogers, and their emulators were travesties of conventional Westerns, set in a fantasy modern West of radio stars and rodeo celebrities and villainous nightclub owners. Autry wore ornamented shirts outlined in gold braid and piped tailored trousers tucked into gaudy boots adorned with silver spurs attached by straps fastened with silver buckles. The boots he wears in the photograph on page 31 are typical Thirties movie-cowboy gear. Narrow, squared-off toes are covered with long, perforated wing tips which contrast with the rest of the vamp and are matched by the counter foxing. The uppers are inlaid with tall multicolored flowers and leaves that surround a longhorn steer head. Yellow inlaid stars and crescent moons fill the only available area below the white carved collar, which is itself inlaid with hearts and diamonds and arrows.

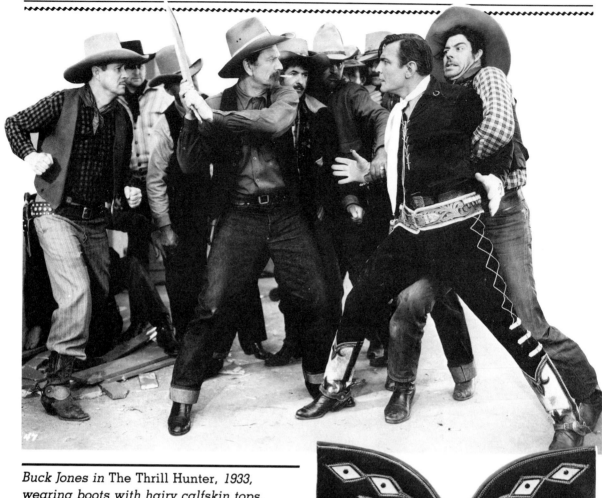

*Buck Jones in* The Thrill Hunter, *1933,*
*wearing boots with hairy calfskin tops.*

**T**he popularity of western films was
part of an enthusiasm for exotic cowboy
life that had been widespread since the
late 1800s. Newspaper articles and dime
novels had reported more or less fantastic
stories of the Wild West, and privileged
outsiders could observe working cowboys
close up from rather early on. By the end
of the century, private Pullman cars were
taking wealthy easterners and Europeans
to lavish resort hotels in the Southwest.
When the cattle business began to fail,
ranches were opened up to boarders
during the off seasons, and hunting
parties or packing trips were organized to
give visitors "a taste of the West." By
1926, when the Dude Rancher's
Association was formed, visits to paying
guest ranches had become fashionable
and were encouraged by the Association
as being adventures that were in fact
somehow ennobling:

*The heritage of the old-time West has been handed down to the dude rancher. His now is the responsibility to keep forever fanning those few sparks and embers still left, and thus keep alive the memory of those traditions that made this country what it was.*

So easterners came West to ride in the desert and watch cowboys brand calves.

sidesaddles, and they had for some time worn pretty much the same riding clothes as men. Both men and women visitors to the western ranches adopted cowboy clothes, and by the Thirties a more or less androgynous western style of dress had emerged. In 1934 the Justin Boot Company, which had been making cowboy boots since 1879, acquired lasts for women's sizes.

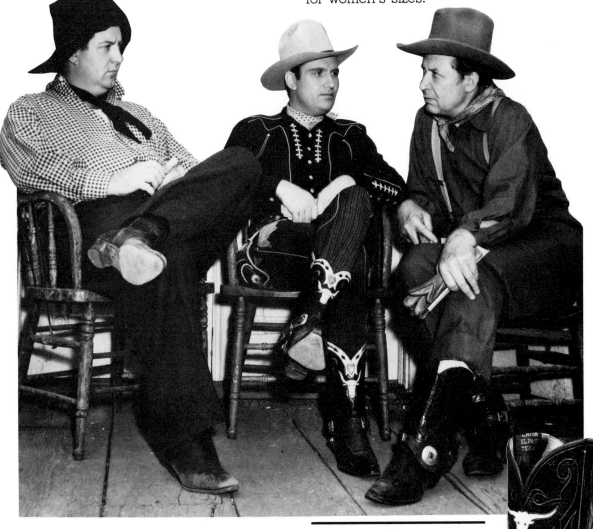

At first they brought their own riding clothes. Women guests were mockingly called "dudeens" by the ranch hands, who were unaccustomed to the "masculine" riding outfits the women wore. Eastern women riders had begun to ride astride in 1901 or so, several years before women in the West discarded

*Gene Autry on a movie set with his supporting actors. His boots are inlaid with longhorn-steer heads, stars, crescent moons, hearts, and arrows. Right: A late Forties boot style from the Tony Lama Company.*

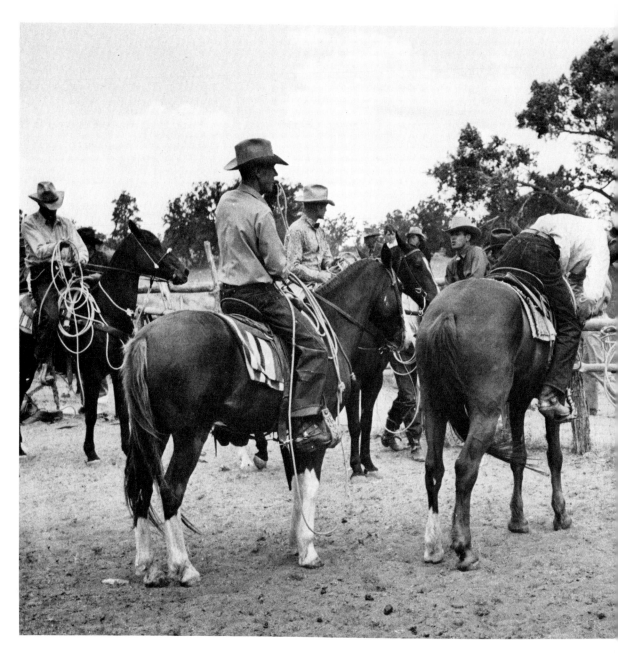

Cowboy fashions had always been manifestations of a sort of dandyism, and the ornate western shirts and boots of the Thirties and Forties were simply extrapolations from that. Western movies and fashionable dude ranches produced new customers for cowboy clothes and inspired designers of western wear, but most of the piped shirts and high-heeled boots were worn by cowboys who still rode horses and chased cattle. For them the embellished western fashions were conventions of their own theater, the rodeo ring. Rodeos had begun as informal contests among cowboys from different ranches, and by the turn of the century were tests of skill for money. By 1920 there was a year-round rodeo circuit, with events usually tied to some sort of celebration—the Fourth of July, Frontier Days, the Roundup. As rodeo cowboys became more professional they made alterations in their boots according to the event they were in. Bronc riders, for

enable them to run quickly from their horse to the calf after the catch was made. Bulldoggers preferred very high, sharply slanted heels that they could dig into the ground to brace themselves against the animal they were trying to throw. The boots worn by rodeo cowboys when they weren't performing, however, were distinctive mostly for their flamboyance. They influenced the style of ordinary cowboys, who were likely to order for themselves something similar to what they had seen at the rodeo.

**S**uch bequests from the exotic to the mundane are typical of the history of the cowboy boot. The stitching patterns, toe shapes, colors, and inlaid-leather designs of the boots of movie heroes or rodeo stars were picked up by the common boot wearer, and boots generally became

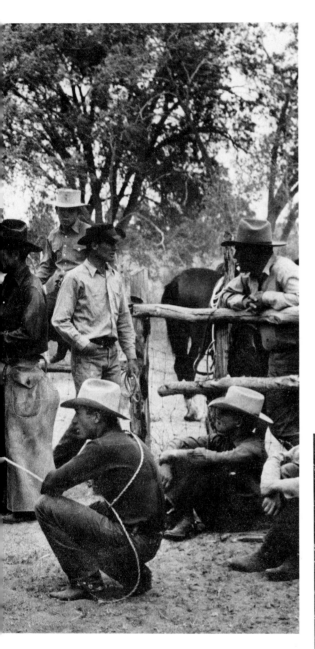

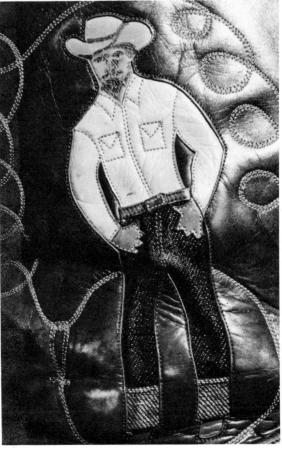

instance, removed the shank from their boots so that they could get a better grip on the narrow bronc-riding stirrups. Calf ropers put on a low heel that would

Above: *Cowboys at a rodeo in the Forties. Photograph by Russell Lee.*

Right: *Inlaid design on the top of a boot made by the Justin Boot Company in the 1950s for a Levi Strauss salesman. The leather cowboy has pants made of blue denim.*

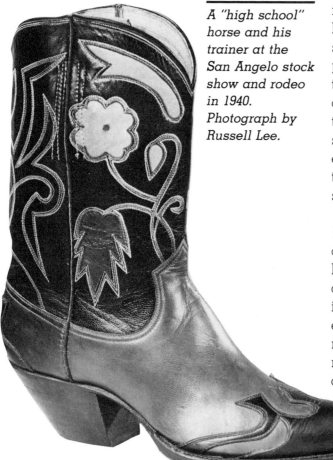

*A "high school" horse and his trainer at the San Angelo stock show and rodeo in 1940. Photograph by Russell Lee.*

fancier. The plain cowboy boots of the late nineteenth century with their squared-off tops and simple stitching patterns soon acquired deep notches in the collar; stitching designs became more complicated, and multiple rows of colored thread were sewn on in place of the single row of reinforcement. Long "mule ear" pulls were sometimes draped down the side of the boot, and inlaid stars or steer heads were cut into the tops.

Bootmakers became more inventive. By 1923 the Justin Boot Company was offering its customers thirty-two styles—in kangaroo, Morocco kid, French waxed calf, alligator, with color combinations and inlaid designs. The cowboy mania engendered by western movies and dude ranches encouraged bootmakers to add multiple rows of stitching in contrasting colors to boot tops already encrusted with decorative figures. Toes and heels were trimmed with tooled or perforated wing tips and foxing. Heels were nearly two

inches high well into the Fifties, but tops, which in the beginning had been very tall—eighteen or nineteen inches—were about fourteen inches high by the Twenties and in the Forties were quite short—from six to ten inches. These short, fancy boots were clearly not riding boots, but they still had high heels, and toes were sharper than ever.

Then in the early Sixties boots became more sober. The inlaid patterns and symbols in boot tops were pretty much discarded in favor of a solid-color boot made from an "exotic" skin—ostrich, shark, swordfish, crocodile, various South American lizards, boa, or python. The most common cowboy boot in Texas in the Sixties and Seventies was essentially a conservative businessman's boot—not too tall, not too short, with a low, "walking" heel. There were of course exceptions to this, and custom bootmakers were still asked to put bulldogging heels on plum-colored lizard boots with flying-eagle inlaid tops or to cut a blue iguana Star of David into black sharkskin for the local rabbi, but until the late Seventies, when there was a renaissance in traditional cowboy imagery, boots were generally rather plain.

The move away from the fanciful boots of the Forties and Fifties toward brown or black boots of lizard or ostrich can on the one hand be attributed simply to fluctuations in fashion—change for its own sake. But fashion reflects social changes, and it was during those years that the Southwest was becoming the most affluent region in America. While Texans still thought of their achievements as emanating from the frontier spirit, it was the Cadillac and the computer rather than the horse and branding iron that symbolized their place in the world. Corporate engineers in Texas continued to wear cowboy boots, but they were worn

with Brooks Brothers suits. The conservative boots preferred by Texans permitted them to keep what had become almost a badge of regional identification while declaring themselves free of the old-fashioned, provincial Texas of the Wild West.

Recently, when cowboy boots were assimilated into the culture at large, the old images found a new audience, and boots became colorful again, inlaid designs reappeared, stitching was more ornate. The cowboy boot, which had begun as a somewhat fanciful notion about a piece of working gear, was adopted by "cowboys" who were attracted to the traditional imagery partly because Texas is affluent and vital and they wanted to be part of that, but also because the imagery refers to an unfettered, fiercely independent stance that is increasingly difficult to emulate in real life.

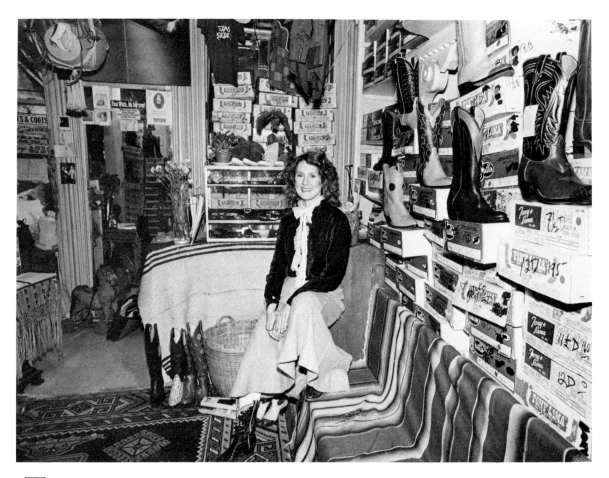

The recent enthusiasm for the old-fashioned cowboy boots of Texas was nurtured in New York, and the person most responsible for the trend is a displaced Texan fashion photographer. Judi Buie grew up in Itasca, Texas (pop. 1,483), about fifty miles north of Waco. Her parents gave her a "real boring" pair of cowboy boots when she was twelve, and she saw fancy boots at local rodeos, but boots didn't inspire her until around 1975, after she had left Texas and moved to New York, where she was photographing fashion collections. She came home that year for Christmas and was given "another pair of brown boots," which she picked out at the giant western store in Lott. Those brown boots encouraged what was to become a boot craze. Judi began wearing them with skirts, and people began asking her to bring back a pair for

them when she next returned from Texas. Saddle shops in New York then carried cowboy boots, but only in a few styles and sizes.

"My first inclination was to go down there and get a truckload of boots. And one day I just decided I should open a shop. I had ten thousand dollars, and I called Tony Lama and Justin and asked them what to do. They said you don't have to do anything, we'll just send a representative to you. So the boot manufacturers came to my apartment and I chose the boots that I wanted, which are

*Judi Buie in her shop, Texas, in New York City.*

Opposite page: *Judi Buie's black calf-skin boots with white spread eagles inlaid into the tops.*

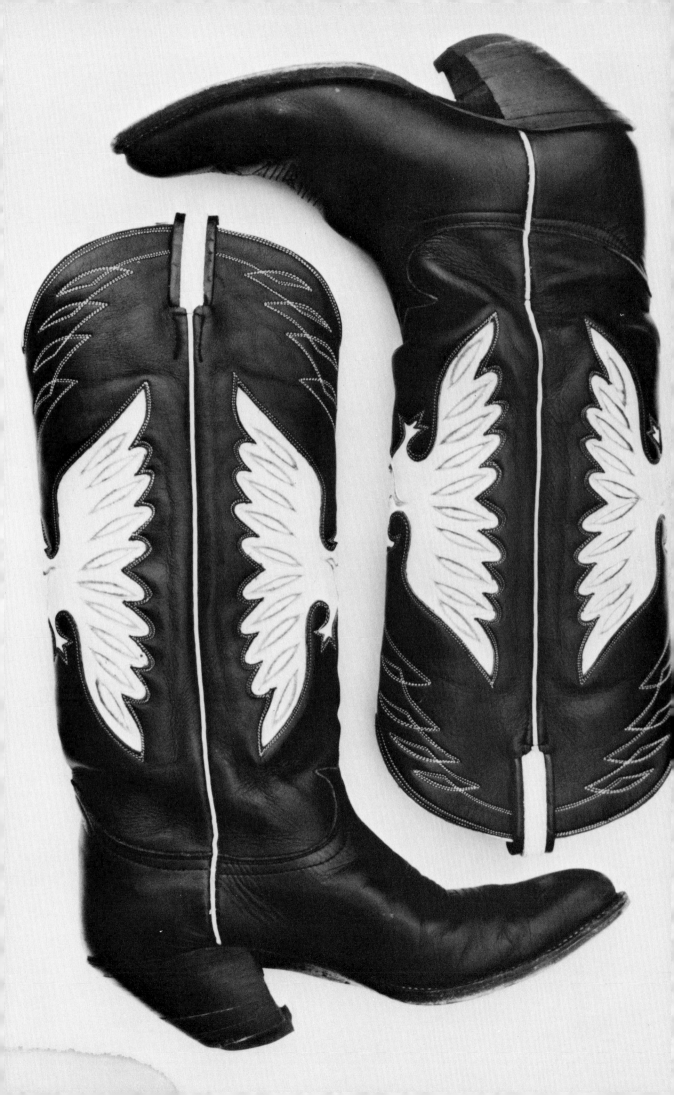

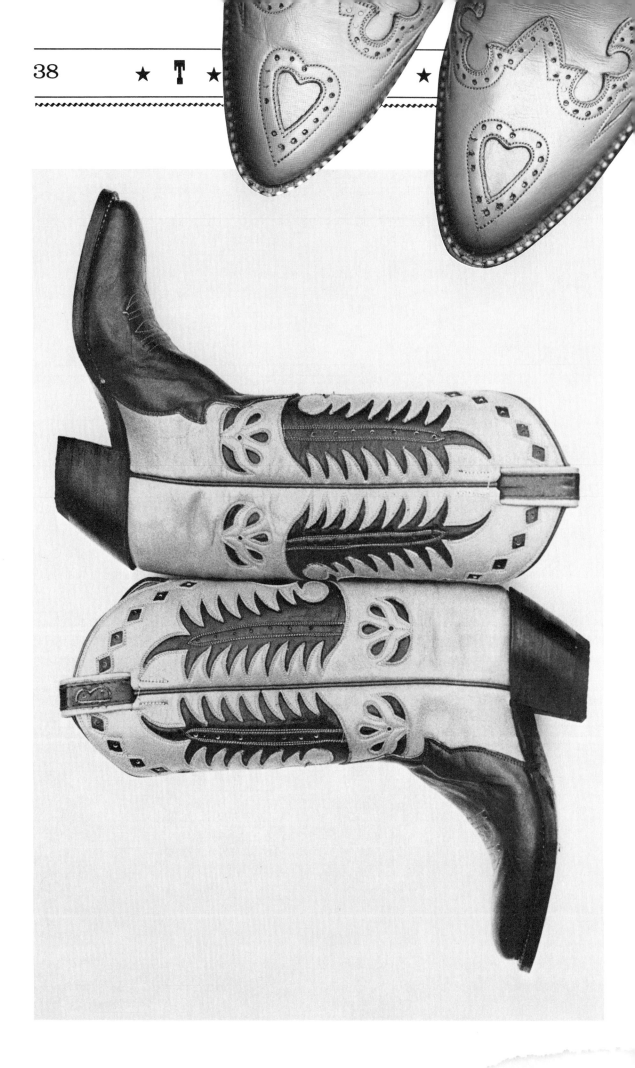

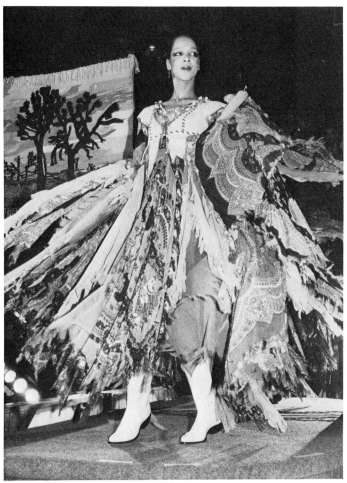

Left: *A model wearing white ostrich boots and a chiffon and feather Giorgio Sant' Angelo dress at Judi Buie's 1977 fashion show at the Lone Star Cafe on Fifth Avenue. New Yorkers "discovered" cowboy boots here. Photograph by Paul Hosefros/NYT Pictures.*

Opposite page: *Judi Buie's designs are marked with a leather "B" stitched into the pull straps. This pair has a kelly-green triad-style vamp and yellow calfskin tops inlaid with red palm leaves and diamonds.*

Opposite page, above: *Detail of Judi Buie's yellow calfskin boots with fancy wing tips. See also color plate 20.*

still the basic things I keep around. I learned then to trust my intuition. The Tony Lama rep kept telling me to get a boot that he said was the hottest boot they had, and I hated that boot, thought it was the ugliest thing I'd ever seen. But he gave me so much trouble that I ordered thirty pairs of them. Four years later I still had a pair of those boots left."

Judi Buie's intuition and taste shaped a look. Early in 1977 she invited some friends and celebrities to model in a fashion show at the new Fifth Avenue western bar, the Lone Star Cafe. She lent everybody a pair of boots and told them to "dress around them." The tap dancer and choreographer Tommy Tune couldn't get his boots on, so he came out walking on his hands; New York City Ballet star Jacques d'Amboise wore his costume from

"Stars and Stripes" and danced in his Tony Lama boots to a cowboy band; a woman in a Giorgio Sant' Angelo dress made out of feathers and chiffon wore white ostrich boots and stole the show. It was three o'clock on a Tuesday afternoon, the place was jammed, and there were huge crowds in the street. Cowboy boots had arrived in New York.

The first customers for Judi's boots were designers and models, but the taste for boots spread, and a lot of people wanted boots in colors and designs that the factories didn't supply. Judi had boots made up for her customers by the Dixon boot company in Wichita Falls, but she became interested in doing her own designs one day when she discovered a cache of boots from the early Fifties. She was driving along the road from Nocona,

near the Oklahoma border, and stopped in Henrietta at the Olsen-Stelzer boot company. A bunch of pink, pale green, and orange and lavender boots were lying on the floor of the office. The Olsen-Stelzer people had found them in the attic and were trying to get rid of them. "I couldn't believe it. I spent the whole day in the attic going through boxes, flipping out. But nobody there understood what I was doing. They were the craziest boots those cowboys had ever seen." She bought all that she could find, forty-four pairs, and took them back to New York, where they became the inspiration for her own styles.

The combinations of colors and decorative details distinguish Judi's boots from those of other designers. Her most successful style, for instance, is a lavender boot with red wing tips and counter foxing, beige side seams and beading, with a beige diamond-inlay pattern in a sort of latticework all the way up the top of the boot (see color plate 23). She makes a kelly green and mustard yellow triad-design boot with lavender wing tips and counter foxing, a solid red calfskin boot with huge red and black inlaid butterflies, a black calfskin boot with white counter foxing and white perforated wing tips that flow all the way back to the side seam.

Until recently, when she decided to become a free-lance designer, Judi sold boots at her shop, Texas, tucked away over a restaurant in what was once the second-floor back parlor of a townhouse on one of Manhattan's elegant East Side streets. The other shops on the street sold Italian suits, French silk shirts, tennis

outfits. At Texas a Willie Nelson tape was usually turned up loud, boot jacks and pulls were scattered all over the Indian rug, and about five hundred boxes of cowboy boots were jammed in stacks against the walls, piled in the middle of the floor, spilling out onto benches and chairs. In the midst of this clutter one was likely to find a Japanese businessman selecting five or six pairs to take back to Tokyo, models and movie stars coming to pick up their custom-made boots designed by Judi, Wall Street lawyers trying on something that would be "OK for the office." Judi Buie initiated this commingling of cultures. And no one in New York makes jokes about her accent anymore.

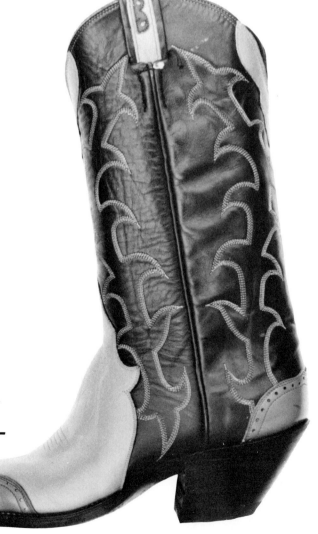

*Judi's boots with lavender wing tips and counter foxing on yellow vamps. The tops are dark green with multi-colored flame stitching.*

# PARTS of a BOOT

Pull straps

Piping

Scallop

Beading

Collar

Inlaid decoration

Tongue

Vamp

Medallion

Wing tips

Counter
(with foxing)

Stitching on welt

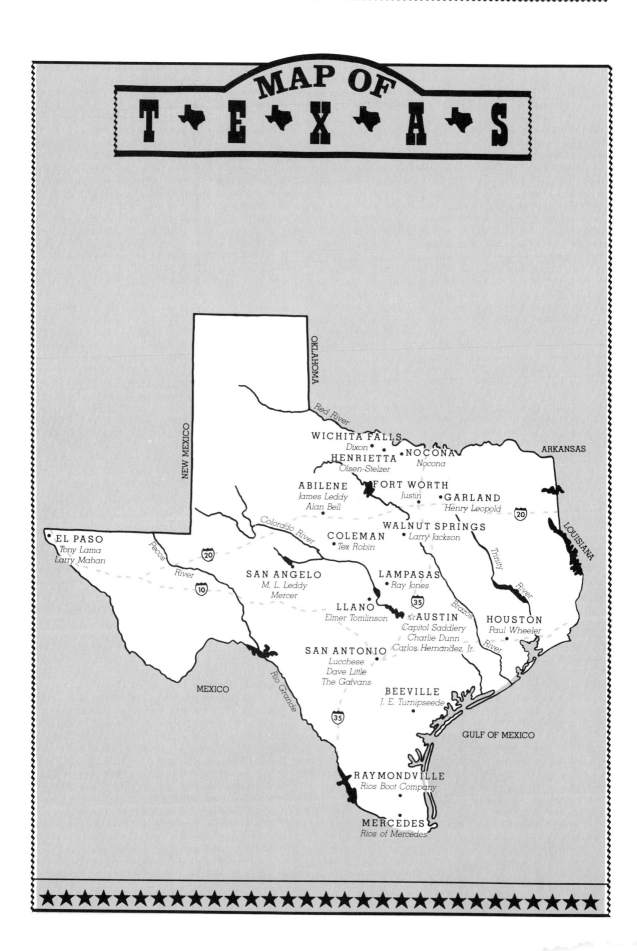

# MAP OF T ✦ E ✦ X ✦ A ✦ S

OKLAHOMA

NEW MEXICO

Red River

ARKANSAS

**WICHITA FALLS**
Dixon
**HENRIETTA**
Olsen-Stelzer

**NOCONA**
Nocona

**ABILENE**
James Leddy
Alan Bell

**FORT WORTH**
Justin

**GARLAND**
Henry Leopold

Colorado River

**WALNUT SPRINGS**
Larry Jackson

**COLEMAN**
Tex Robin

LOUISIANA

Trinity

20

**EL PASO**
Tony Lama
Larry Mahan

Pecos

20

River

**SAN ANGELO**
M. L. Leddy
Mercer

10

**LAMPASAS**
Ray Jones

River

Brazos

35

**LLANO**
Elmer Tomlinson

☆**AUSTIN**
Capitol Saddlery
Charlie Dunn
Carlos Hernandez, Jr.

**HOUSTON**
Paul Wheeler

**SAN ANTONIO**
Lucchese
Dave Little
The Galvans

River

MEXICO

Rio Grande

**BEEVILLE**
J. E. Turnipseede

35

GULF OF MEXICO

**RAYMONDVILLE**
Rios Boot Company

**MERCEDES**
Rios of Mercedes

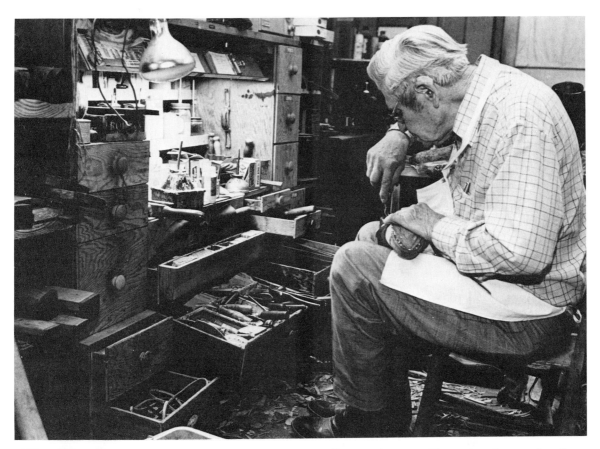

# T★H★E B★O★O★T★ M★A★K★E★R★S

Cowboy boots were conceived in Texas, and the preeminent bootmakers—the most famous, the most prolific, probably the best—are still Texans. Cowboy boots are made in other places, but in Texas one finds the principal suppliers of prestigious factory-made boots as well as the little band of elite craftsmen who turn out the finest handmade cowboy boots in the world.

Bootmaking in Texas is often a family enterprise. In some instances the family businesses evolved into large corporations—the local cobbler became bootmaker to movie stars and presidents and sheikhs—and in others the tiny shops remained tiny, producing a few pairs of handmade boots a week for devoted customers. The bootmaking dynasties—the Lamas and the Justins—exist alongside small shops that father handed down to son.

The most obvious distinction between bootmakers in Texas is that between custom bootmakers and the factories. There are large factories that have machines which enable them to turn out thousands of pairs of stock boots a week, and there are little shops where

*Master bootmaker Henry Leopold in his shop in Garland, assembling boots by hand.*

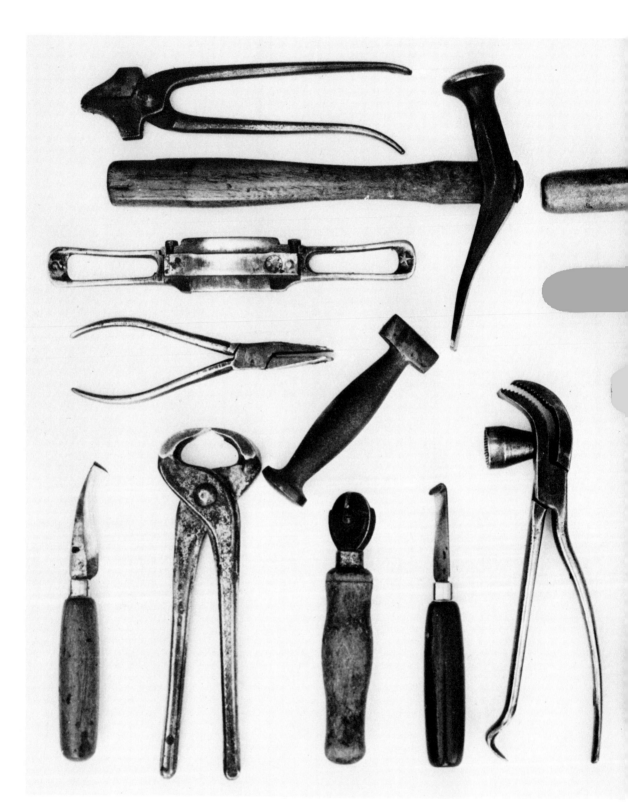

bootmakers do most of the work by hand and produce only a few pairs, specially crafted for each customer. Large custom shops, like M. L. Leddy in San Angelo, that employ a few dozen bootmakers fall somewhere in between. Most bootmakers have traditionally done both custom and stock work, and cowboys who couldn't

*A bootmaker's tools.*

the same shop that made custom boots for the more affluent. But with the recent increase in demand for boots and the dearth of young bootmakers it hasn't been possible for custom bootmakers to do much more than try to keep up with their special orders.

The size of a shop determines to an extent the working methods of a boot-maker, and this is in part a regional distinction. In northern Texas, aside from the factories like those of Justin and Nocona, there are numerous shops where a bootmaker works either alone or with some members of his family or one or two helpers. Such bootmakers are craftsmen in the Old World sense. They do all the work themselves (except for the stitching on the uppers, which is often sewn by wives and daughters). They cut out the hides, fit the lasts, shape the sole and heel, and assemble the top pieces. Henry Leopold, James Leddy, Tex Robin, and Alan Bell are representative of this sort of workman. Theirs is not exclusively a northern practice, of course, for there are boot shops in southern Texas with more or less the same system, but it is more common in the north because of the difficulty of finding skilled hand craftsmen of the sort bootmaking requires.

In southern Texas the difficulty is alleviated to an extent by the presence of Mexican workers. Shops are organized so that the nominal bootmaker designs the boots, takes the customers' measurements, selects the skins, and directs the actual putting together of the boot, which is done by his employees—whom in most cases he has trained, since in fact he has usually put in a stint as a worker himself, often in his father's shop. Cosimo Lucchese in San Antonio was the exemplary bootmaker of this sort. For years his shop produced some of the finest boots in Texas, and some of his

afford a made-to-measure boot could buy a boot in a standard size off the shelf in

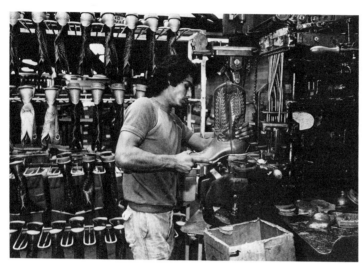

*A worker at the Tony Lama factory in El Paso holds a nearly finished boot while nails are driven into the heel at high speed.*

**Opposite page:** *The toe boxes on this pair of boots are drying before being covered over.*

workers are legendary for the extraordinary things they can do with leather. Boots made in shops like Cosimo's and that of Dave Little, also in San Antonio, are distinctively those of the particular bootmaker—a Lucchese or a Little boot is easy to recognize—but several hands went into producing them.

Another difference among bootmakers, a fundamental one, is that between a "top man" and a "bottom man." This is mostly a question of emphasis, for a good top man often makes excellent bottoms, and vice versa, but they are known for their specialties. A bottomer is concerned with shaping the sole and heel of the boot, molding the arch so it has the proper angle for the heel height, and fitting the vamp to the sole. Henry Leopold, perhaps the best bottom man in Texas, will spend days adjusting angles which are imperceptible to everyone except the client who finally gets to put on the exquisitely balanced boot Leopold produces. His boots are beautiful to look at, but he is less concerned with the decorative aspects of bootmaking than with the careful assembling of the base. A top man, or "fitter," like Charlie Dunn or the legendary Charlie Garrison, specializes in making lasts and fitting the vamp to the foot. Measuring a foot so that all its

idiosyncrasies, invisible tender spots, and bumps will be reproduced in the last is something which only a very good top man does exactly right. He then cuts out the leather for the vamp so that it will fit over the last, joins the pieces together with the uppers, and decorates the boot.

Top men have different ideas about what sort of decoration a boot should have. Many are not particularly interested in stitching patterns, for instance, and think that five rows are too gaudy. Others are devoted to dense rows of fine rainbow-colored stitches or complicated underlaid and overlaid leather designs. Dave Wheeler, for example, in his father's shop in Houston covers the upper parts of his boots with elaborate western landscapes. Lakes and cactuses and rock formations lie in his leather deserts under baby-blue cowhide skies lit by orange kidskin suns. This is ambitious ornamentation, but hardly more so than that of the pinched and raised red roses blossoming out of green kidskin stems and leaves that are underlaid into the soft calfskin of the boots decorated by Pancho Ramirez ("The Golden Needle") for the Galvans in San Antonio.

In Texas, one can find a bootmaker who will satisfy whatever notion one has of the perfect boot.

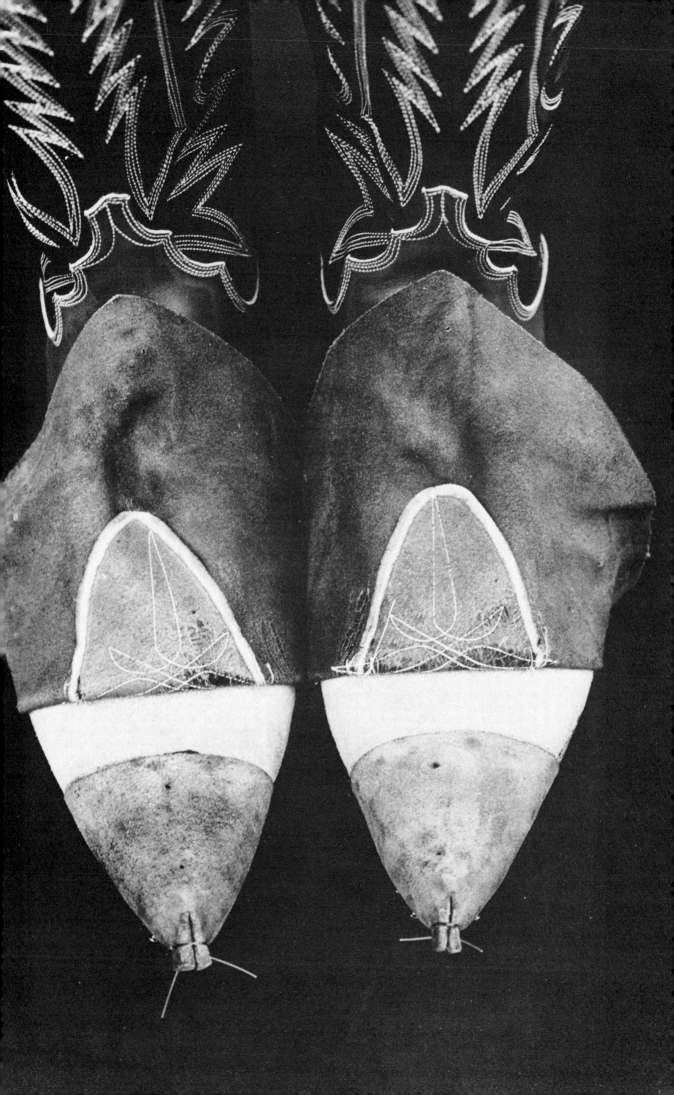

# COLOR PLATES

**1.** After a lot of hard wear, a pair of boots made by Ray Jones for a local rancher stand in Jones's shop waiting for repair.

**2.** Boots made by Ben Little, Dave Little's father, in the 1950s. They have alligator bottoms and multicolored longhorn and star inlays.

**3.** Longhorn overlays on the vamps of a pair of boots recently made by Dave Little.

**4.** A pair of boots made by Carlos Hernandez, Jr., in the Lucchese Boot Company shop in the late 1940s. The tops are inlaid with a western panoramic scene that is dominated by cactuses.

**5.** Another version of a cactus inlay, this time on a pair of boots with gray ostrich bottoms made by Charlie Dunn.

**6.** Paul Wheeler's "playing card" boots, with flame wing tips and an intricate inlay and overlay pattern.

**7.** Dave Wheeler's interpretation of a western panoramic scene. The bottoms are made from a piece of ostrich skin that is only partially covered with quill bumps.

**8.** A particularly luxurious stitch pattern: twenty rows on the tops of a pair of Justin boots from the 1950s.

**9.** Charlie Dunn's three-dimensional "pinched" rose inlay.

**10.** The full-ostrich boots designed for the centennial of the Justin Boot Company. The diamond set in a gold star represents the town of Spanish Fort, Texas, where "Daddy Joe" Justin began his bootmaking career.

**11.** Alan Bell's fully hand-tooled boots.

**12.** Boots by Tex Robin. The bottoms are of belly ostrich, with the bumpy quill section covering only half of the vamp.

**13.** A pair of Larry Mahan boots with anteater bottoms.

**14.** Tex Robin's French calfskin boots with butterfly designs and chocolate-brown overlays of kangaroo skin.

**15.** Boots made by The Nocona Boot Company in the early 1950s. The bottoms are kidskin, the tops calfskin with butterfly inlays.

**16.** Anaconda vamps on a pair of Nocona boots.

**17.** Ornate boots from the 1950s, from Judi Buie's private collection.

**18.** French calfskin boots made in the Galvan shop in San Antonio. The "pinched" red rose inlays on the tops were made by Pancho Ramirez, "The Golden Needle."

**19.** A full red rose pinched and stitched by Pancho Ramirez.

**20.** Judi Buie's yellow calfskin boots with ornate wing tips and green sunburst inlays.

**21.** A pair of calfskin boots made by the Olsen-Stelzer company in the early 1950s.

*List of color plates continued on page 81.*

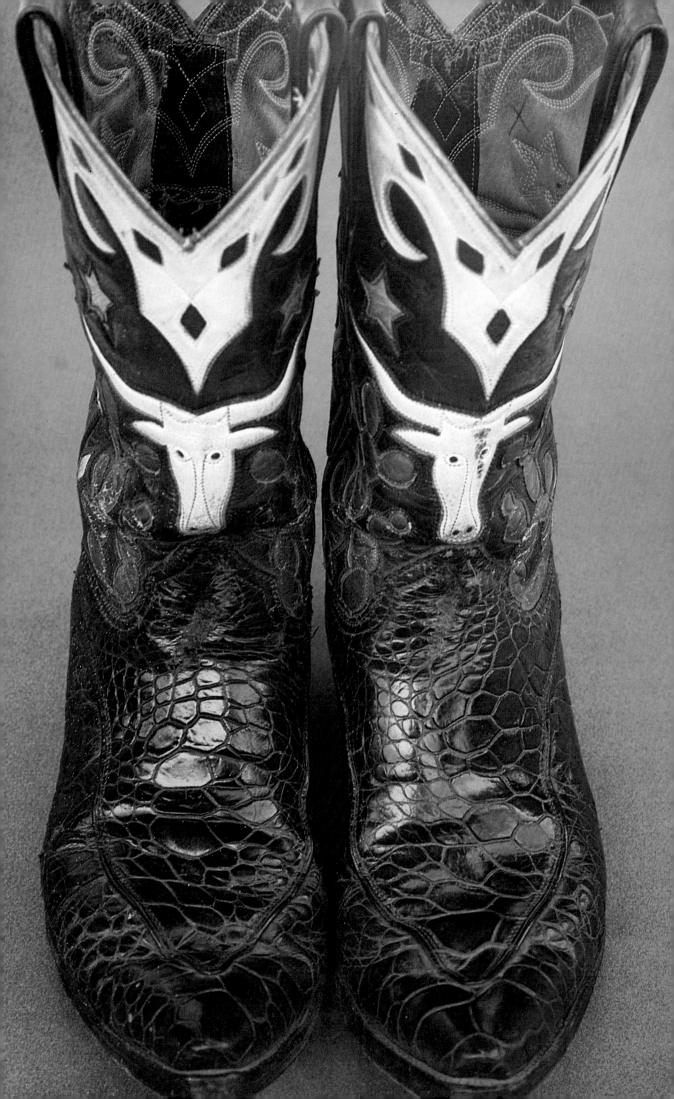

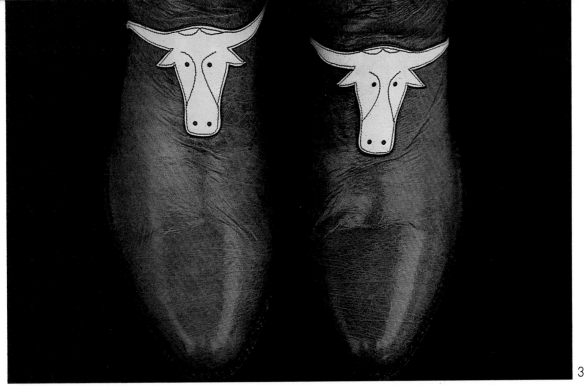

3

4

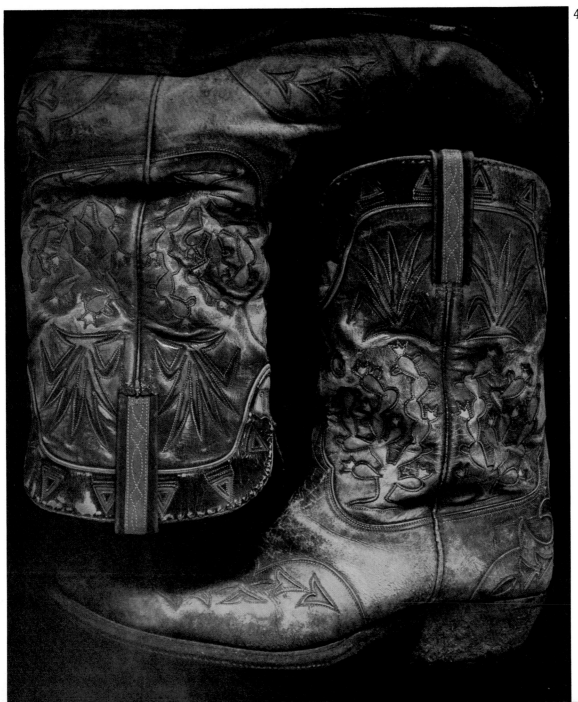

2

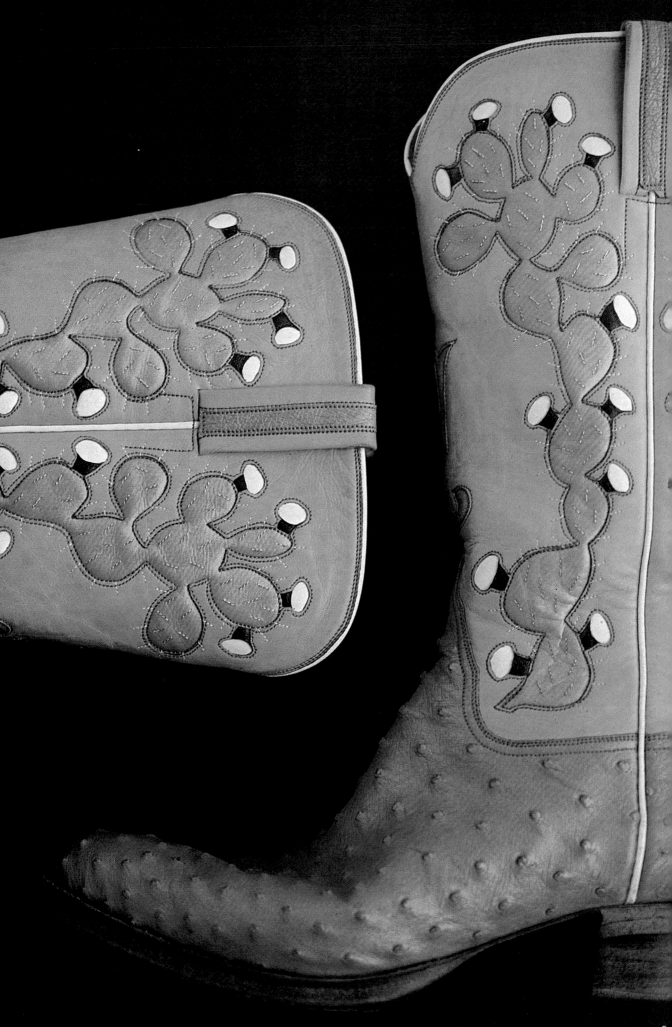

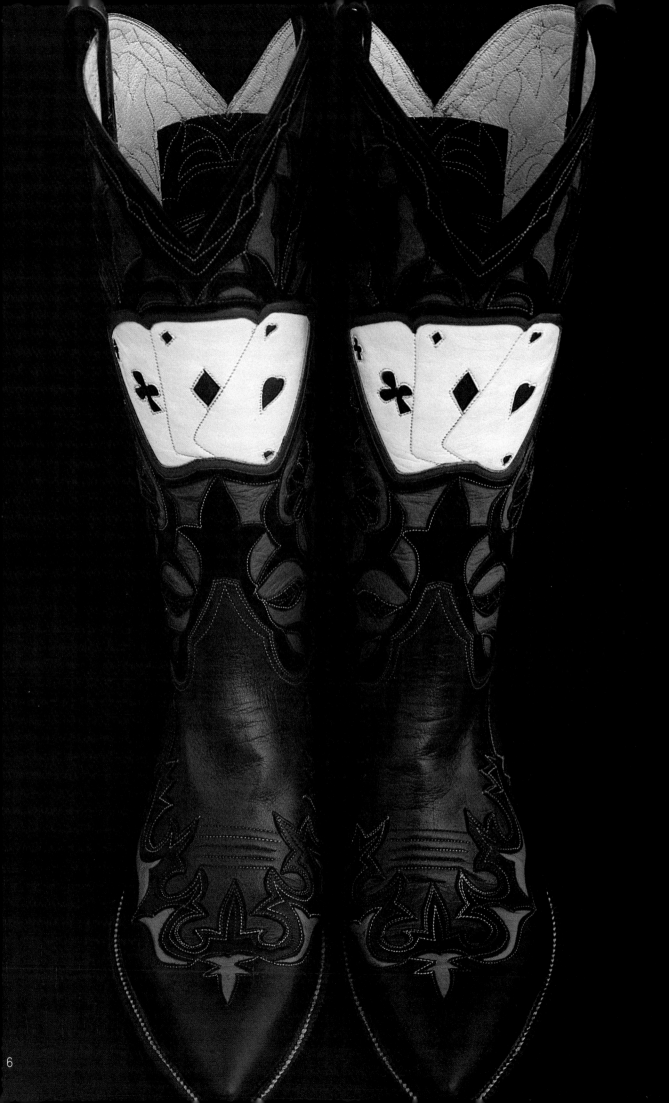

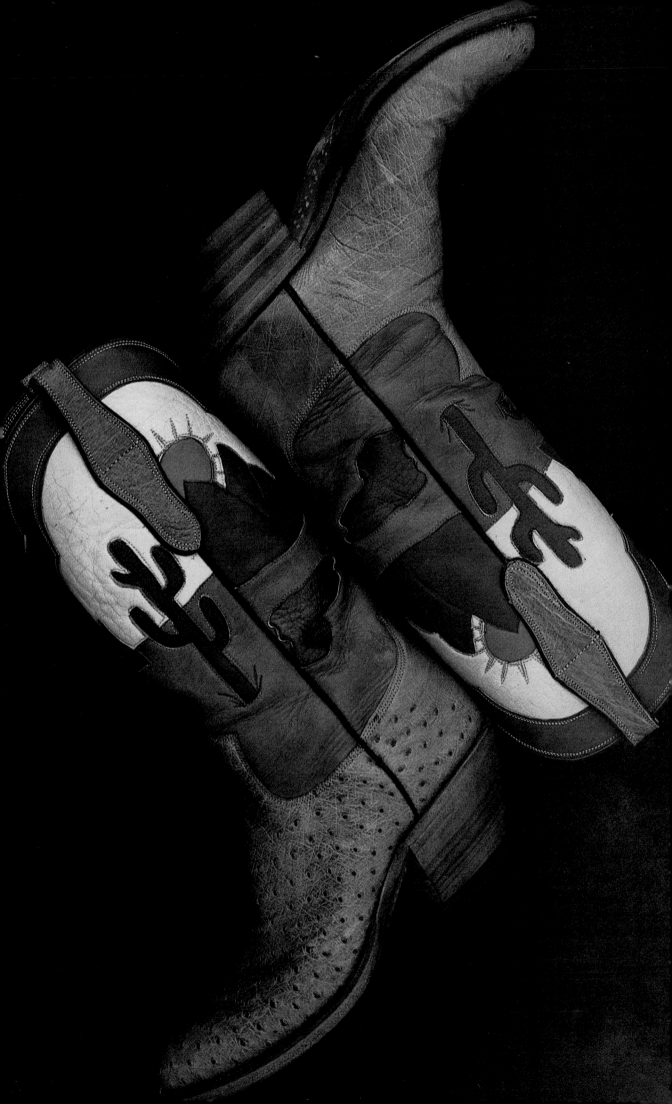

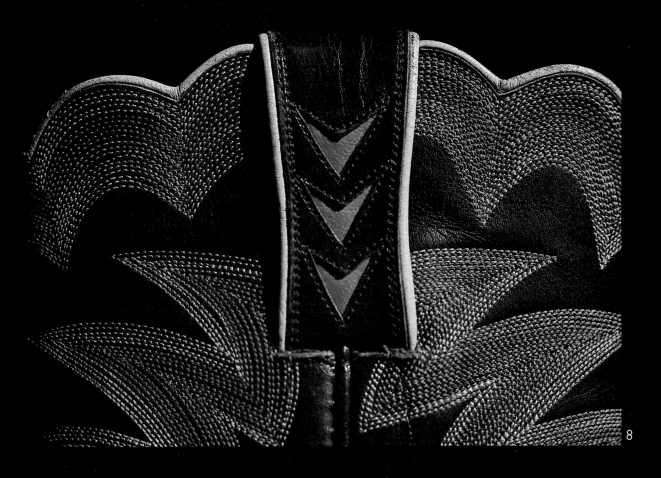

8

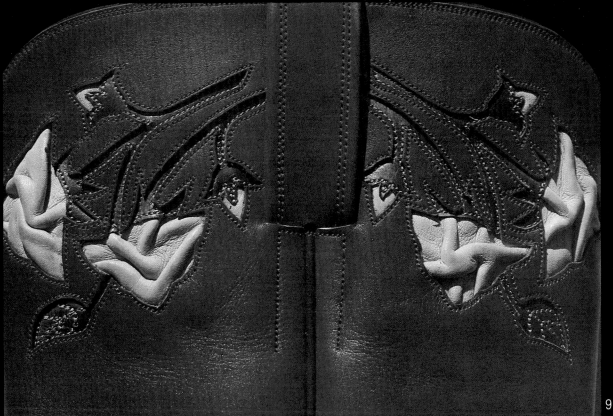

9

7

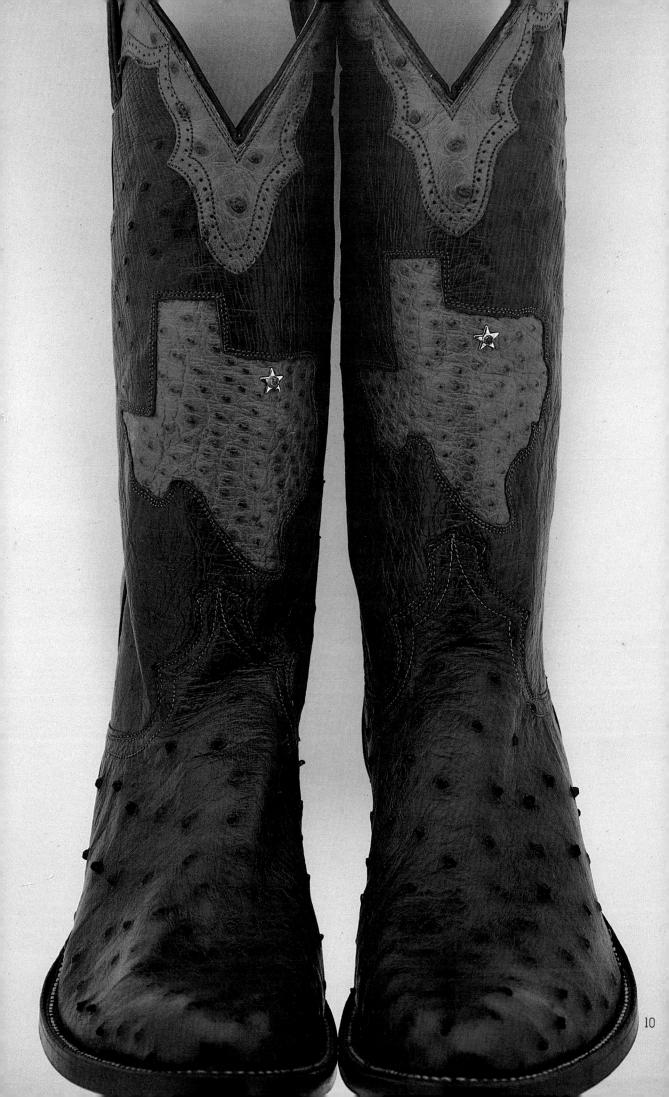

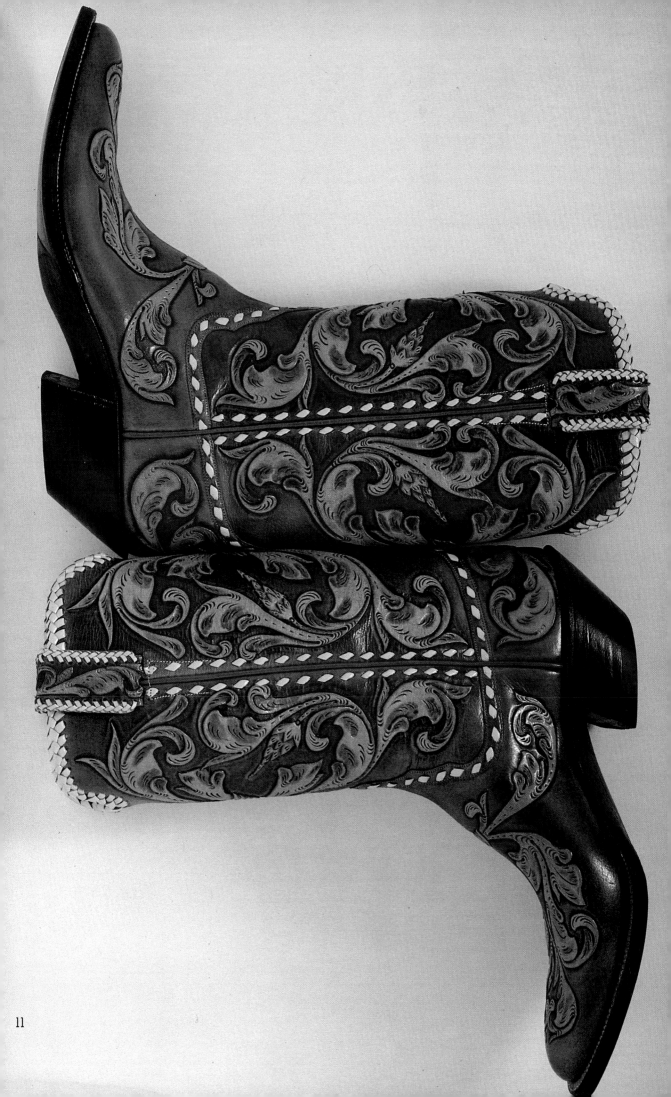

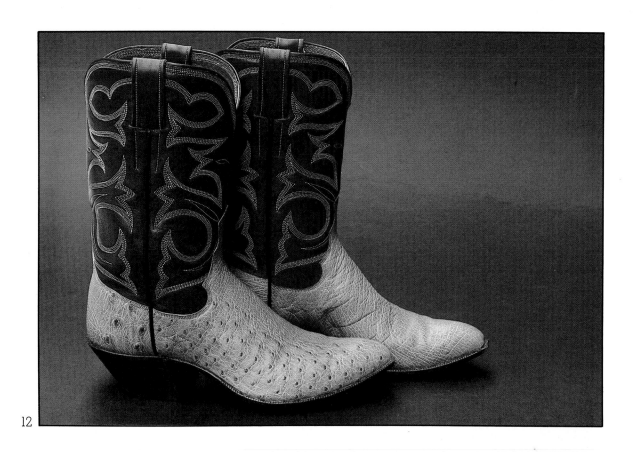

12

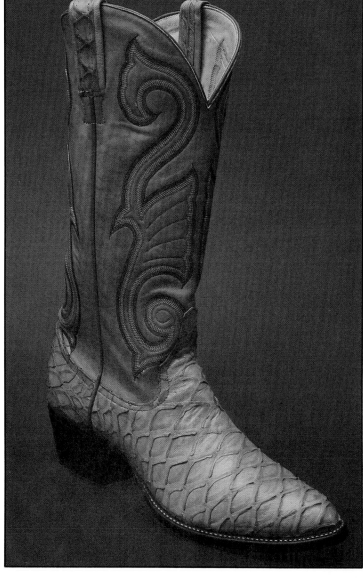

13

14

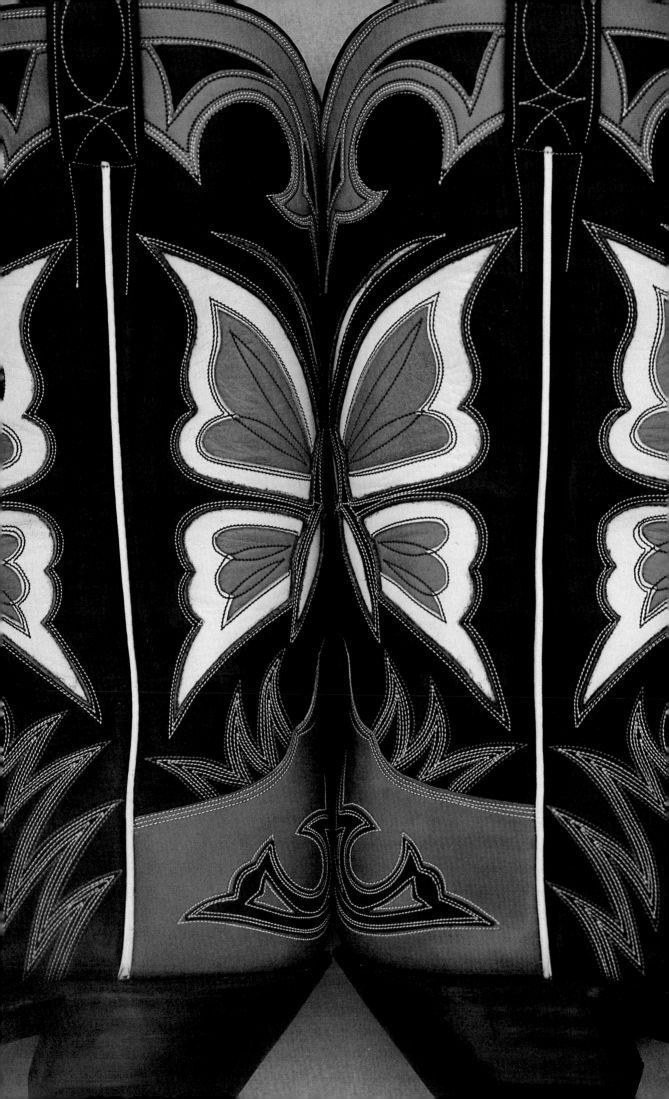

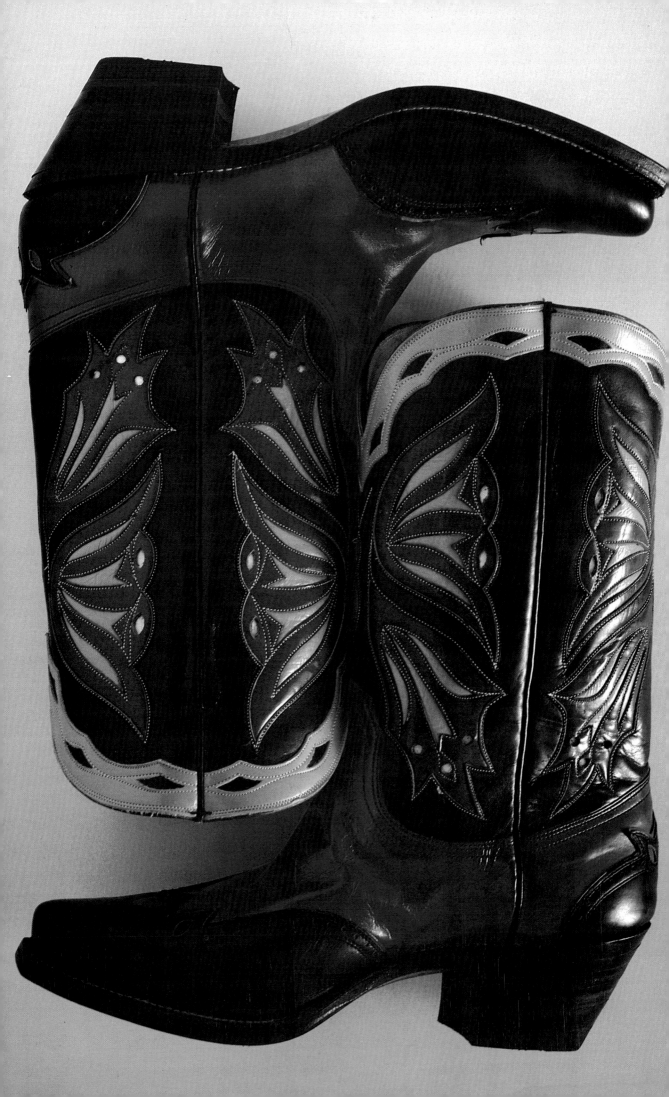

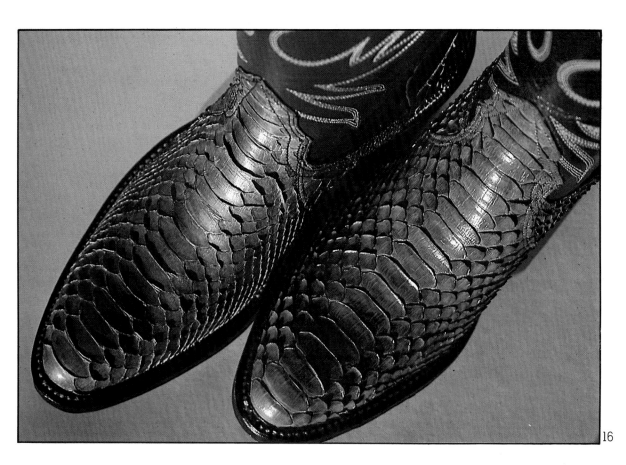

16

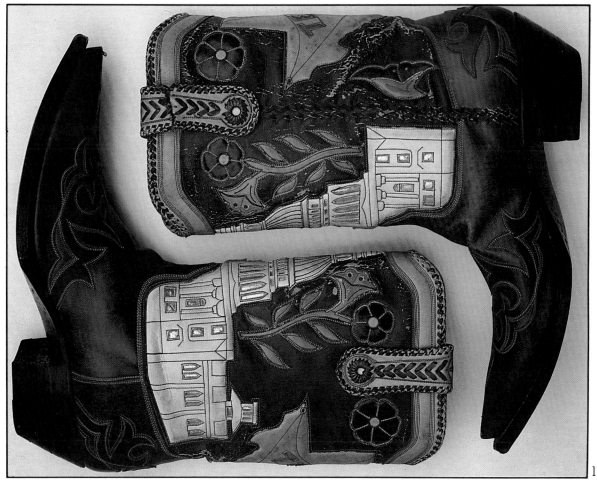

17

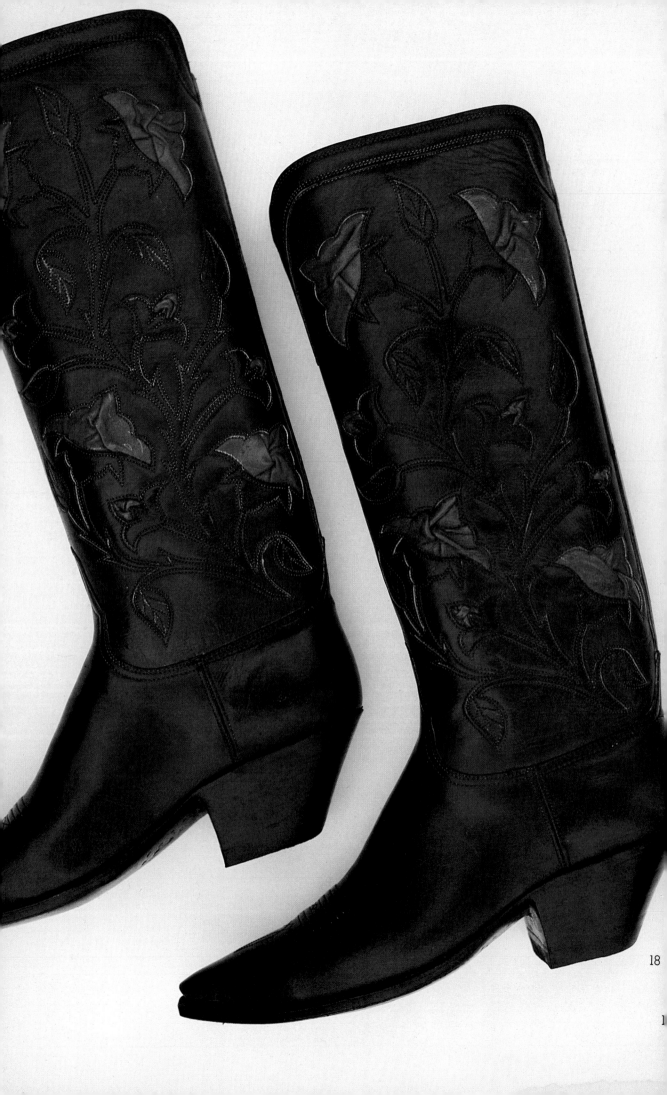

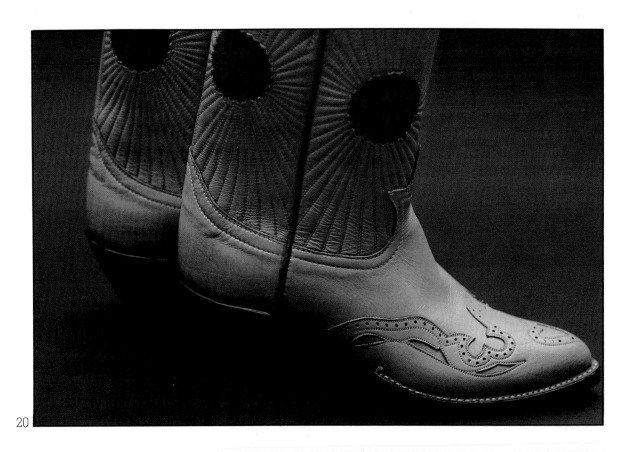

20

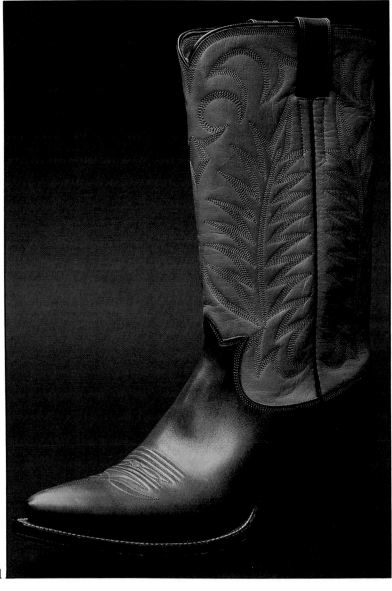

21

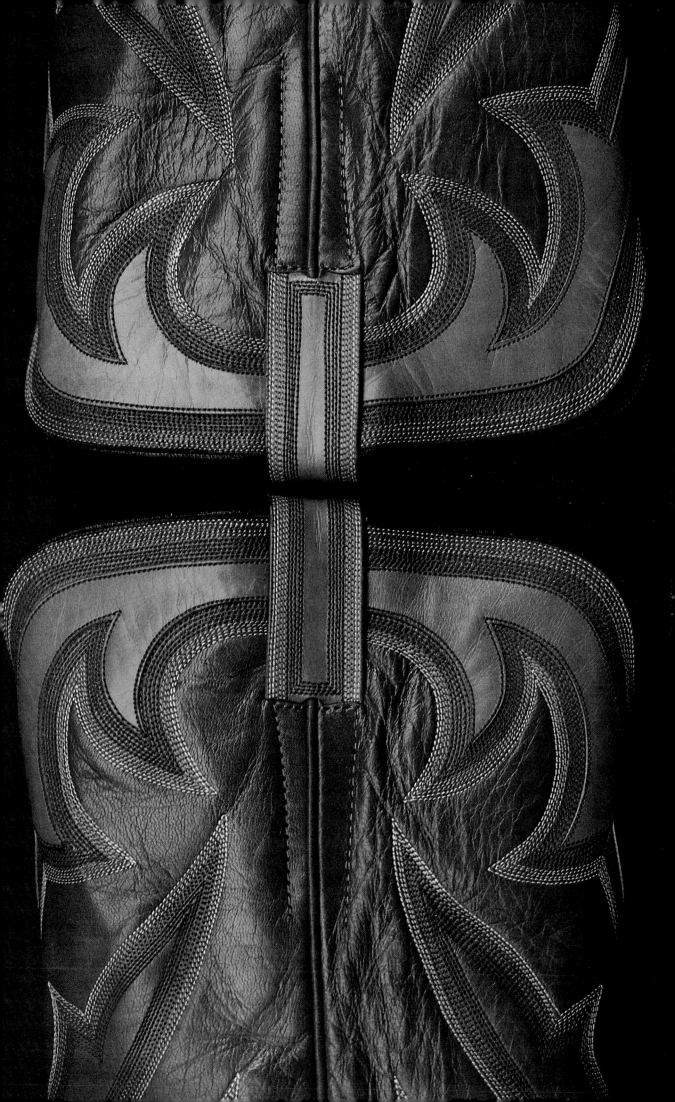

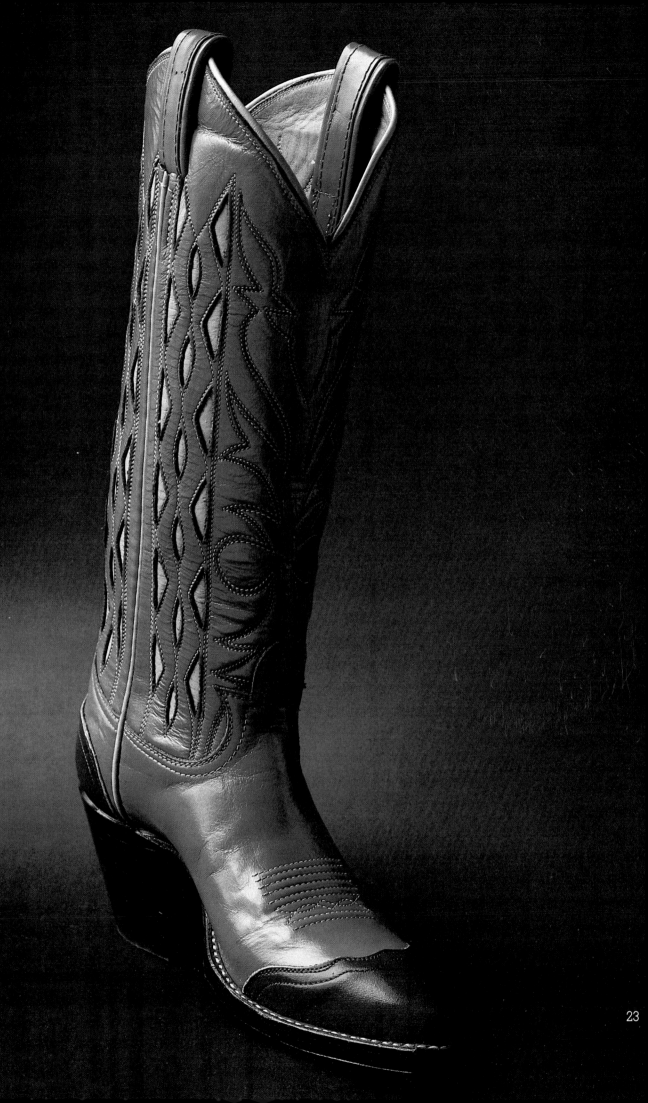

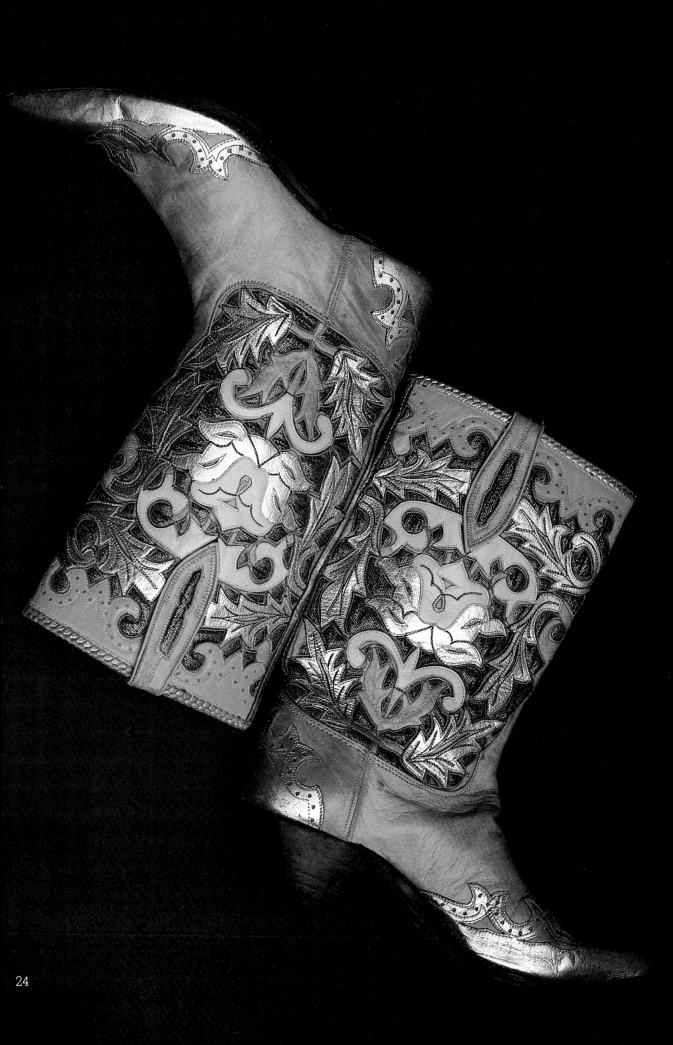

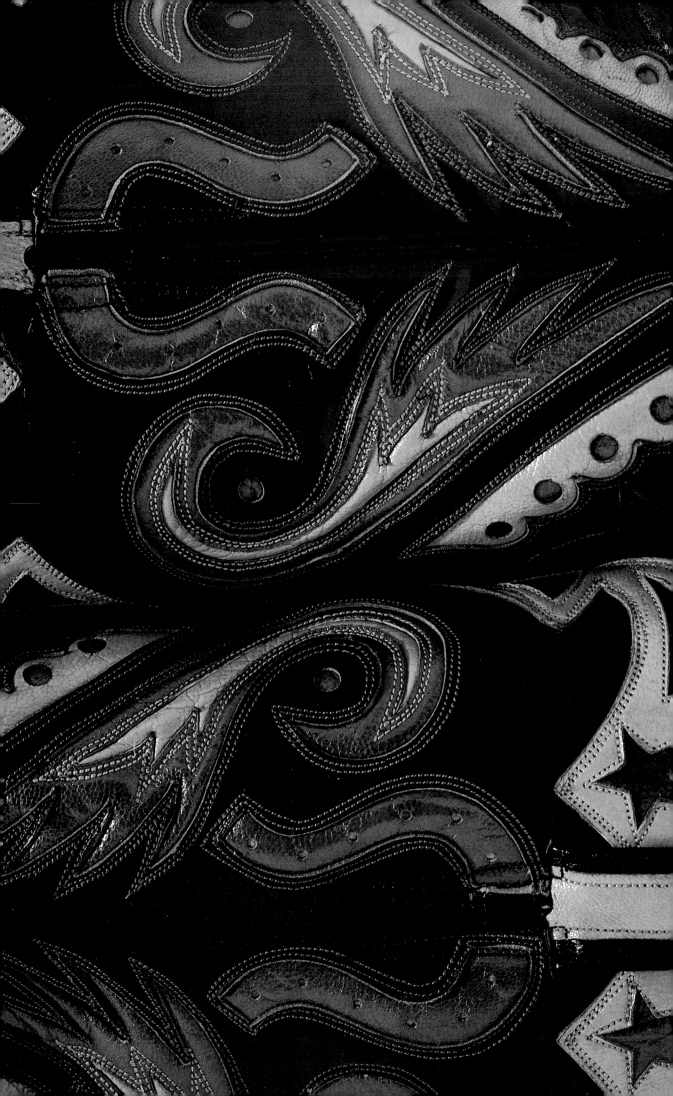

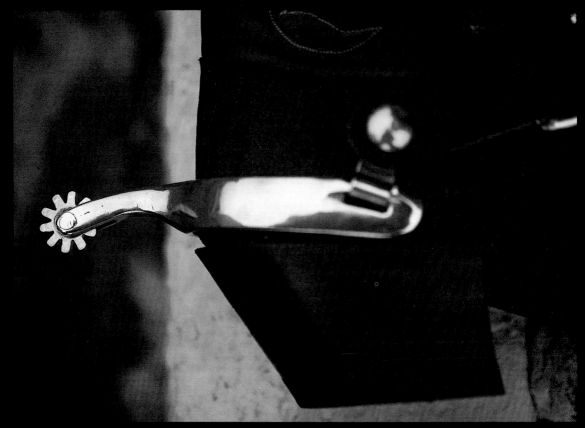

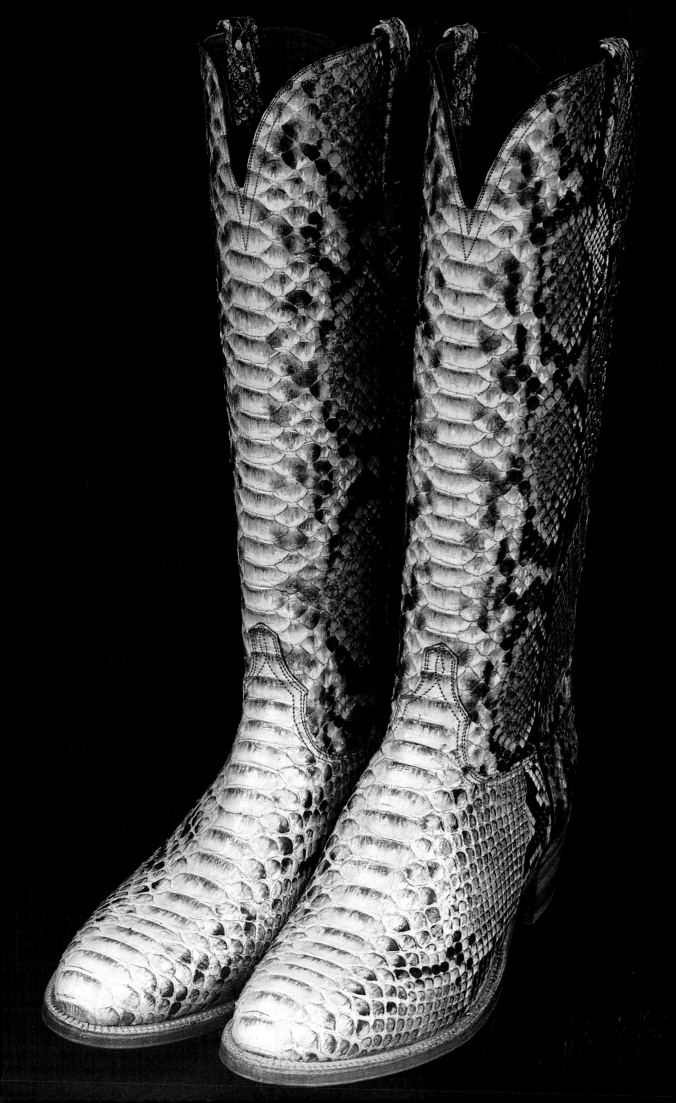

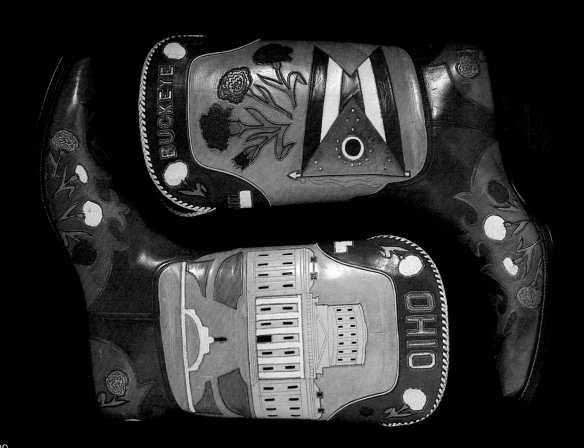

30

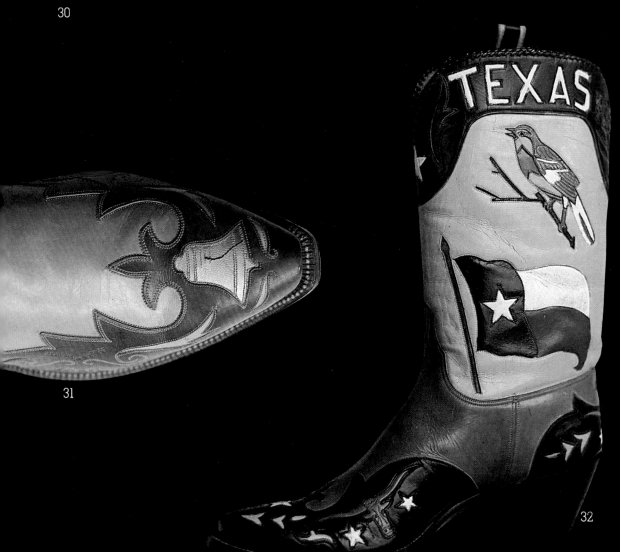

31

32          33

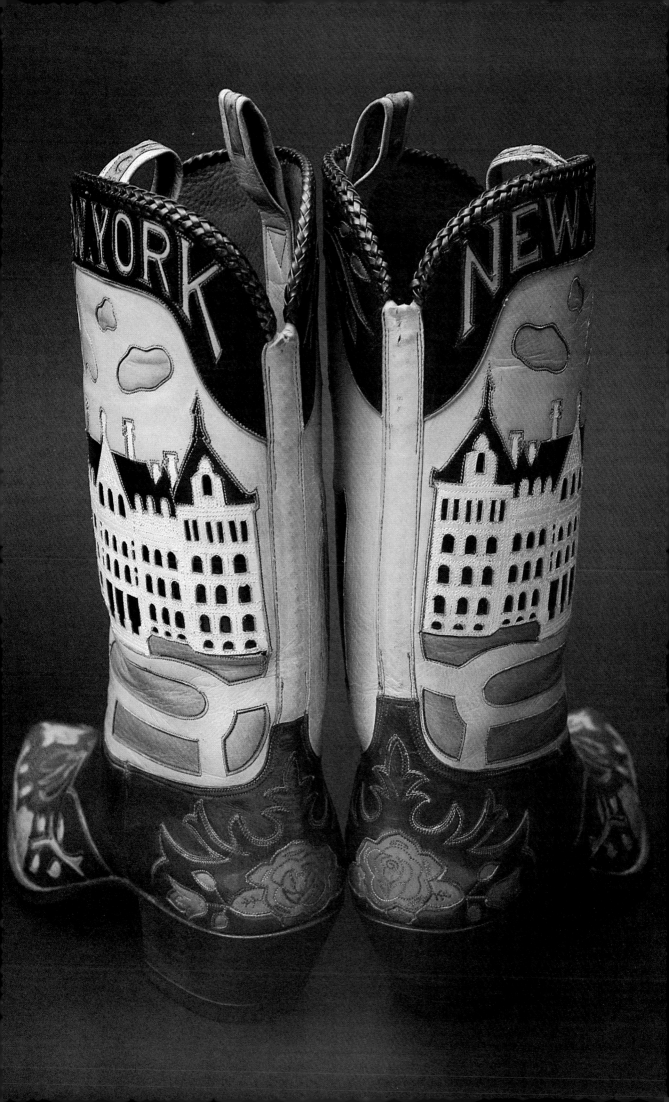

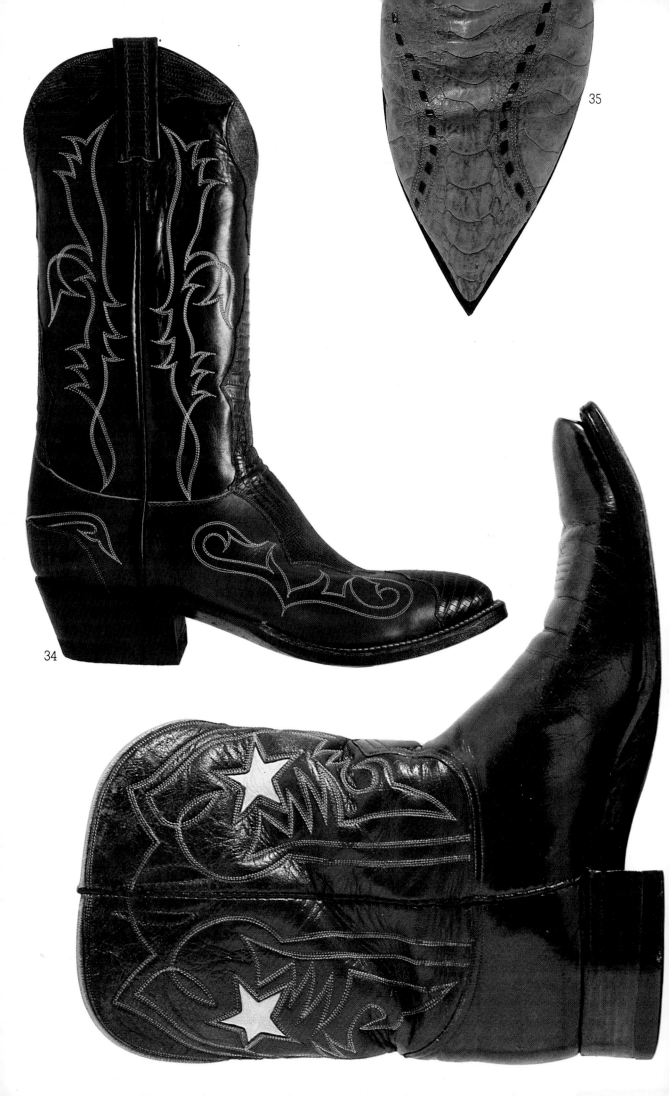

34

35

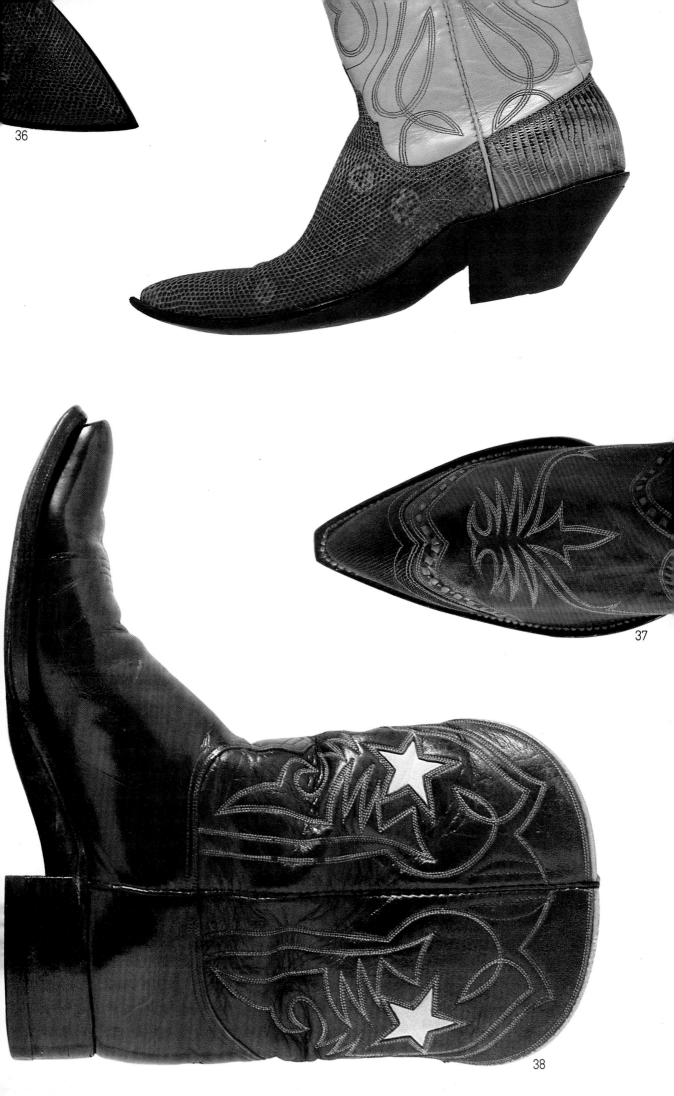

36

37

38

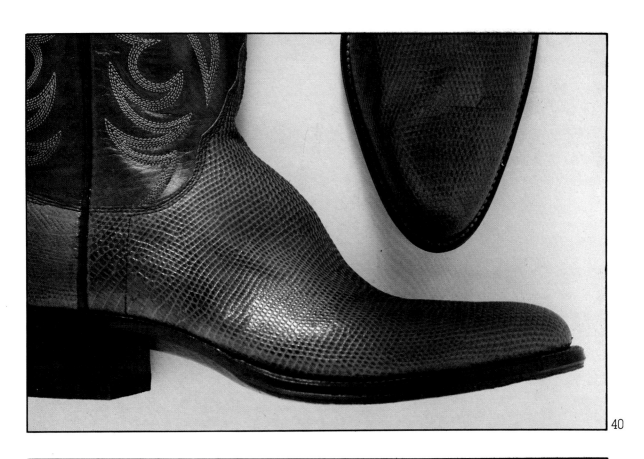

40

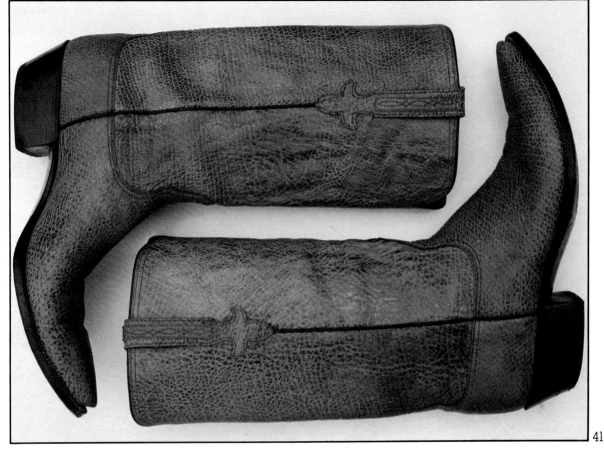

41

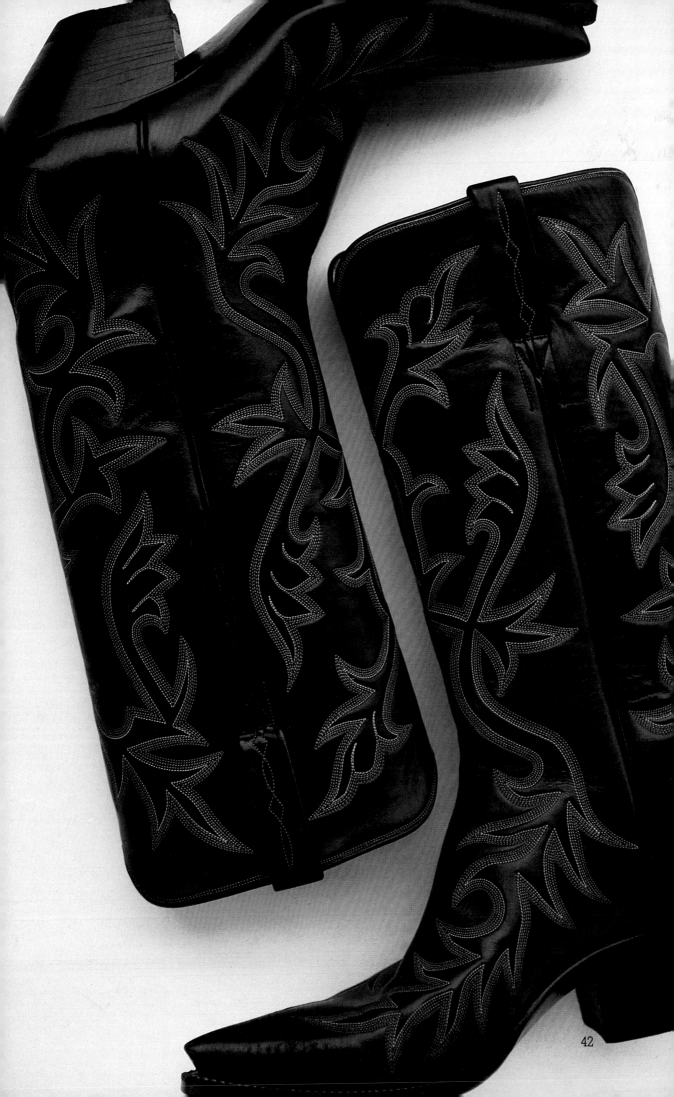

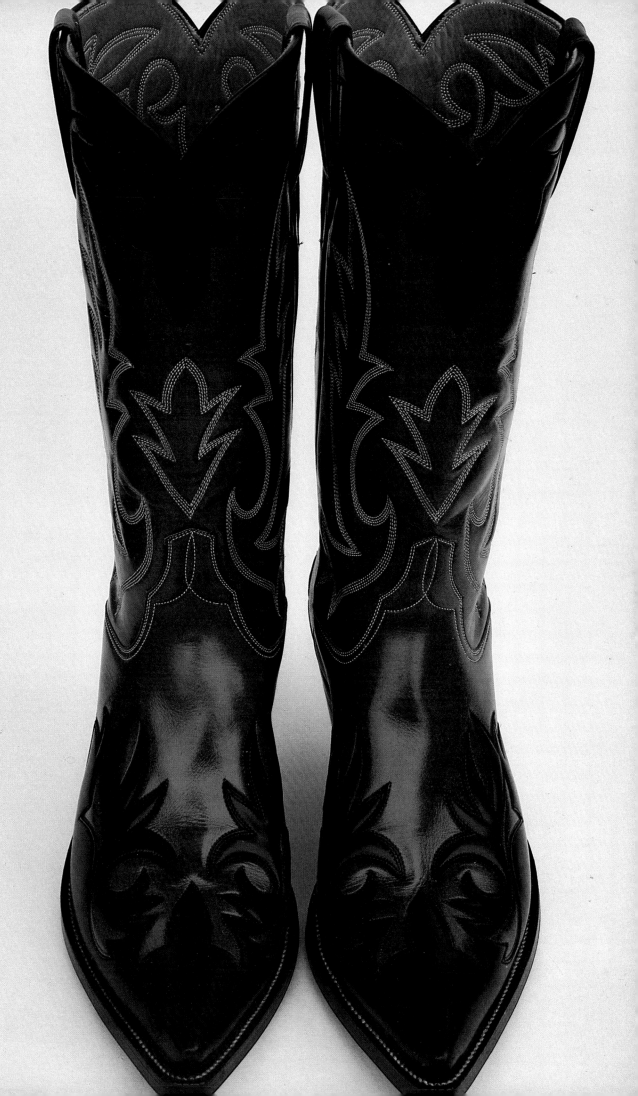

43

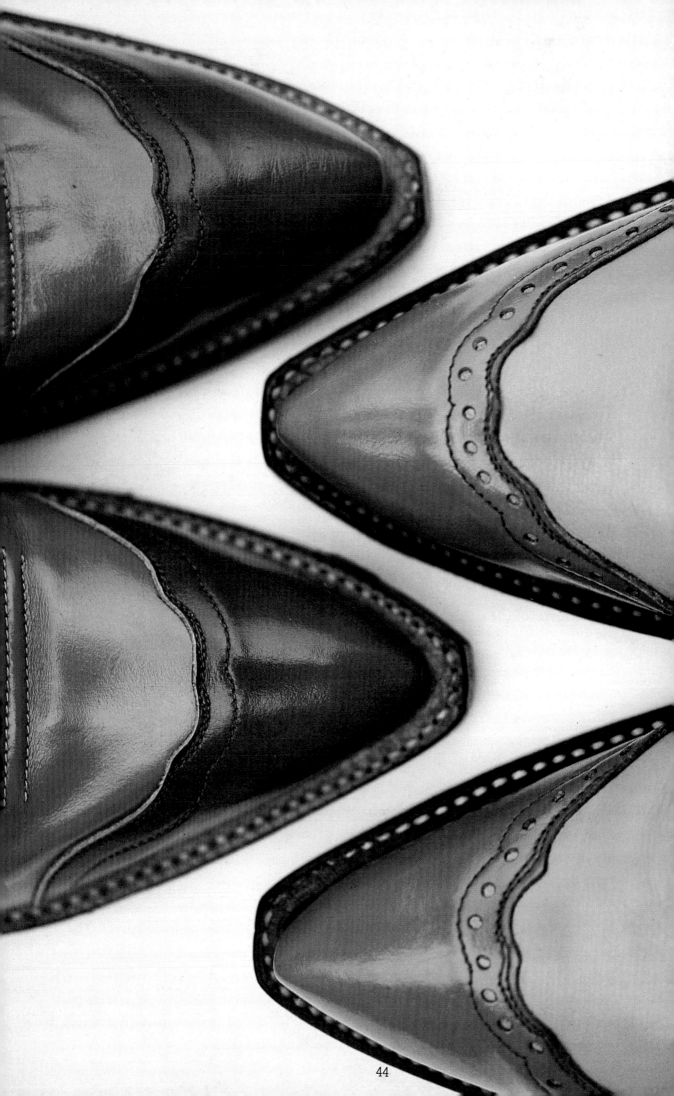

## COLOR PLATES *continued from page 48*

**22.** Multicolored collars and pulls are featured on these Olsen-Stelzer boots from the early 1950s.

**23.** Judi Buie's most popular design.

**24.** Boots from the early 1950s in Judi Buie's private collection.

**25.** Detail of multicolored inlays on black kangaroo boots made in the late 1940s by Tony Lama, Sr., for his daughter-in-law Aurora Lama.

**26.** Black calfskin boots with silver eagle inlays and sterling silver toe caps, designed by Tony Lama, Sr., in the early 1950s for his daughter Teresa.

**27.** Toes of a pair of full python boots made by M. L. Leddy & Sons.

**28.** Spur mounted on an M. L. Leddy boot.

**29.** Full boa boot made by the Lucchese Boot Company. These boots are unusual because on each boot the intact belly skin runs from the toe to the collar.

**30.** The Ohio boot from the set of state boots made by the Lucchese Boot Company in the late 1940s.

**31.** The Liberty Bell inlaid in the toe of the Pennsylvania boot from the same series.

**32.** The Texas boot.

**33.** The New York boots. The inlay is of the statehouse.

**34.** A brown cowhide boot with lizard-skin overlays made by the Tony Lama Company.

**35.** James Leddy's needle-toed boot made from ostrich-leg skin, with decorative buck stitching.

**36.** Pearlized pink ring-mark lizard boots designed by James Leddy for his mother-in-law.

**37.** Detail of a kangaroo-skin boot with a gray lizard wing tip and an unusual scorpion-pattern toe medallion, made by the Tony Lama Company.

**38.** Tony Lama boots from the 1950s with star inlays on the tops.

**39.** James Leddy's boots with gray ostrich bottoms, wine calfskin tops, and six rows of variegated flame stitching.

**40.** Details of a pair of lizard-skin boots made by Henry Leopold.

**41.** Unusual sawfish-skin boots made by the Lucchese Boot Company.

**42.** Blue calfskin boots made by Dave Little in an unusual design that is put together with only two principal pieces of leather.

**43.** Dave Little's red calfskin boots with black overlaid collars and wing tips.

**44.** Detail of wing tips designed by Judi Buie.

# TONY LAMA

### *El Paso*

Someone at the Tony Lama Company has figured out that two pairs of Tony Lama boots are sold somewhere in the world every minute. Tony Lama is the largest manufacturer of quality boots in Texas, and many people in the West were raised with the notion that it was the *only* one. When Judi Buie was growing up in a small town south of Fort Worth, her first pair of boots were Tony Lamas, and in 1977 the boots she put on a ballet star in tights and a military tunic at the famous Lone Star Cafe fashion show were Tony Lamas too.

The Lamas do not encourage the idea that they are part of some kind of fashionable trend, and point out in their catalogs and house newsletters that for some time they have been making "boots for the working cowboy." This is certainly true, for cowboys on horses and in pickup trucks all over the West continue to wear rugged sharkskin and bullhide and even Wellington-style Tony Lama boots, but it is also true that very fashionable people treasure their boots with the white full-quill ostrich vamps and bone uppers with seven rows of stitching, not to mention the cranberry shark boots with burgundy tops covered with lavender and pink flame stitches made by Lama for a dress shop in Soho.

In 1980 the Tony Lama Company sold approximately $50 million worth of boots to cowboys in pickups and models in chic boutiques. They employed eight hundred people and produced thirty-seven hundred pairs of boots a day. This rather

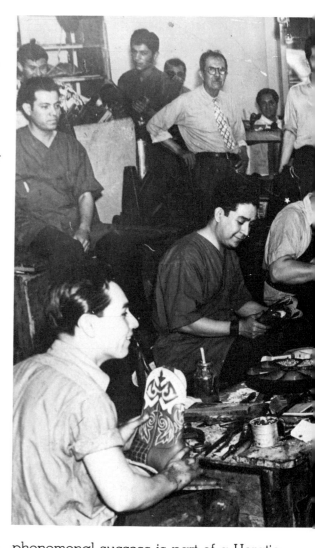

phenomenal success is part of a Horatio Alger story. Tony Lama, Sr., was born in 1887 to an Italian immigrant family in Syracuse, New York, and was orphaned at an early age. When he was eleven his uncle made him quit school and go to work in a shoe factory, where he learned to do repairs. Lama joined the army to escape the dismal life of a turn-of-the-century factory worker, and was sent to Fort Bliss in El Paso. There he repaired boots for General Pershing's cavalry, which was garrisoned across the border from Juarez to protect the dusty American cow town from Pancho Villa's frequent raids. In 1912 Lama was discharged from the army and opened a small shop where he and another cobbler

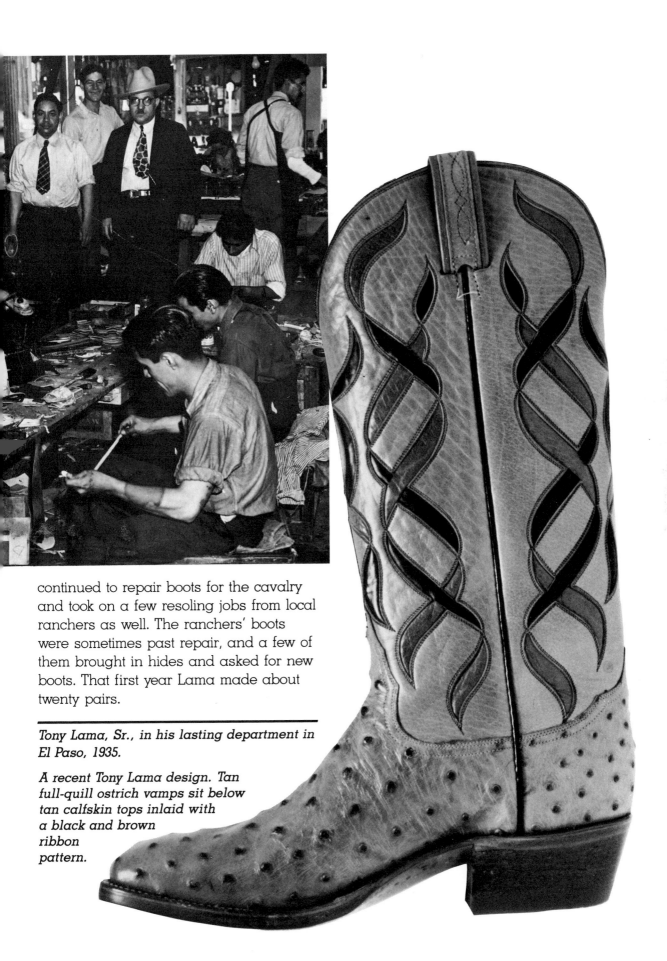

continued to repair boots for the cavalry and took on a few resoling jobs from local ranchers as well. The ranchers' boots were sometimes past repair, and a few of them brought in hides and asked for new boots. That first year Lama made about twenty pairs.

*Tony Lama, Sr., in his lasting department in El Paso, 1935.*

*A recent Tony Lama design. Tan full-quill ostrich vamps sit below tan calfskin tops inlaid with a black and brown ribbon pattern.*

By the early Thirties Lama had a small line of boots that was sold in western stores in Texas, Arizona, and New Mexico. The Tony Lama Company was principally a military boot-repair shop until 1946, however, when the U.S. Army discontinued its cavalry. By this time Tony Lama had married Esther Hernandez, and they had six children, one of whom, Teresa, married a soldier from Fort Bliss. John Weber, the new son-in-law, joined the family business and took it on the road, traveling all over the West with boot samples. The late Forties was a golden age for cowboy movies and things western, and Weber was extremely successful at selling the Tony Lama line. The boots themselves were the classic flashy boots of the period, made of alligator and kidskin and calf, with eleven-inch tops covered with silk stitching and ornate inlaid butterflies and stars and flowers. The boots that are shown on the opposite page were made in 1947 for Aurora Lama and are typical of those styles: black kangaroo foot and top, with a narrow squared-off toe and uppers covered with fuchsia-colored overlaid dragon designs underlaid with turquoise calfskin. A turquoise calf collar is underlaid with fuchsia stars and diamonds and outlined in red piping. (Details from these boots are shown in color plate 25.)

In 1948 Tony Lama made a pair of "El Presidente" boots for Harry Truman (size 9D, kangaroo vamp, kidskin tops, inlaid with gold and silver) and since then the company has been bootmaker to several other presidents, as well as movie stars, rodeo champions, and football players.

Below: *The stitching department in 1935.*

Opposite page: *Aurora Lama's boots.*

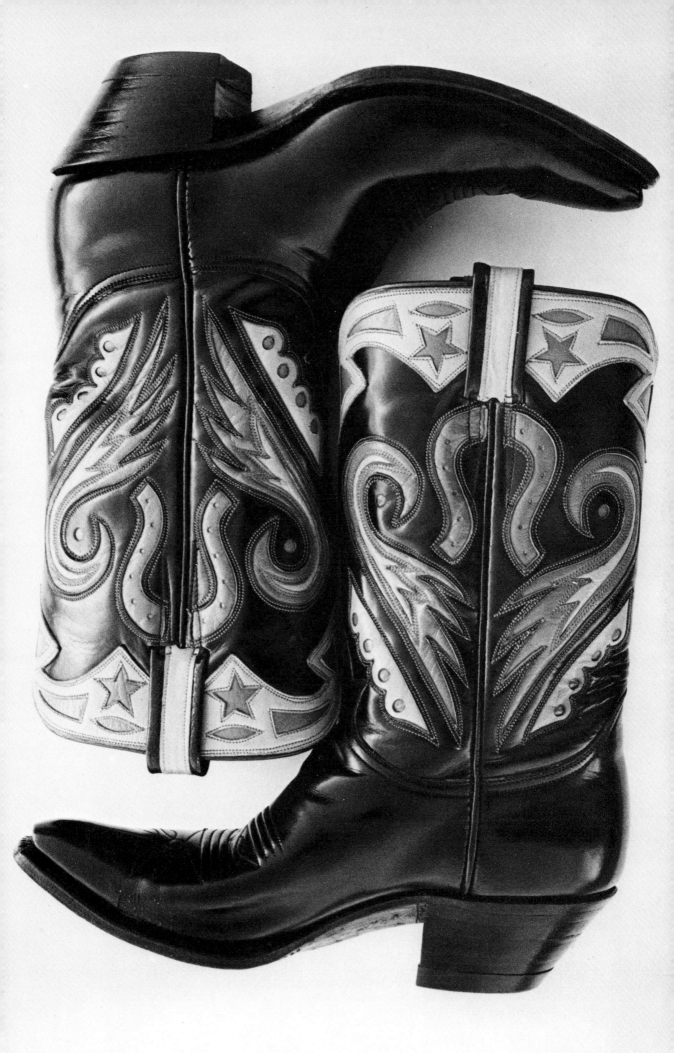

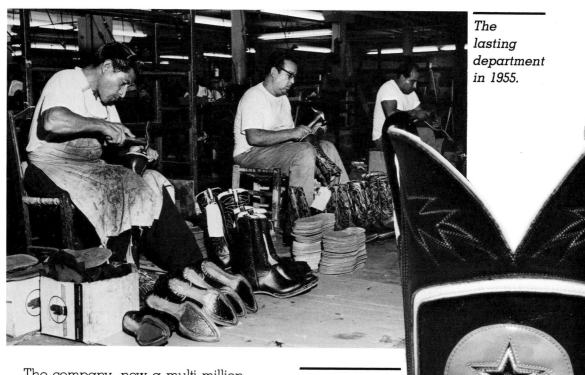

*The lasting department in 1955.*

The company, now a multi-million-dollar corporation, is still a family enterprise. Tony Lama, Sr., died in 1974, and Tony Lama, Jr., is its current president. His brother, sisters, brothers-in-law, and nephews are corporate officers and sales managers, production overseers, and heads of other company divisions. In 1977 the heir to another bootmaking dynasty, Sam Lucchese, was hired as director of research and development, and while the traditional Lama cowboy styles remained in the line, Lucchese added a series of "gentlemen's" boots. Lucchese's specialty was an elegant boot with a minimal amount of graceful, conservative stitching on soft European-tanned leathers, usually in black or shades of brown.

Today the Tony Lama Company makes hundreds of styles—work boots, children's boots, fancy boots of exotic skins, simple cowhide boots. Teresa Lama Bean remembers working with her father in the Forties, when "we were sewing inlaid boots like mad. A cowboy liked loud boots then, and they're coming back." A

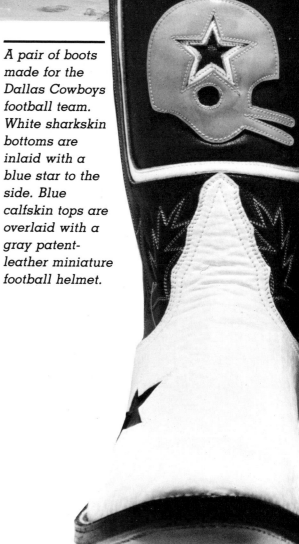

*A pair of boots made for the Dallas Cowboys football team. White sharkskin bottoms are inlaid with a blue star to the side. Blue calfskin tops are overlaid with a gray patent-leather miniature football helmet.*

fancy stock boot now has a walking heel
and is made from full-quill ostrich skins or
lizards or snakes. But Tony Lama also
puts together a lot of boots for designers
who order custom-made boots in fantastic

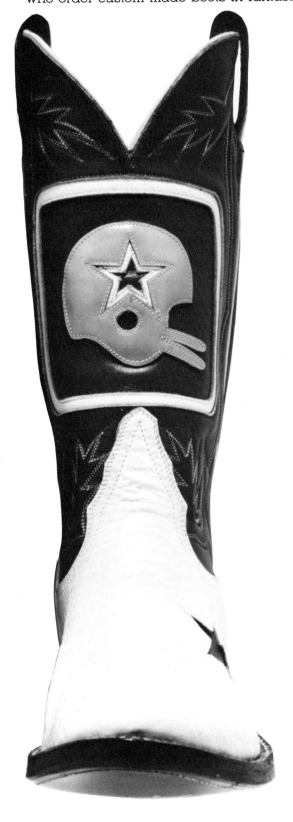

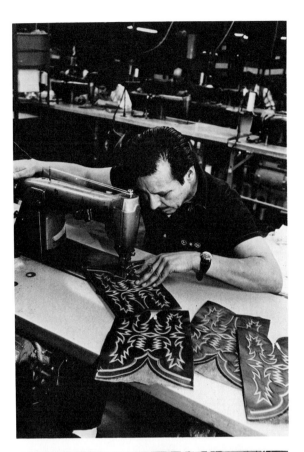

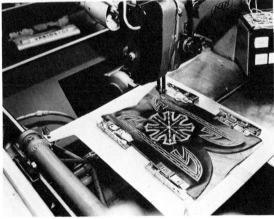

*Top designs are now stitched by hand or by
a computerized stitching machine.*

colors with intricate cutout designs and
overlays and two-inch underslung heels.
The two pairs of Lama boots that are sold
every minute in Tokyo or Stockholm or
Abilene or Seattle could look like almost
anything—whatever makes real cowboys
or pretend cowboys happy.

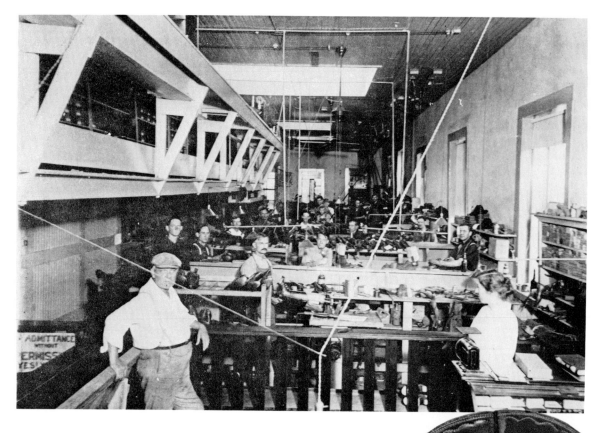

# JUSTIN BOOT COMPANY

*Fort Worth*

In 1879 the Justin Boot Company was a tiny boot-repair shop in the north Texas hamlet of Spanish Fort, a few miles from the Chisholm Trail. Today it is part of Justin Industries, a giant conglomerate that manufactures not only boots but also ceramic cooling towers, brick and concrete building materials, and industrial equipment. The company produces several thousand pairs of boots a day in plants in Fort Worth and El Paso. Justin Industries is light years away from its beginnings.

The young H. J. Justin had arrived in Spanish Fort almost penniless, with only the skills he had picked up while working in a shoe shop in the small town of Gainesville. He took a job with a barber in Spanish Fort and mended boots on the side. Legend has it that he made his first pair of boots at the request of a passing cowboy. As John Justin, Jr., observes wryly, "I imagine the first pair he made was pretty crude."

In 1879 the art of fitting boots and shoes was crude indeed, particularly in the West. But H. J. Justin must have had a natural aptitude for bootmaking, because his reputation soon extended beyond Spanish Fort. Cowboys on cattle drives would stop and have Justin measure them for boots, which they would then pick up on their return to Texas. Justin prospered, and in 1889, when the people of Spanish Fort abandoned the settlement for the new townsite of Nocona fifteen miles south, near the railroad line, the Justin Boot Company's business really began to expand.

Justin had married in 1886, and at first his shop was purely a family affair in which he, his wife, Annie, and their seven children did all the work on the boots. One of the most important innovations made during this time was a self-measuring kit—devised by Annie Justin at the suggestion of O. C. Cato, the manager of the XIT Montana ranch—which permitted a customer to order a pair of boots without having to come to Nocona for a fitting. This invention completely changed the way Justin could sell his boots and transformed him from a local bootmaker to a regional and, later, a national supplier.

The Justin Boot Company was one of the earliest bootmakers (and probably the first in Texas) to be organized as a

Opposite page: *H. J. Justin in the factory at Nocona, 1916.*

*Two boots made by the Justin company in the 1950s. The one on the opposite page has a fairly typical pattern of green and yellow inlaid stems and flowers. The one below has an unusual "embroidered" stitching pattern, with pink flowers on shaded green stems.*

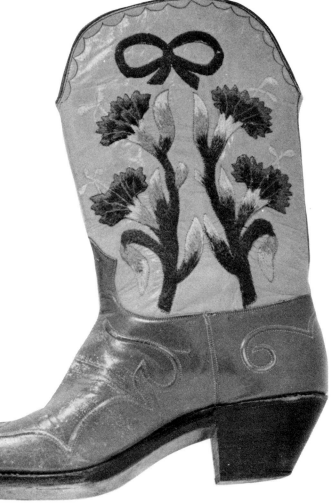

corporation rather than as an artisan's shop. By 1907 the company employed twelve workers and a foreman and was being run as a factory. Justin's eldest sons, John and Earl, served as traveling salesmen, drumming up business in the surrounding towns, distributing self-measuring kits, taking orders. By 1911 Justin was doing $180,000 worth of business and producing about seventeen thousand pairs of boots a year. Justin boots could be ordered through department stores, principally the A & L August department store in Fort Worth.

When H. J. Justin died in 1918, John and Earl took over the company. The early 1920s was a period of dude ranches,

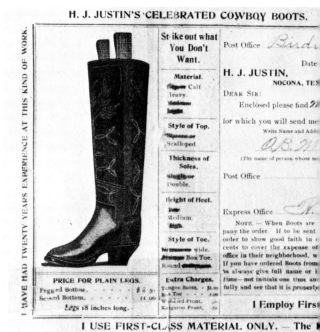

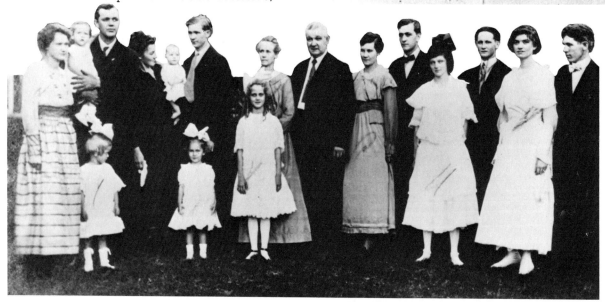

western movies, and a vastly expanded audience for western clothes. Movie stars like Tom Mix began ordering boots from Justin, and the brothers became convinced that in order to continue growing they needed to move to a larger place. In 1925, despite the opposition of their sister Enid (who remained in Nocona and founded her own boot company), the Justins left Nocona for Fort Worth. This was one of the great periods for bootmaking in Texas, and designers at Justin produced extraordinary boots

Above: *The order form from the self-measuring kit devised by the Justins at the turn of the century.*

*The H. J. Justin family in Nocona, 1915. H. J. Justin and his wife, Annie, are at the center of the photograph. Earl Justin and his family are to his parents' right, and Enid Justin and her husband, Julius Stelzer, are to Mr. Justin's left. At the extreme right of the photograph is John Justin, Sr., and his wife, next to Samuel Justin.*

Opposite page: *Detail of a boot made for President Lyndon B. Johnson.*

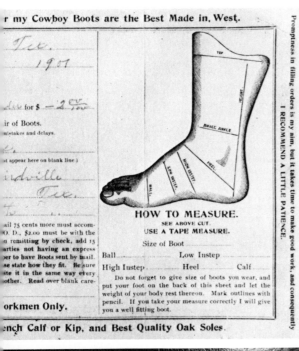

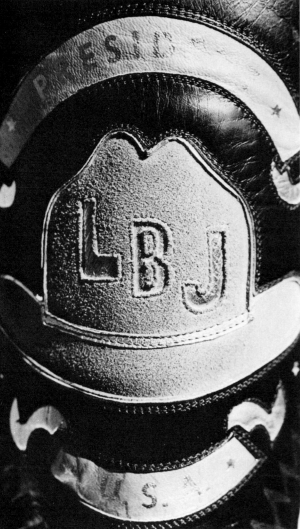

Above: *Toe styles from the 1952 Justin catalog.*

Overleaf: *Details of a hand-stitched and hand-tooled boot made by the Justins during the Forties.*

throughout the Thirties and Forties, including a fully hand-tooled boot, shown on pages 92–93, that took over one hundred hours of work per pair to produce. Justin has always prided itself on innovative design, and when John Justin, Jr., assumed control in the late 1940s the company produced many fancy inlaid and multicolored styles that were the dominant look of the period. In the 1950s Justin made heavily stitched boots. One extraordinary pair that is reproduced in color plate 8 had twenty rows of orange, yellow, green, and white hand stitching—the work of an anonymous craftsman in the Fort Worth plant. Another special boot (shown on the cover of *Texas Boots*), made up for John Justin, Jr., in the early Sixties, was embellished with inlaid oil wells, steer heads, the Texas flag, and a leather Alamo.

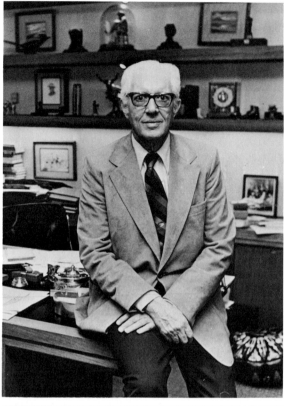

**Above:** *John Justin, Jr., in his office in Fort Worth.*

*This inlaid ostrich-skin map of Texas appears on the top of the boot designed for the Justin Boot Company's centennial. See also color plate 10.*

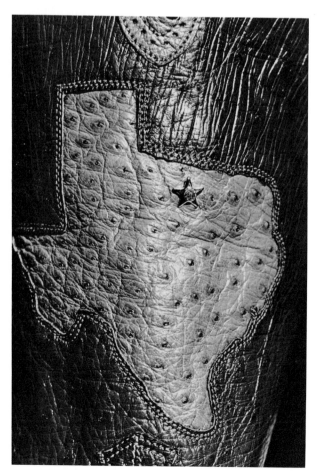

Today Justin tries to satisfy the demand for fashion boots as well as the traditional markets of rodeo riders (Justin makes the official boots of the Professional Rodeo Cowboy's Association), oilmen, and ranchers. Justin will still make custom boots for those who ask for them, and their chief designer, Eddie Kelly, is an artist with intricate inlay work. For the centennial of the Justin company, she put together a special boot made of antique-brown full-quill ostrich with a peanut-brittle ostrich inlaid map of Texas on the throat and a diamond set in a gold star placed to represent the town of Spanish Fort.

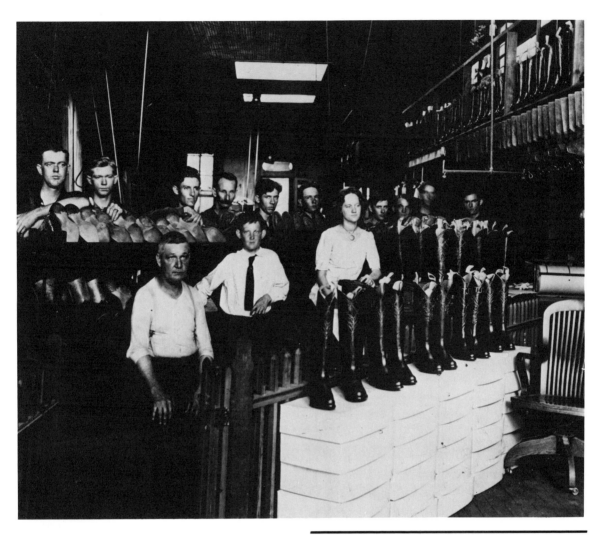

# THE NOCONA BOOT COMPANY

*Nocona*

*Enid Justin with her father and brothers at the Justin factory in Nocona, 1910.*

Enid Justin is a woman at the top in a man's world. She is president and major stockholder of The Nocona Boot Company, one of the "big three" Texas boot manufacturers, producer of fifteen hundred pairs of boots a day and employer of over three hundred and fifty people at the factory in Nocona, near the Oklahoma border. Miss Enid was born in 1894, the daughter of H. J. Justin, and began working in his boot shop when she was twelve. Today she lives a few blocks from her factory, in a pink house with a cowboy-boot weather vane on the roof and a Cadillac with the license plates EJ BOOT in the garage.

Enid was the fourth of H. J. Justin's seven children, and when she was suspended from school for a minor infraction just before she was to enter the eighth grade she decided to go to work

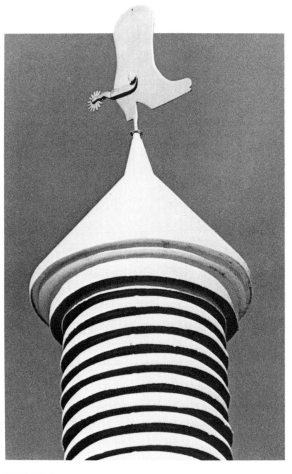

*The pink cowboy-boot weather vane on the roof of Enid Justin's house in Nocona and her pink Cadillac.*

Opposite page: *Detail of a pair of brown calfskin boots with gold inlaid oil wells, made by The Nocona Boot Company in the 1950s.*

for "Daddy Joe." "I had a legible hand, not a very pretty one but legible, so I did all his correspondence and ordered his materials. I also stitched the patterns on boot tops, real simple patterns that we still use to let the girls learn on." In 1915 Enid married Julius Stelzer and they lived for a time in nearby Muenster before moving back to Nocona, where Julius learned to make boots. In 1918 Daddy Joe died, but the business, by now extremely successful, was kept going by the rest of the family. Then in 1925 the big rift came, when Enid's two brothers, John and Earl, decided to move the company to Fort Worth, and Enid didn't want to go. "I was born and raised here. This is my home and I didn't want to move to the city. It broke my heart when I saw those great big old vans loading up the machines. Several of the boys who worked for my father didn't want to go either, so we just stayed home."

She and Julius started The Nocona Boot Company with a five-thousand-dollar bank loan and some good will from the Singer Sewing Machine Company, which leased machines to them and helped set up a tiny shop. There were seven employees that first year, making a pair of boots a day. Enid took in boarders,

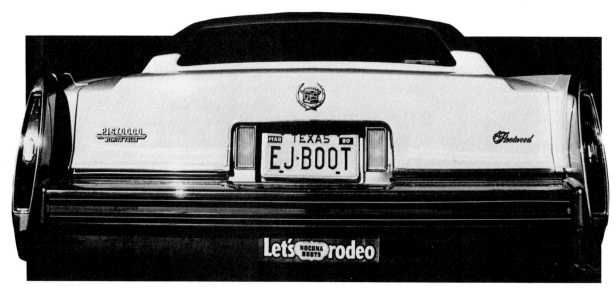

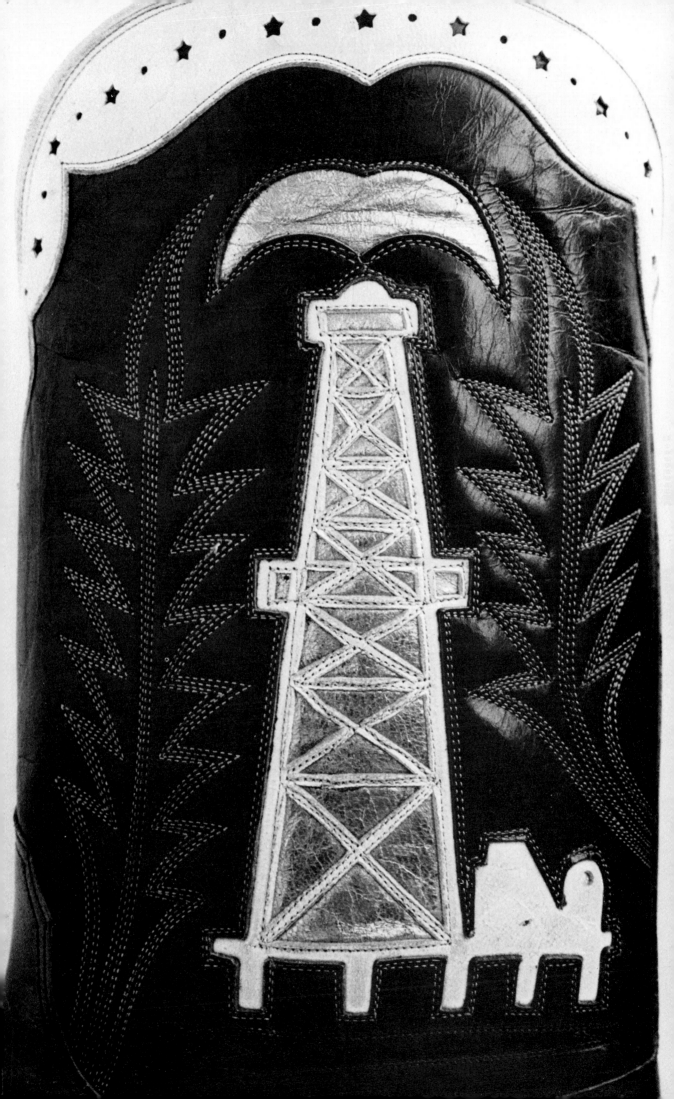

The Nocona factory today.

Below: *Detail of boots designed by The Nocona Boot Company in the 1950s. The Hereford-head inlay is of hairy white calfskin.*

sold coal and Maytag washing machines, and did "a little bit of everything to keep the wolf away from the door." She didn't want to use her brothers' stitching patterns so she "just looked at an old velour couch with curlicues on it and visualized a few things." In 1926 she and her sister traveled in a Model T over unpaved roads to find new customers in West Texas, and her little company was on its way. Julius soon left to start his own business a few miles west, in Henrietta, and Enid persevered.

In the late Forties Miss Enid opened a big modern plant with air conditioning and intercoms and a PA system over which football games could be broadcast. She has always been a benevolent employer, and the walls of the Nocona offices are covered with awards given to her for civic good works—citations from 4-H Clubs, Jaycees, Boy Scouts, and municipal councils grateful for her donations of playground equipment. Her energy is legendary. "All my life I've gotten up at five o'clock in the morning. I made my bed and took a bath and fixed breakfast and was at the office by

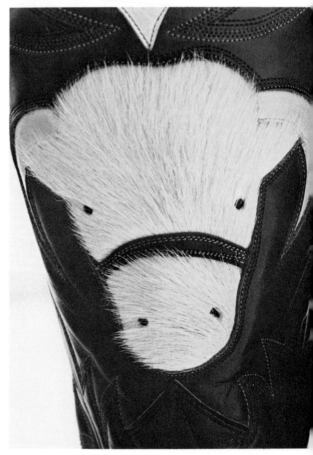

seven." For years she insisted on looking at all the company mail herself, and kept track of the details of day-to-day business. At the same time, she is, as she

puts it, "rather feminine." Her house and office are filled with little China figurines and she is carefully coiffed and perfumed. She has never worn cowboy boots. "I was president of our rodeo association here for ten years. Somebody wanted me to lead a parade once, and I was highly honored, but it never occurred to me that they would want me to ride a horse. I've always gone in a car."

Miss Enid started her boot company when fancy cowboy boots had sharp toes, high heels, and lots of inlay work and stitching. The Nocona Boot Company has weathered all the fluctuations in boot fashions and the western market since then, surviving the ebb in interest in the late Fifties and then watching business

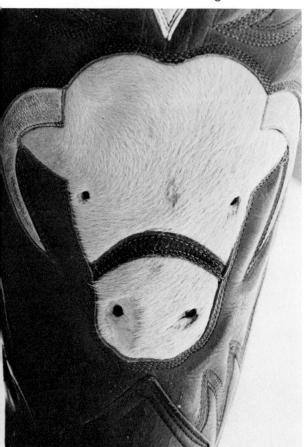

double in the early Seventies. In the windows outside the factory store there is a display of old Nocona boots: short-topped boots from the Forties with

inlaid hand-tooled flowers and green cutouts, a pair of brown calfskin boots with an inlaid gold oil well, extravagant metallic-blue boots from the Fifties with huge mustard yellow and red butterflies inlaid on the tops and little yellow hearts on the wing tips and counter. There are more than sixty styles in the catalog now:

*Toe and heel styles from a recent Nocona catalog.*

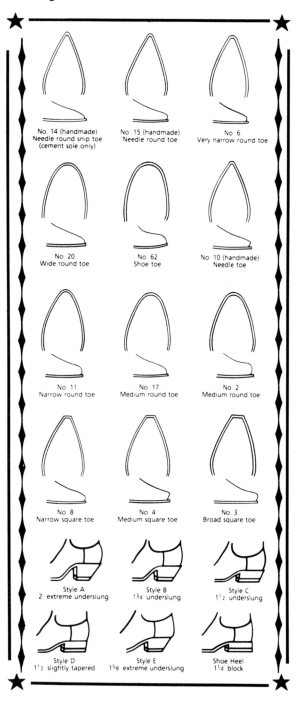

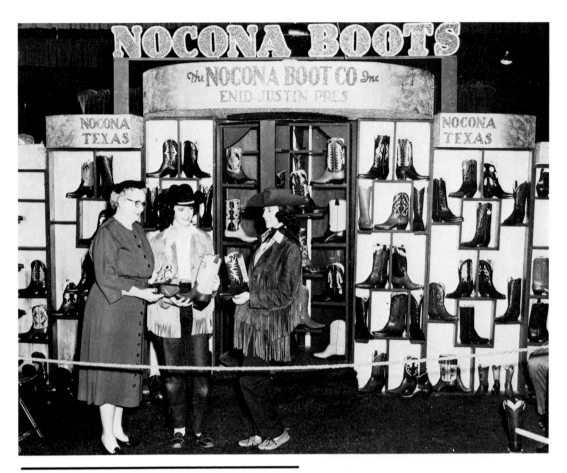

*Enid Justin at the Fort Worth stock show, 1955.*

a beautiful gray anaconda boot, honey-colored lizards, full-quill ostrich, plum-colored boots with fifteen-inch tops and two-inch underslung heels. There are twelve toe shapes, six different heels, seven toe medallions, and five varieties of scallop for the tops.

Enid Justin is a successful woman in a business that until recently has paid little attention to women even as customers. The phrase "Enid Justin, President" follows the company name wherever it appears, and Miss Enid is still very much a presence in Nocona. Her nephew Joe Justin is now vice-president and general manager and has taken over much of the running of the business, but Miss Enid goes to the factory to look things over as often as she can, driving down the aisles between the rows of machinery on a small scooter.

*Joe Justin.*

# LARRY MAHAN BOOT COLLECTION

*El Paso*

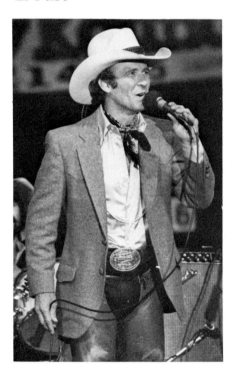

L arry Mahan is a modern cowboy star. He has been a professional bull rider since 1963, and between 1965 and 1975 he won six World Champion All-Around Cowboy titles. Now he sings in a country-and-western band, has a nightclub show, and appears in movies and on television. He flies his own plane and does "what I want to do. That's what being a cowboy stands for." His boot company makes boots for people who like that style: flashy

*Larry Mahan at the Umpqua Valley Roundup in Roseburg, Oregon. Photograph by Nicholas deVore III.*

boots. Boots with eighteen-inch tops and little inlaid butterflies off to the side of the vamp; boots with two-inch underslung heels and twelve rows of scrolled stitching spread over wine-colored calfskin; gray suede boots with elaborate purple wing-tip cutouts.

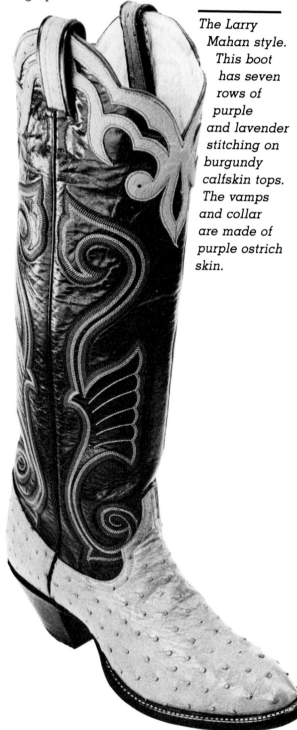

*The Larry Mahan style. This boot has seven rows of purple and lavender stitching on burgundy calfskin tops. The vamps and collar are made of purple ostrich skin.*

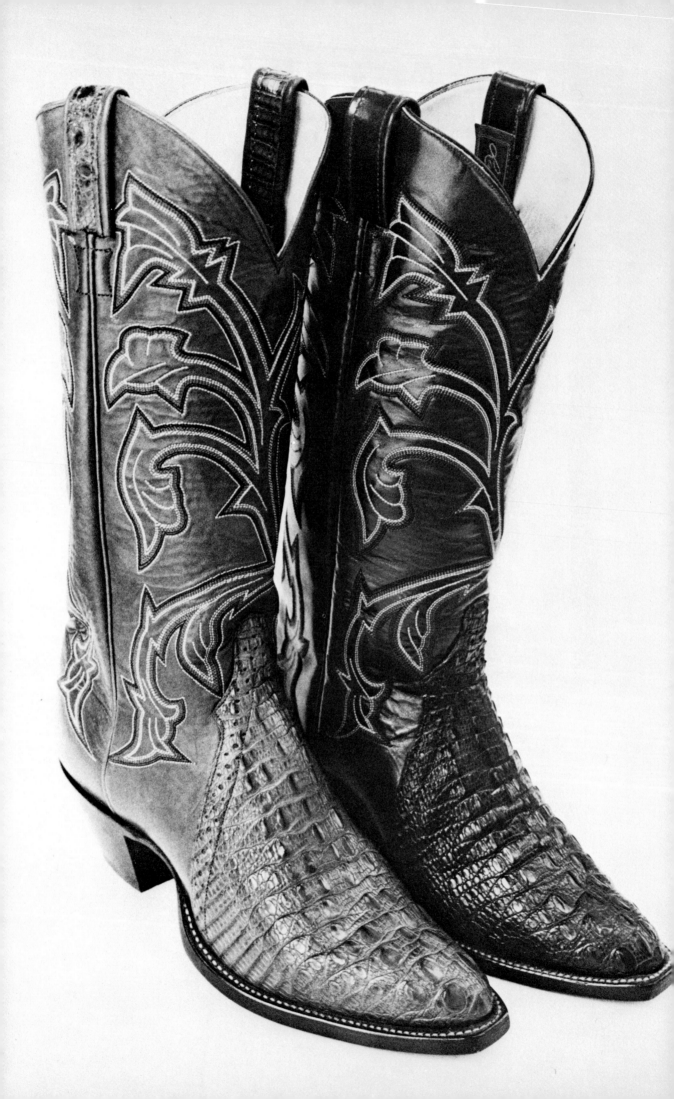

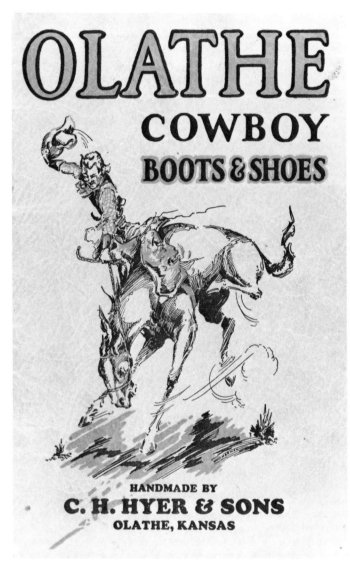

OLATHE COWBOY BOOTS & SHOES

HANDMADE BY
C. H. HYER & SONS
OLATHE, KANSAS

*The cover of the Hyer Boot Company's 1925 catalog.*

*Opposite page:* Larry Mahan's triad-design boot with seven rows of multicolored stitching and horn-back lizard vamps.

In 1973 the Larry Mahan Boot Collection was created as part of the Ben Miller Boot Company in El Paso, which then became the Hyer Boot Company in 1977, when it bought the assets of the Hyer business in Olathe, Kansas. The Hyer company had been founded in the late 1870s by C. H. Hyer, who learned shoemaking from his father in Illinois and then came west to work in a little town near Kansas City where many of the big cattle drives ended. Buffalo Bill is said to have been one of their early customers, and later they fitted dude ranchers and movie stars, cowboys and oilmen and truckers. In the early Forties their catalog had fifty-six different styles, made from kangaroo and French calfskin and alligator, with patent-leather inlays in seven different colors, hand-tooled tops, cutout roses, butterflies, and dice.

Even though the Hyers made a good handmade boot with a lot of style, the factory in Olathe was closed in 1978. The Hyer bootmaking equipment was moved to El Paso, where today the factory produces about three thousand pairs of boots a week. Larry Mahan boots are shipped everywhere, because they are by no means simply boots for the working cowboy. The Mahan people are very conscious of their boots as fashionable objects, more appropriate on Larry Mahan himself when he is in a recording studio or on a movie set than when he is astride a bull.

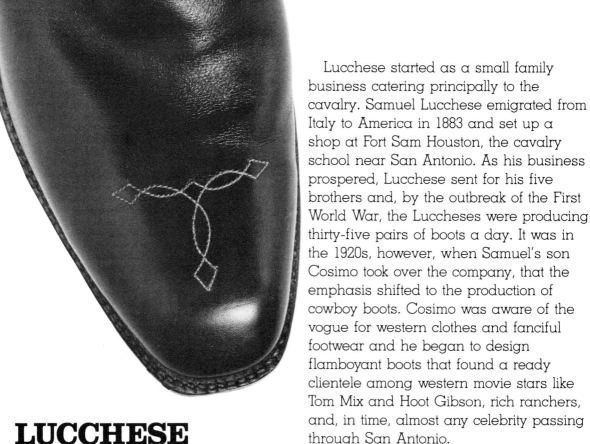

# LUCCHESE BOOT COMPANY

## San Antonio

Even before most boots were produced in factories, when Texas towns had their own bootmakers, the Lucchese Boot Company was widely considered to make the finest made-to-measure boots in Texas. Lucchese customers have included Teddy Roosevelt, Will Rogers, John Wayne, Sam Rayburn, Lyndon Johnson, John Connally, Johnny Cash, Anwar Sadat, and the Shah of Iran—to name only a few. Lucchese used the finest leather, employed the best craftsmen, and the Luccheses themselves had a gift for designing boots that were somehow more elegant, more graceful than those of their competitors.

Lucchese started as a small family business catering principally to the cavalry. Samuel Lucchese emigrated from Italy to America in 1883 and set up a shop at Fort Sam Houston, the cavalry school near San Antonio. As his business prospered, Lucchese sent for his five brothers and, by the outbreak of the First World War, the Luccheses were producing thirty-five pairs of boots a day. It was in the 1920s, however, when Samuel's son Cosimo took over the company, that the emphasis shifted to the production of cowboy boots. Cosimo was aware of the vogue for western clothes and fanciful footwear and he began to design flamboyant boots that found a ready clientele among western movie stars like Tom Mix and Hoot Gibson, rich ranchers, and, in time, almost any celebrity passing through San Antonio.

One of the secrets of Lucchese's success was its knack for acquiring and retaining the services of the finest craftsmen (almost all of whom were Mexican) in the San Antonio area. Many of the company's workers have been on the job for thirty years or more—the designer Jesus Garcia, for instance, his brother Gilbert, and the stitcher Pancho Ramirez. These men made many famous Lucchese boots, among them Lyndon Johnson's pair with inlaid maps of Texas on the uppers. Perhaps the most beautiful, however, are the forty-eight pairs of rodeo boots designed for the Acme Boot Company in the late 1940s. Each pair represents a state of the Union, complete with inlaid statehouse, state flower, state bird, state flag, and other

*In the early Sixties, Sam Lucchese began designing boots with an elegant, sloping toe and Spanish-style stitching, as illustrated in the boot on the opposite page and in the toe detail above.*

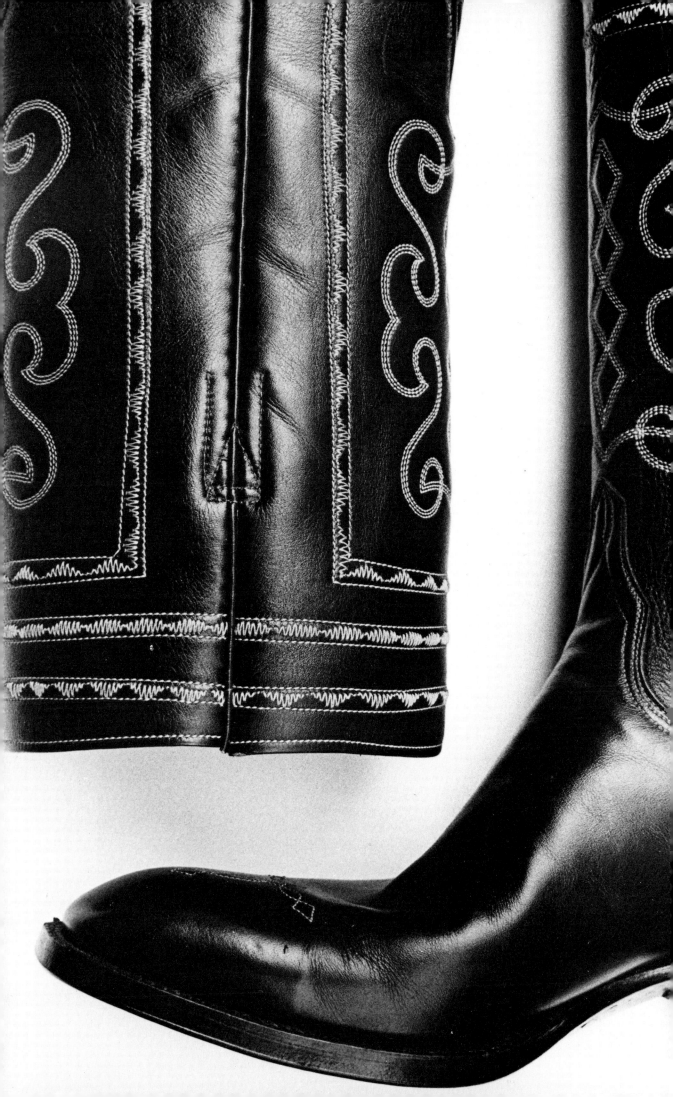

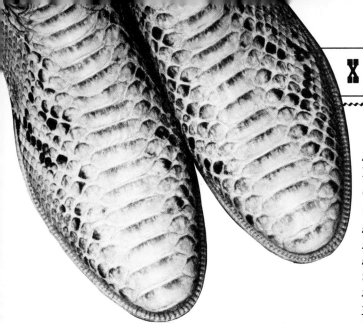

Left: *The toes of Lucchese's full boa boot. See also color plate 29.*

*The Minnesota boot from the state-boot series made by the Lucchese Boot Company in the late 1940s. The white calfskin statehouse is inlaid onto a brown kidskin top. The ornate green wing tips and counter foxing are decorated with delicate pink and yellow symbols. The other side of the boot has a detailed state flag flying under the two yellow birds shown in the photograph on the opposite page.*

particularities. These boots are of an extraordinary delicacy—ornate without being in any way gaudy. Every detail has been sculpted with a deft, subtle hand.

Throughout the 1950s and early 1960s, Lucchese continued to produce exceptional made-to-measure boots. There were elaborate inlaid patterns of flowers, cactuses, and longhorns; one-piece tops with appliqué-like patterns; flamelike wing tips, and more and more ornate stitchery. Cosimo died in 1961, and his son Sam, already in the boot business, took over the management of Lucchese, developing the elegant, understated look of the present-day Lucchese boot. In the 1960s exotic leathers became popular, and Sam began to use them in boots in which the cleanliness of the line and the quality of the leather were unmatched. Lucchese used only the best European kidskin or French calf in its standard boots and they were superbly crafted, unobtrusive.

The Lucchese Boot Company was producing ten or so pairs of these boots a day in 1970, when Sam sold the business to the Blue Bell, Inc. Under Blue Bell, Lucchese began to make stock boots and to phase out its made-to-measure operation. Their lastmaker retired and it was difficult to find a replacement. Now Lucchese makes made-to-measure boots "in the old way" only for customers whose lasts are already on file and concentrates on producing some of the finest stock boots made anywhere. Two hundred people produce about a

thousand pairs of boots per week, 80 percent of which are in men's sizes.

Sam Lucchese left the company in 1977 and was a designer for the Tony Lama Company until his death in 1980. But the Lucchese tradition of fine design is carried on by Jesus Garcia. One can't help but regret that Lucchese no longer concentrates on custom work, but every Lucchese stock boot is a testimonial to the ability of the factory method to produce graceful,                    fine-quality boots.

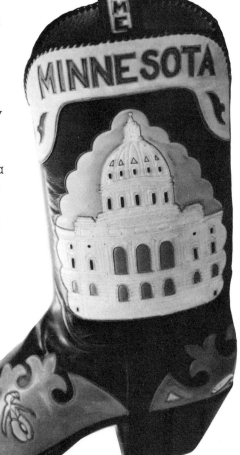

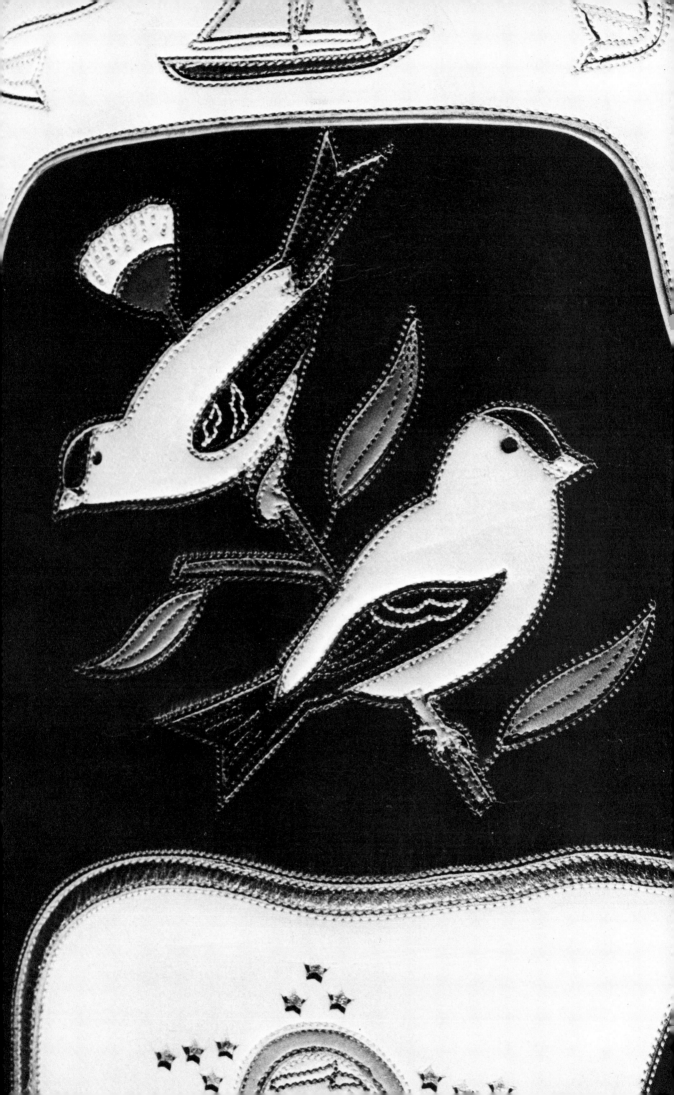

# RIOS BOOT COMPANY

*Raymondville*

At the southern tip of Texas, in the tropical region between the Rio Grande and the Gulf of Mexico, the name Rios means pretty much what Lucchese does farther north. The Rios family has been making boots there since 1925. Abraham Rios, the founder of the company, came from a family of shoemakers in General Terán, Mexico; he brought his cousins and his nephews to Texas to learn bootmaking and taught his son the craft there. Abraham Rios's early boots had long multicolored wing tips, high counter foxing, and inlaid half moons and stars on low tops—typical of the fancy styles of the Twenties and Thirties. He made boots for Roy Rogers and Gene Autry and later for President Eisenhower. Today boots from the Rios Boot Company are usually rather conservative, made from exotic skins and decorated primarily with a customer's brands or initials, although the shop will make up any style. Recently, for instance, they made a pair of polo boots for Prince Charles. Abraham's nephew Armando, who has himself been making boots for twenty years, manages the shop, which employs thirty-six people and turns out about one hundred thirty-five pairs of boots a week. They make custom-designed, made-to-measure boots for clients who have been with them for several decades as well as for an increasing number of people who have just heard of them and who order by mail.

*Abraham Rios holding samples of some of the extraordinary top pieces he designed and executed in the Fifties.*

# RIOS OF MERCEDES

*Mercedes*

Rios of Mercedes is connected to the Rios Boot Company in Raymondville only in that the Mercedes business was started by one of Abraham Rios's cousins. The last Rios retired in the early Seventies, and the company is now run by J. M. Evans and his son, J. Trainor Evans, who were ranchers in New Mexico before they got into the boot business.

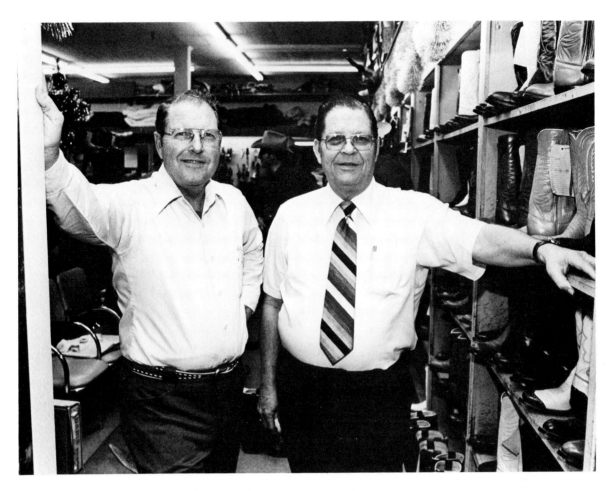

They employ seventy people in their factory and produce about five hundred pairs of boots a week—high-quality boots in standard sizes that are sold to retail stores in the Southwest, primarily Texas, Oklahoma, and New Mexico. Rios of Mercedes boots are similar in appearance and quality to Lucchese boots. About half the boots are made from calfskin and about half from exotic leathers. Tops are usually thirteen inches high and most heels are low. Rios boots are of visibly higher quality than most other factory-made boots, and the methods used in the Rios workshop are close to those used in smaller operations. They still crimp the vamp leather before it is sewn together, for instance, which makes it possible for them to put together boots with narrow tops and assures a fit that won't change with wear.

# M. L. LEDDY & SONS

*San Angelo*

L eddy's in San Angelo is on the one hand a big western store with everything for the cowboy: cotton snap shirts, spurs, electric clippers for grooming horses, hunting knives, aluminum bootjacks shaped like

*M. L. Leddy's sons, Hollis and Dale, in the Leddy store in San Angelo.*

large roaches, saddle-blanket seat covers with built-in rifle pockets for pickup trucks. Upstairs, however, the whole second floor is given over to sewing machines, shelves jammed with hides and lasts, tables covered with patterns and nails and glue pots and pieces of leather. Here about two dozen bootmakers turn out twenty pairs of handcrafted custom-made boots a day in what has been the preeminent boot shop in West Texas for over forty years.

San Angelo is in the heart of ranch country, where since the early Forties herds of cattle, sheep, and goats, fields of wheat and cotton, have coexisted with thousands of oil rigs drilling into the Permian Oil Basin. It is to San Angelo that the region's cowboys, drillers, and farmers come to do their business, and to buy their boots. Custom bootmakers have worked in little shops there for decades, but to most people a West Texas boot is a Leddy boot.

In 1918 M. L. Leddy was working on the family cotton farm north of the San Saba River. There was a drought that year, and the cotton dried up, so Leddy moved into town—Brady, Texas—and began repairing boots and shoes in a room at the back of Scag's Saddlery. He had a fair amount of time between repair jobs, and to keep busy he put together a pair of boots, which were bought by a visiting rancher. The next year the same rancher came by for another pair, and Leddy became a bootmaker. In 1922 the saddler sold him the whole shop on credit, and Leddy's five brothers came into town to help him out. Ten years later the Leddy boot and saddle business moved to the bigger town of Menard, and then in 1936 to San Angelo, seventy miles north. Today M. L. Leddy & Sons has a second store in Midland, the oil capital of West Texas, and a third in Fort Worth.

Almost all Leddy boots are made in the San Angelo shop, although a few tops are sent to Fort Worth, where the staff there assembles half a dozen pairs a day. Theoretically, the Leddys make boots in stock sizes for their three stores, but in fact they have so many orders for made-to-measure boots that they haven't had time to make stock boots for several years. They work nine to ten hours a day, six days a week, just to keep up with the custom orders. The Leddys will make up any kind of boot a customer wants, and the styles in their old catalogs reflect shifts in fashions, from fancy to plain and now back to fancy again. What doesn't change is the way the boots are put together. Toe boxes are made of leather, sanded down smooth and shaped for a perfect fit and then hardened with cement. Welts extend around to the instep. Tops are pulled over by hand. Instead of a steel shank piece, the Leddys have traditionally used a forty-penny bridge nail, hammered down to the shape of the last and held to the insole with leather

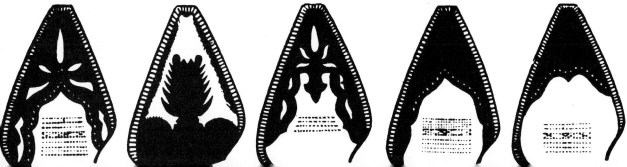

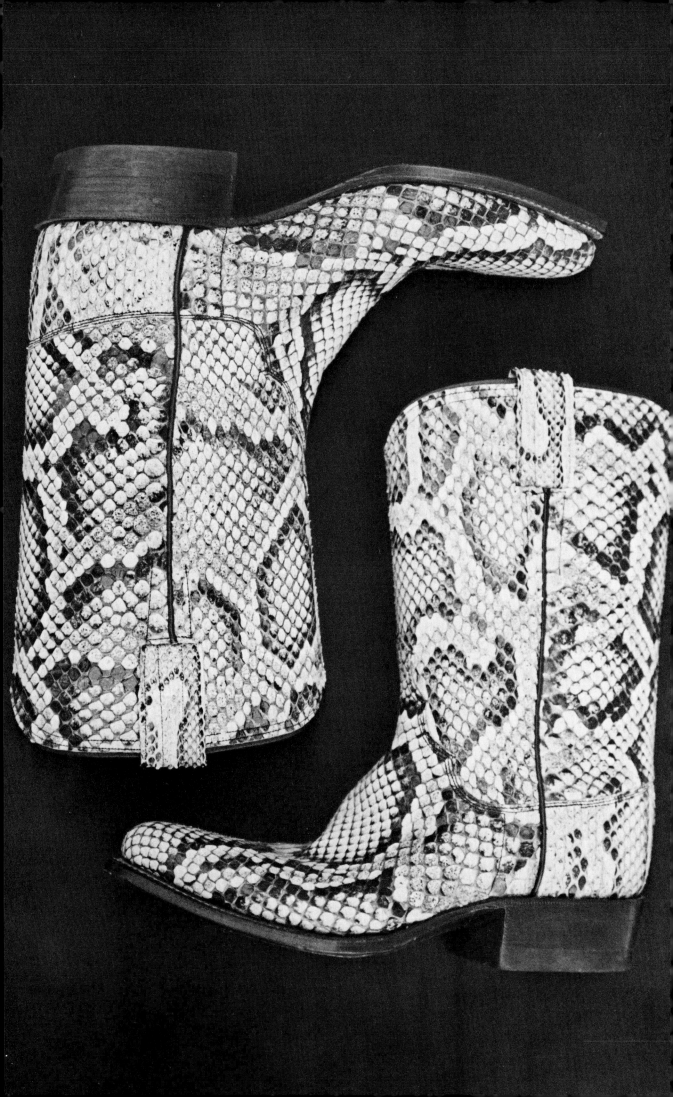

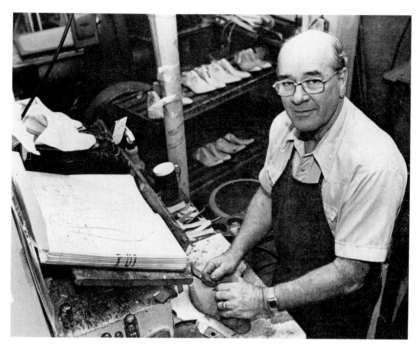

*Full boa boots made for Dale Leddy's niece.*

*Robert Castleberry, head bootmaker at the Leddy shop.*

strips. They swear that this shank will never snap no matter how hard a cowboy rides. The soles around the shank are reinforced with two rows of wooden pegs, driven into the last and then rubbed down smooth inside the boot.

The chief bootmaker at M. L. Leddy's is Robert Castleberry, who learned to make boots from Wilson Leddy, one of M.L.'s brothers, and from the old-time San Angelo craftsmen. Castleberry was raised on a ranch, and was fascinated by boots when he was a child, whittling them out of wood and "trying to get them perfect." He had a shop of his own in the 1940s, where he did all the work by hand, but found he could only make a pair a week that way, which didn't provide a living, so in 1946 he came to work for M. L. Leddy. Castleberry has been working at making perfect boots for nearly forty years, and he remembers when cowboy boots were mostly for cowboys. "They liked the idea of fancy boots and would have a pattern put on that was a kind of brand for them. Certain types of heels and toes were known by the name of the person who thought them up. For instance, we had a guy named Alvin Barnett who wanted a high, underslung heel for bronc riding and he wore that heel for years, and then other people would come in and want an 'Alvin Barnett heel.' A man by the name of Henry Clark started the round, sloping-off toe in this part of the country. So we call it the 'Henry Clark toe.' It's the same way with patterns."

Robert Castleberry worries about bootmakers becoming "pretty scarce" now, even though handmade boots are in demand more than ever. The Leddys receive orders for all kinds of boots. Bronc riders want light boots with no shank at all so that their foot grips around the stirrup; women customers in Dallas want high-heeled boots with inlaid flowers. They used to sell a lot of boots in Iran—to Texans in the oil business there and to the former Shah. Perhaps the oddest Leddy boot of all is owned by Bum Phillips, the former coach of the Houston Oilers. He has a cowboy golf boot, with cleats.

# OLSEN-STELZER BOOT AND SADDLERY

*Henrietta*

The Olsen-Stelzer company has been supplying high-quality boots to southwestern ranchers and businessmen for decades. To easterners they are known principally because a few samples of their work from the Fifties have been displayed for the last few years in Judi Buie's New York shop, Texas. These boots, with their sharp, squared-off toes and striking juxtapositions of colored leather and stitching (see the example shown in the photo below and in color plate 21), were the inspiration for Buie's own designs, and influenced the late Seventies renaissance in fancy boot styles. A typical boot made in the Olsen-Stelzer shop today is likely to be black or brown, with medium-round toes and walking heels. About a third of these boots are custom-designed, and the rest are made in stock sizes and sold to stores in Montana, Wyoming, the Dakotas, Texas, New Mexico, and Arizona.

There has been a boot shop in Henrietta, a small town near the Oklahoma border between Wichita Falls and Nocona, since Carl Olsen opened his bootmaking and repair business there at the turn of the century. Carl's three sons learned the trade, and in the early Thirties they were joined by Julius Stelzer, who left The Nocona Boot Company after he became estranged from his wife, Enid Justin, Nocona's president. The shop was producing about fifteen pairs of boots a day in 1976, when Norman and Harry Olsen sold the company to Katherine and Jerome Spivey, a couple with a retail store in nearby Bowie.

The head bootmaker at Olsen's is Horace Parsely, who also makes saddles. He and Mrs. Spivey measure for custom orders, and she and a young designer, Troy Price, make up the styles. There are about twenty-five people in the shop turning out forty-five pairs of boots a day, in kangaroo and calfskin, or in the exotic leathers preferred by most westerners. The pink and baby-blue and orange and soft green boots with delicate inlaid flowers and rainbow stitching that made their way East from Henrietta aren't much in demand there now, but they had an emphatic effect on the look of cowboy boots in Los Angeles, New York, and Paris.

*A pair of lavender and orange calfskin boots made in the 1950s by Olsen-Stelzer.*

# DIXON BOOTS

*Wichita Falls*

The Dixon family began making boots in 1889 in Ardmore, Oklahoma, where Henry J. Dixon, a preacher and part-time bootmaker, taught his sons the craft. In 1946 Andy and Noble Dixon moved to Wichita Falls and established themselves there as quality bootmakers of classic cowboy boots. The Dixon brothers—Andy was a fitter and Noble made bottoms—no longer own the shop, although Noble still works there occasionally. Dixon Boots is now managed by Bill Bock, who has been a bootmaker for thirty years and who oversees ten other bootmakers, producing six to eight pairs a day. Dixon's clients include cattlemen and local businessmen, Nashville celebrities and movie stars. Gene Autry is an old customer for whom they recently made a pair of solid ostrich boots in white and burgundy, with his initials cut into the tops. Jerry Flowers, Ernest Tubb, Don Gibson, Jack Dempsey, and John Wayne have all owned Dixon boots. Many of Dixon's customers ask for a very sharp "Hollywood" toe, and Dixon will put together multicolored fancy boots out of the over thirty different kinds of leather in stock. They are accustomed to receiving mail orders, and send customers a pamphlet showing stitching patterns, toe shapes, etc., as well as a self-measuring form.

# MERCER'S BOOT SHOP

*San Angelo*

John Mercer belongs to the generation of itinerant bootmakers who during the Twenties and Thirties supplied Texas cowboys and ranchers with handmade boots. In 1939 he bought the Texas Boot Shop from the legendary fitter Charlie Garrison and settled in San Angelo. Garrison himself worked occasionally in the Mercer shop over the years, as did Henry Leopold and other master bootmakers. In 1959 Mercer's business manager, Walt Weaver, bought the shop and inherited the staff, including the foreman Eugene Lopez, who had been Charlie Garrison's protégé and who is the head bootmaker at Mercer's today. The shop employs eight bootmakers and turns out twenty to twenty-five pairs of boots a week. Most of these are the high-quality conservative boots made from exotic skins that are preferred by affluent Texas businessmen, for the shop has little call for the fancy designs Eugene Lopez learned from Garrison, although it is prepared to make up just about anything. Lyndon Johnson regularly ordered boots from Mercer's as presents for congressional friends, and oil men, rich ranchers, and western politicians form the core of the shop's steady clientele.

# HENRY LEOPOLD

### *Garland*

I guess I'm the last of the old bunch. When I first started I stitched by hand. Stitched the soles by hand." Henry Leopold was born in 1903 and has been making boots since he was twelve. He works now in a shop set up in the garage next to his house in a suburb of Dallas. The neighborhood around him is quiet, with wide streets named after trees and little frame houses set off by yards. Every mile or so down the biggest streets a shopping center squats around a large asphalt parking lot. It is not a neighborhood that the

*Henry Leopold's workbench.*

affluent "horse people" who are Henry's customers would normally frequent, and there is no sign to indicate that the low gray building with no windows is the workshop of one of the most sought-after bootmakers in Texas. Henry has not retired, but he has a two-year backlog of orders and he would prefer not to be disturbed by people importuning him to make boots.

Henry's customers, some of whom have been buying boots from him for twenty-five years, say he is the best bottom man alive, maybe the best

bootmaker. He is a meticulous, obsessive craftsman who will stay up all night brooding over a boot and then tear it apart and put it back together again to make a tiny change. Henry says the first thing to look for when evaluating a boot is its shape, and his own boots are graceful testimonies to this concern. The arch and the heel are put together so that the top of the boot stands straight up at a right angle to the base, the vamp sits sleekly over the sole and heel, joints and connections are flat and smooth. Henry Leopold's boots are elegant, dignified.

He is a second-generation bootmaker who, like his father, was something of a rover, in the tradition of the itinerant nineteenth-century craftsman. Frederick William Leopold ran away from his home in West Virginia when he was seventeen to fight in the Civil War and, by the time he was twenty-one, had started the first of what would be his three families. When the war was over he apprenticed himself to an old shoemaker on the Bowery in New York City. Then, like many young shoemakers in the 1870s, he came West to make boots for the drovers on the cattle trails. He worked in a large shop in Coffeeville, Kansas, where the first cowboy boots were being made.

In 1915 Henry's father had his own bootmaking shop in Odessa, Texas, and Henry helped him put boots together for the local ranchers. Henry made his first complete boot there when he was fifteen. These were the tall, sturdy boots made for working cowboys, who, as Henry explains, were very particular about the way their boots fit. "When I was a kid and they began to build fences, a boss would come to town for the fellows who worked day work—they didn't want to work steady, just when there was a roundup or something—and they'd say 'no fence work.' They just wanted to ride. They wanted their boots with sharp toes, and they wore them very tight. I've seen them when they had to stomp all over the shop to get them on. There was a big old country store next to my father's shop, with a hitching rack in front and a horse trough. And they'd walk up and down in this horse trough, and pour water in the tops. And then they'd say they got a good fit when the boots dried. It was amazing. But they weren't on their feet. They rode."

After his father died in 1920, Henry Leopold began moving around from shop to shop in the Southwest, refining his craft. Over a period of twenty-five years, he worked in Midland, Fort Worth,

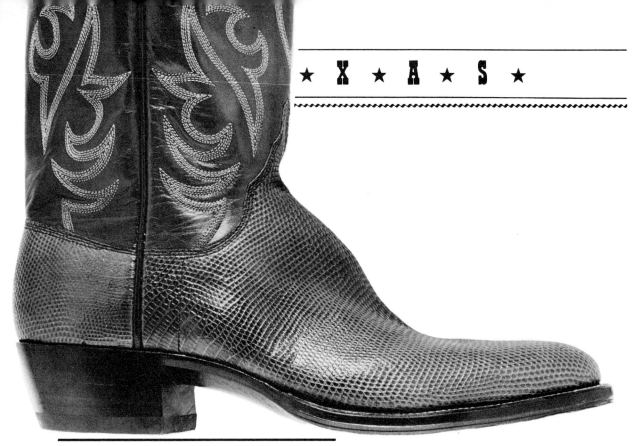

*The elegant, balanced line of a Henry Leopold boot. See also color plate 40.*

Amarillo, and even on an assembly line in Tucson, Arizona, where he put lasts on four pairs of boots a day and sewed the welts. In San Angelo in the Forties he and Aubrey Duvall and Charlie Garrison ran the Texas Boot Shop. Garrison was a master fitter who had worked for a few years as a bootmaker in Hollywood and brought back to Texas a taste for light, fancy boots. He owned the shop in San Angelo, but, as Henry explains, "His wife raised sheep, and Charlie liked to get out on the ranch and fool with them. She taught him a lot about it, and he read about it, and he finally sold the boot business to John Mercer. But from time to time, Charlie would get tired of fooling with them sheep and come into town and open another shop, so over the years I worked with him a lot, and learned a lot."

Henry Leopold has spent a long life thinking about boots, perfecting his own workmanship. He is a courteous man, and although he spends days working over a single pair of boots, he will not malign the factory-made boots that are produced by the thousands every day, pointing out that a machine-sewn seam is "just as good if not better" than a

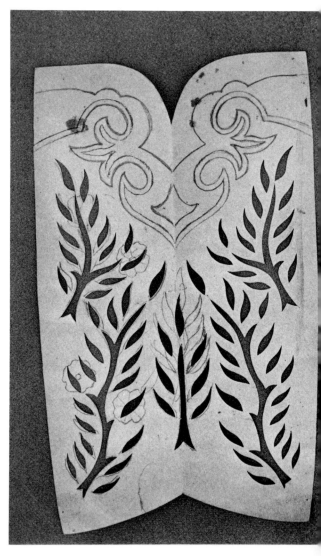

Right: *Robert Grissom, Henry Leopold's assistant, has himself become a master bootmaker.*

Below: *Paper patterns used by Leopold for cutting out inlays, collars, and counters.*

hand-sewn seam if the machine is set correctly and has a good operator. But he says that he doesn't think he would wear a factory-made boot himself, because he couldn't get a good fit. The attention to detail Henry's clients are accustomed to cannot be approximated in a factory. "For example, we have a dozen soles. Some of them are soft, some of them are hard. I have a customer that's hard on boots I put a hard sole on his boot. Another customer never wears soles out and I put a little softer sole on his. But the factory just picks them up as they come."

Henry has been making boots for his privileged clients since 1952 in the little shop near Dallas. For the last eight years he has been assisted by Robert Grissom, who came to learn how to make boots and stayed on as a colleague. Henry says Bob is a natural bootmaker who can now do anything he can do, but Bob defers to Henry as the master bootmaker. He has pretty much taken over the detailed top work—inlays and fancy stitching—but Henry still stays up through the night meticulously assembling the perfectly fitting boots with the graceful lines.

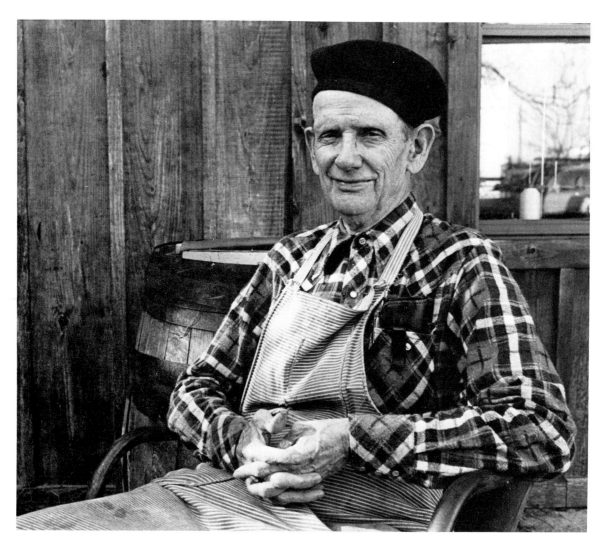

# CHARLIE DUNN

*Austin*

**C**harlie Dunn is far and away the most celebrated bootmaker in Texas. Working out of a small, five-man shop adjacent to his house on a quiet Austin street, Dunn is now besieged by customers from all over the world who come to be fitted for boots. At eighty-two, he is the oldest working bootmaker in the state, and has become something of a cult figure. Jerry Jeff Walker has recorded a song about him, and, at the end of his career, Charlie is enjoying an extraordinary renown.

Dunn prides himself on being the best fitter around, and people who wear Charlie Dunn boots swear that they fit like no other custom-made boot. He calls himself a student of the anatomy of the foot and claims to have invented a unique measuring system. He takes quite a bit more time measuring than other bootmakers do, and he asks more

*Charlie Dunn's signature boots, with brown ostrich vamps and brown calfskin tops. Dunn's name is stitched across the front and back in metallic gold thread.*

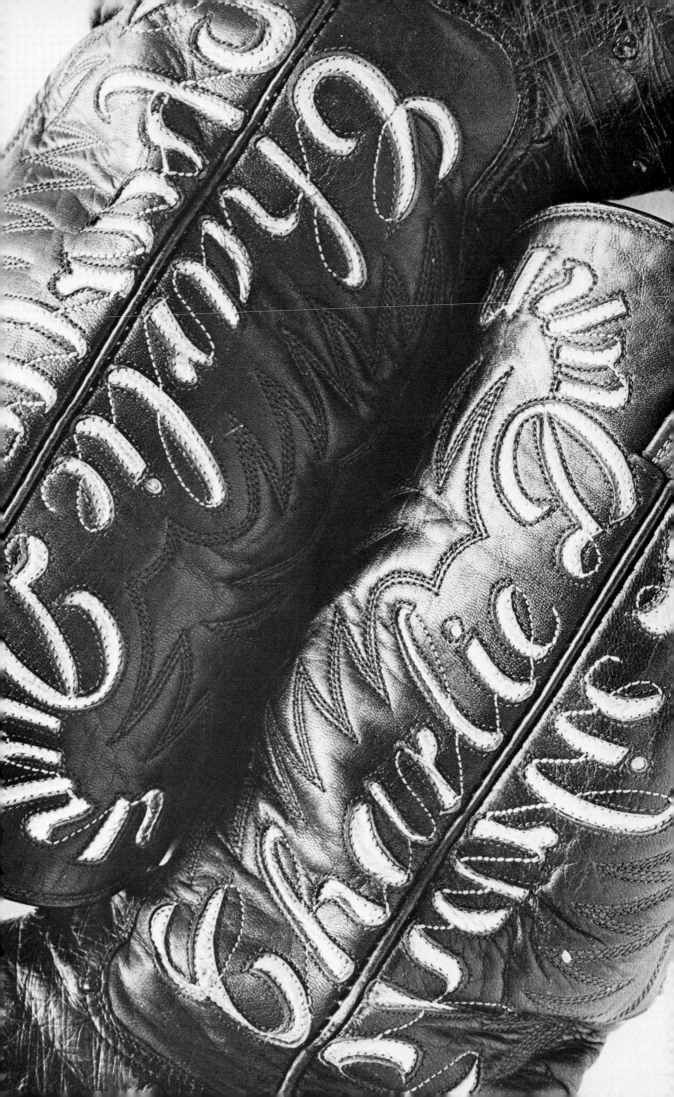

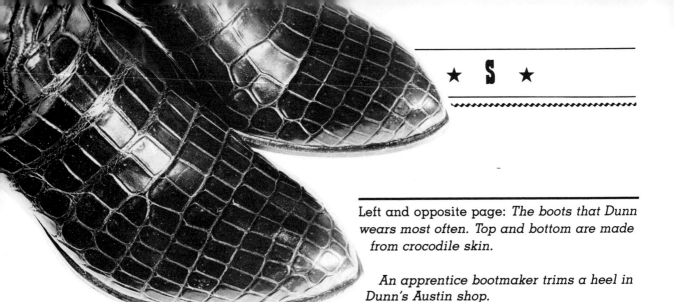

Left and opposite page: *The boots that Dunn wears most often. Top and bottom are made from crocodile skin.*

*An apprentice bootmaker trims a heel in Dunn's Austin shop.*

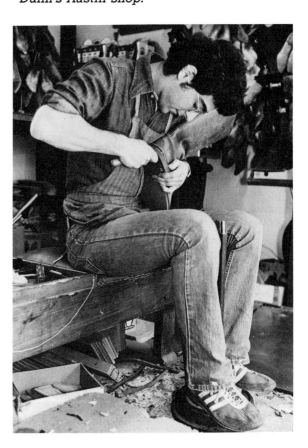

questions, often accurately diagnosing a customer's old fracture or a particular abnormality despite a Texas law that prohibits a bootmaker from measuring bare feet. "I can feel the veins anyway," he says, "even if they keep their socks on."

Charlie Dunn was born in 1898 on a houseboat on the White River between Newport and Batesville, Arkansas. When he was eight he was apprenticed to Ed Lewis, a bootmaker in Paris, Texas, and has been making boots ever since: first in various boot shops in West Texas, then in the 1930s at Fort Sam Houston, and from 1945 until the early 1970s at the Capitol Saddlery in Austin. It is ironic that the most famous Texas bootmaker of them all has never, in fact, owned his own shop. Eventually Dunn decided to retire. By this time, however, he was extremely famous in Austin, and in 1974 two young Austin businessmen made him an offer that was attractive enough to lure him out of retirement. He has a house behind his shop where he lives with Cecile, his wife of sixty years. Today Charlie Dunn is busier than he has ever been.

A tiny, elfin man with astonishing double-jointed hands, Dunn prowls through his shop in his apron and his ubiquitous beret, cracking jokes, measuring customers, lecturing his assistants on the finer points of bootmaking, and making sure that all the work meets his exacting standards. First

and foremost, Dunn insists on the fit. "Most people," he says, "are going around wearing boots that don't fit." He claims he can tell just by the sound of someone's footsteps what is wrong with their boots. The biggest problem, in Dunn's opinion, is the boot pinching across the toe. "A boot," he says, "should be snug but not uncomfortably tight."

Apart from fit, what Dunn looks for most in a boot is what he calls "the cleanliness of the line." In fact, he is endlessly attentive to detail, sparing no effort to ensure that the stitch patterns are even and graceful, the line of the vamp

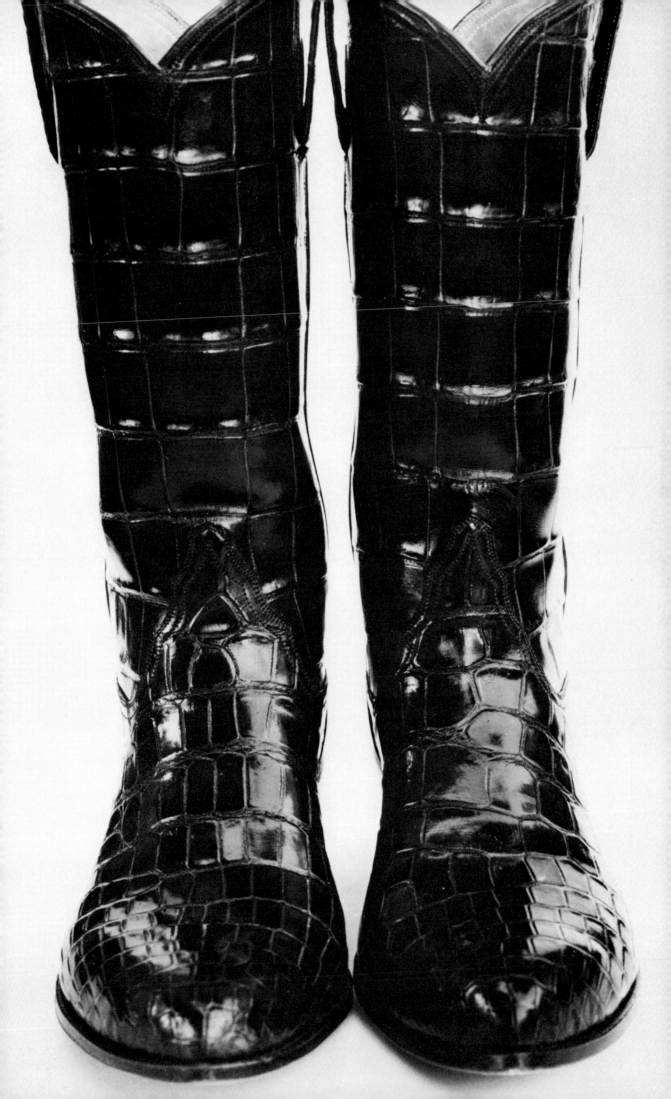

flowing, the angle of the heel appropriate. One of the interesting things about Dunn is that he is very self-consciously "an artist." Indeed, he often refers to the fact that he studied art in Memphis when he was a young man and brings this training to his craft. His ability to render flower inlays is quite uncanny. Dunn's bluebonnets or yellow roses, for instance (achieved by "pinching" the leather) look amazingly real (see color plate 9).  In recent years some of Dunn's customers have persuaded him to apply himself to representing marijuana leaves as well.

Dunn has made nearly every kind of boot imaginable—perhaps fourteen thousand pairs during his career. He has worked with inlays, with exotic leathers—anything a customer has requested. Oddly enough, despite the stiff prices his boots now command, his most expensive pair was made in 1914: kangaroo boots trimmed in unborn-calf hide, with gold, diamonds, and rubies inlaid onto the throats. The gambler who commissioned these boots paid him five thousand dollars.

Dunn himself, like most master bootmakers, does not much favor gaudy styles. He owns four pairs of boots: two done up in plain calfskin for "knocking around," a pair of full crocodile boots of the most exceptional grace and balance, and a pair of black ostrich boots with "Charlie Dunn" stitched in gold thread on the tops. The kind of inlay work that he recommends is discreet, understated: a sprig of bluebonnets around the collar and the customer's initials inlaid at the front, or one long-stemmed yellow rose are typical "Dunn" patterns.

People come as much to hear Charlie Dunn talk as to order boots from him. His fund of anecdotes about the life and times of the itinerant bootmakers, and his salty observations on the world in general, add to his mystique. For if all cowboy boots have something mythical about them, a pair of Charlie Dunn boots has a very special aura.

*Charlie Dunn's hands, holding a pattern for initialed boots.*

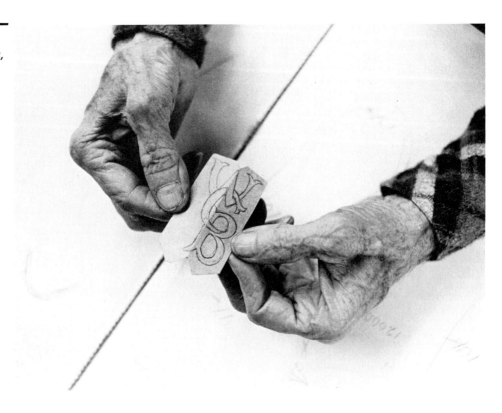

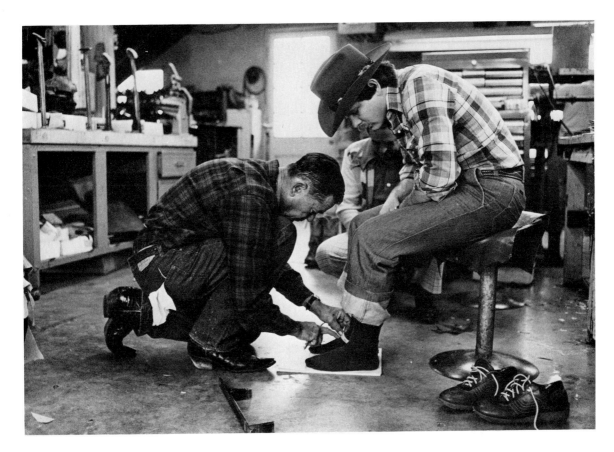

# RAY JONES

*Lampasas*

I f any bootmaker alive today can be said to exemplify those qualities that separate the custom bootmaker from all the rest, it is Ray Jones.

Jones is a legend in the bootmaking fraternity, a man whom other bootmakers acknowledge as embodying the best of their craft. People speak of Jones without even any jealousy; he is simply too good. Unfortunately, he is also too busy: Jones is now working through a four-year backlog of orders. He will accept no new orders, and although he will occasionally relent and make a pair of boots for the son of an old customer, Jones has resolved to retire when he finally catches up.

Ray Jones lives and works in a small two-story building on the outskirts of Lampasas, Texas, seventy miles northwest of Austin. With the help of his wife, Elizabeth, and five assistants, he manages to produce about a thousand pairs of boots a year. Every step in the process (apart from the stitching) is done either by Jones personally or under his direct supervision. And no one is surprised when the bootmaker takes a finished pair of boots, looks at it for a while, and decides to redo it completely. He notices things that escape most bootmakers and boot wearers alike.

The boots Jones makes are not flashy. While there is a characteristic Ray Jones stitch pattern on the toe medallion, it is fit and attention to detail—little things that a casual observer might not notice—that distinguish one of Jones's boots. What

Jones is after is a pair of boots in which every detail is flawless but whose overall effect is discreet, subdued.

Although Jones numbers Dallas bankers and country-and-western singers among his customers, most of his clientele consists of ranchers and working cowboys from the surrounding hill country. A Ray Jones boot is built for use; it can be worn and worn hard. Jones, more than any other of the remaining master bootmakers, epitomizes the superb local craftsman of a bygone era, a time when people needed functional boots and the bootmaker provided a real service to a community. In fact, Jones moved to Lampasas from Dallas in 1938 precisely because he knew that in the small town there would be a market for his talent. With the exception of service in Europe during the Second World War and a brief period at the end of the war when he studied tanning and chemistry at the Leicester College of Commerce and Technology in England,

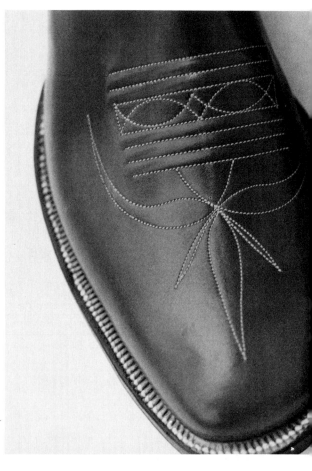

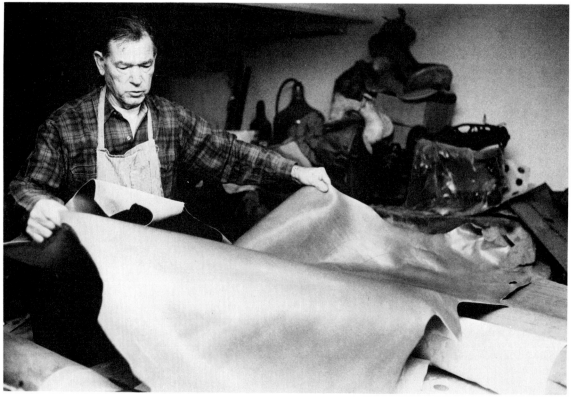

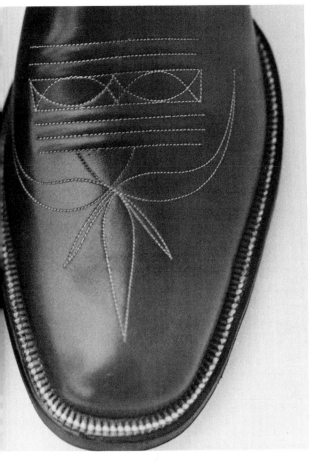

he has been there ever since.

It is not easy for a man like Ray Jones to explain what he does. Although he is more than willing to demonstrate his methods step by step, the essence of what he does consists in his "feel," both for fitting and for handling leather. What any visitor to his workshop notices immediately is Jones's total concentration. He is in constant motion on the work floor, cutting a vamp, watching an assistant peg a sole, doing whatever has to be done. Ray Jones is uncompromising, and his boots are graceful, understated objects made by a master.

**Left:** *One of the ways in which a bootmaker can "sign" his boots is by using a special pattern for the toe medallion. Ray Jones's "bug" marks this pair.*

**Opposite page:** *Jones looking over a piece of calfskin.*

**Below:** *One of Ray Jones's assistants finishing heels.*

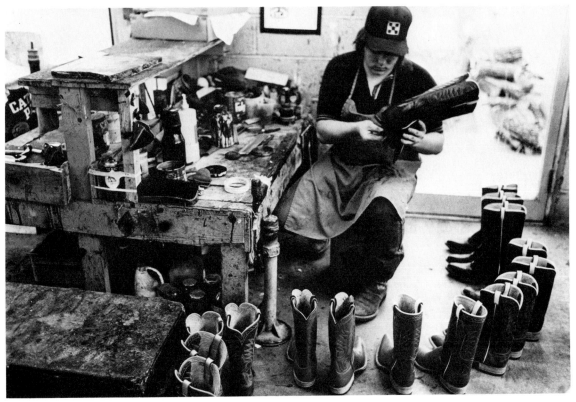

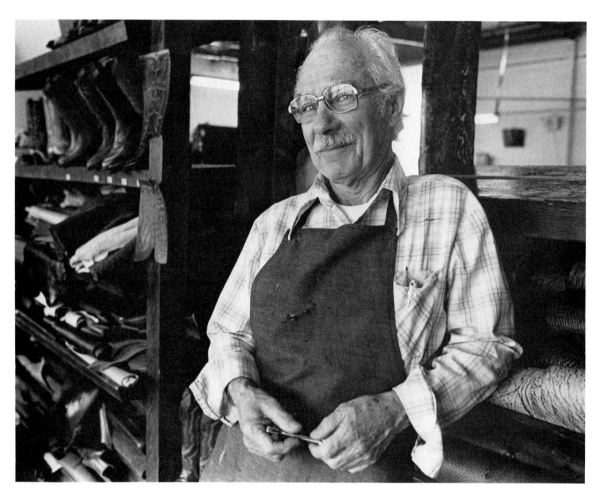

# PAUL WHEELER

*Houston*

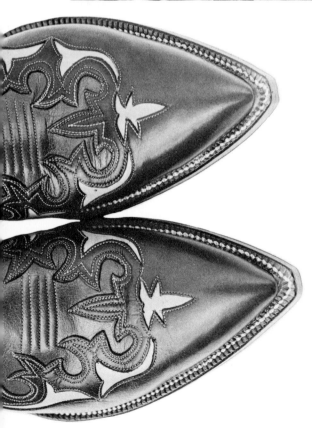

The children of the great old bootmakers have frequently rejected the work, for it can seem too demanding, too tedious, and, above all, not lucrative enough. This phenomenon is of course common to most artisanal work in America, but there are exceptions. Master bootmaker Paul Wheeler has passed along the craft to his son David, who is now a partner in the business and an accomplished and inventive bootmaker in his own right.

Left and opposite page, below: *Details of Paul Wheeler's fancy wing tips.*

Below left: *Paul Wheeler's red and white butterfly on chocolate-colored calfskin.*

Below right: *Dario Canizales's eagle design.*

Wheeler's younger son, Jonathan, is also a bootmaker. Their shop, located in a residential section of Houston, is an old-fashioned family enterprise.

Paul Wheeler is not a Texan. He was raised in a family of Missouri shoemakers and moved to Texas, the home of his wife, Dorothy, some thirty-five years ago, where he began making both shoes and boots. Over the years, he devoted more and more of his energy to bootmaking and is now established as an impeccable craftsman and something of an innovator in design. He enjoys devising complicated

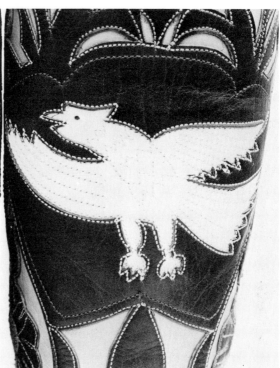

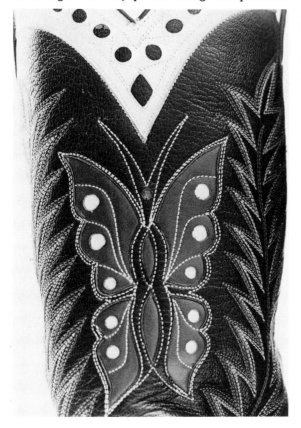

inlay patterns, baroque wing-tip designs, complex combinations of images and lettering. Indeed, the only complaint that Wheeler is willing to voice about factory boots is that they have made people too set in their ideas about design. When a client orders a pair of boots from the Wheelers, he enters into a collaboration in which Paul and Dave consider, embellish, and often delicately transform the customer's original idea.

Overleaf: *Front and back views of a pair of boots made recently by Paul Wheeler. They have gray pigskin bottoms and matching collars; blue flame wing tips, counters, and tops; and are covered with inlays of mockingbirds, buttercups, and stars.*

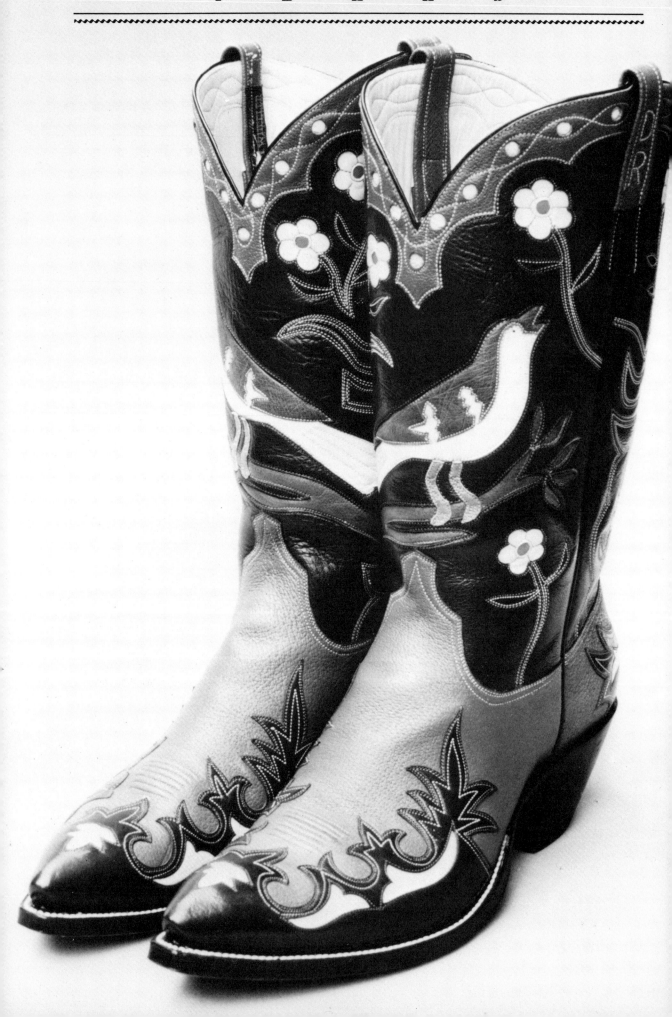

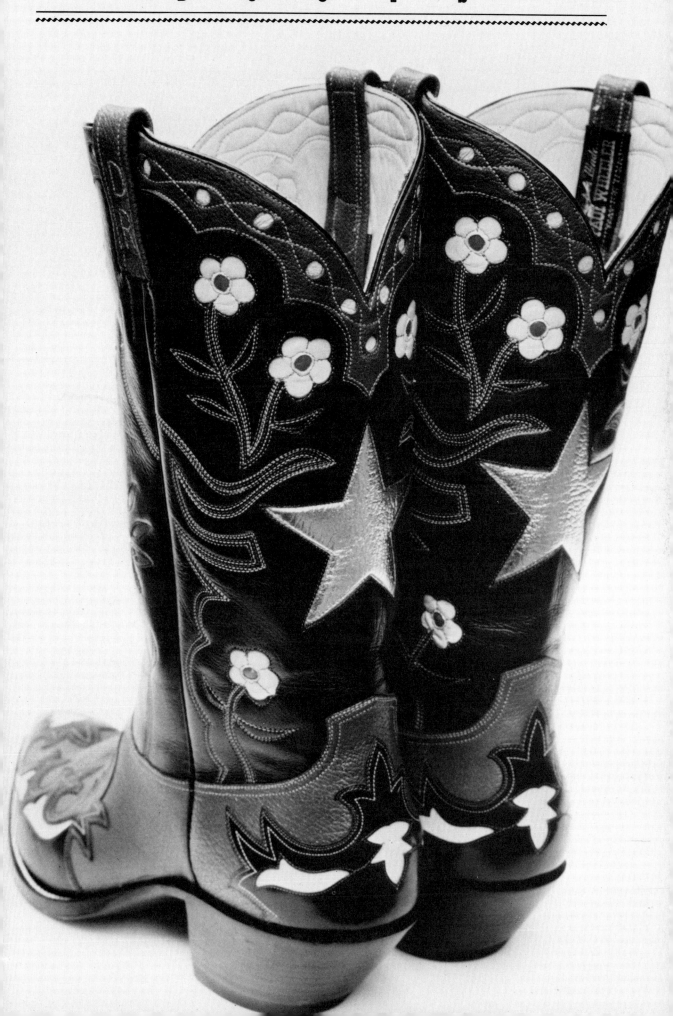

Paul Wheeler does almost all the fitting himself. After that, the making of a pair of boots may be the work of either Paul or Dave, in collaboration with their staff of six Mexican craftsmen. Until recently the Wheelers employed Dario Canizales, a superb Mexican bootmaker famed for his designs, particularly his distinctive flying eagle inlays. Canizales, now too ill to work, is a man of few words who could render almost any image in leather. It was he as much as Paul Wheeler who interested Dave in bootmaking.

The Wheelers' clients include Houston oilmen, rock stars, bankers, and movie people. Paul Wheeler made a pair of boots for Tom Griffin, vice-president of the Merrill Lynch brokerage firm, to commemorate his winning the Terlingua World Chili Championship with his "Buzzard Breath Chili." The boots were made of full-quill ostrich and ivory calfskin with buzzards in ostrich inlaid on the tops and a legend comprising one hundred fifty inlaid letters. Another flamboyant client has a pair of Wheeler boots (shown on pages 130–31) that were made from blue calfskin and gray pigskin with flame wing tips and inlays of mockingbirds, golden stars, and yellow buttercups.

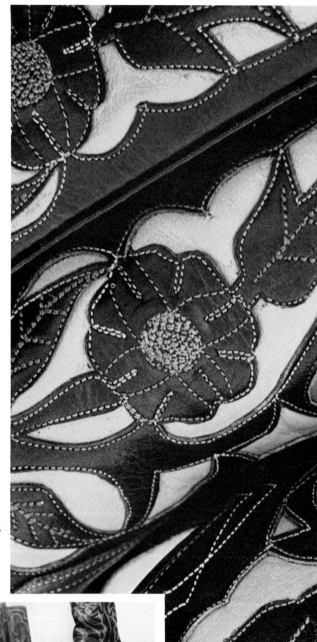

*Dave Wheeler polishing the heel of a boot.*

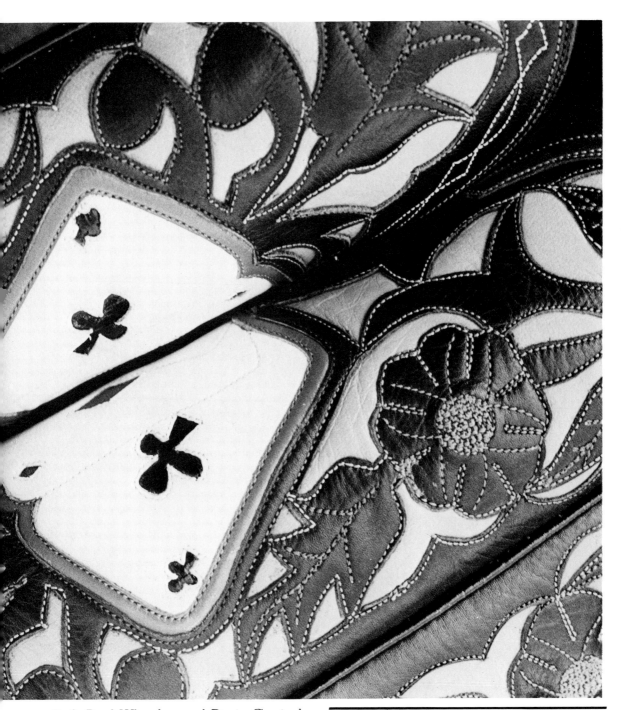

Both Paul Wheeler and Dario Canizales specialized in "old-fashioned" inlay work portraying typical western scenes, and Dave Wheeler has elaborated on this. He stitches together enormously complicated inlaid and overlaid western panoramas—leather scenes of sunsets, mountains, cactuses, and wildlife—that cover the tops of his boots. These designs are reassuring evidence that the

*Inlaid playing-card and flower design. Pink calfskin tops are overlaid with chocolate-brown stems and flowers on which are stitched white playing cards with red and black details.*

bootmaker's art is not disappearing but is becoming refined as its repertoire expands in the care of craftsmen like the Wheelers.

# DAVE LITTLE

### *San Antonio*

Dave Little's boots are flashy. They are reminiscent of the "classic" boots of the Forties, and in fact many of the designs were made up during that period by Dave's father. Little's Boot Company was founded in 1915 by Dave's grandfather Lucien Little, who sold and repaired shoes in San Antonio. One of his repairmen was also a bootmaker, and he taught Lucien's son Ben to make boots. The local cowboys and ranchers who were their first customers wanted heavy boots for working, but by the Forties Ben was designing fancy boots as well and was,

along with Cosimo Lucchese, San Antonio's preeminent bootmaker. He made boots with squared-off pointed toes and sharply pitched high heels, heavily decorated with inlays and overlays and dense rows of stitching. One of his typical designs is a boot with a red calfskin vamp covered with long black flamelike wing tips and counter foxing. The uppers are made of yellow calfskin with stitching around the tongue and green and red butterfly inlays under a green flamelike collar in which red hearts and diamonds are inlaid. Ben Little's butterflies are idiosyncratic in that the wings are not outspread. The insect is in flight, with wings swept back. Other distinctive Ben Little designs include a cactus overlay made from green lizard, a white longhorn steer head, fanned-out playing cards, flame stitching that extends over the

*Dave Little's spider-web stitching pattern.*

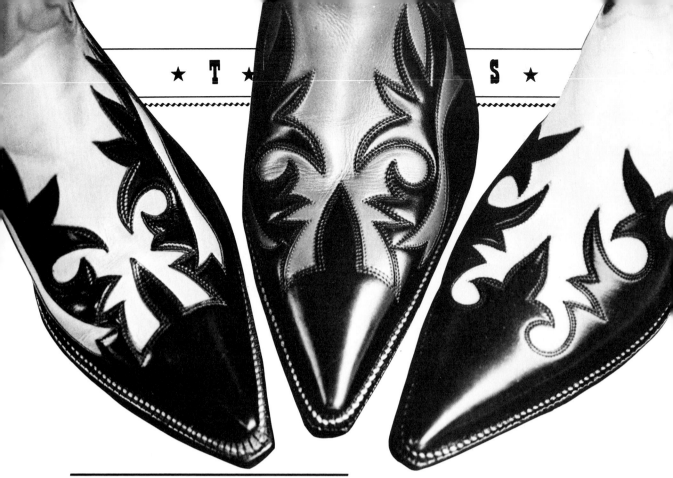

Above: *Black wing tips overlaid on vamps of three different colors.*

Right: *Dave Little's top patterns and stitching samples.*

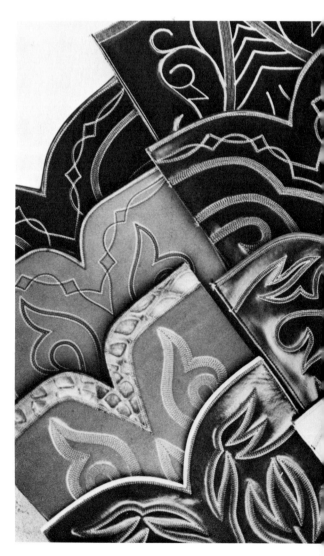

vamps, and a dense spider-web stitching that covers a whole top.

Almost all of these designs can still be found at Little's Boot Company, along with several new ones, like Dave's big spread eagle and his raised overlay of a white horse in the center of raised leaves and stems and flowers. Dave makes boots from exotic skins as well as conventional calfskin boots, but he wants people to know that he can give them "something unusual"—and something that is made with the care of an old-time bootmaker. His pointed-toed boots, for instance. "Sometimes people with an extremely long middle toe will have trouble with a pointed toe. But not many. It declined in popularity because it's hard for the machinery to stitch around. The factories would have to stop the stitching on the welts and stitch by hand around the pointed toes."

Dave likes putting together a boot specially for each customer, "being

somebody's bootmaker," and he likes to talk about the people who fly in from New Orleans or Buffalo to order his boots. He employs six bootmakers he trained himself and his wife tends the shop and takes care of the books while he measures customers, makes lasts, and supervises the other work. This is a good system, and for quite some time now Little's Boot Company has been working at capacity, turning out fifteen pairs of boots a week. But Dave wants to bring the advantages of a made-to-measure custom bootmaker to a wider audience, and he has devised a method for fitting customers who can't come to him. A catalog illustrates the styles that he has to

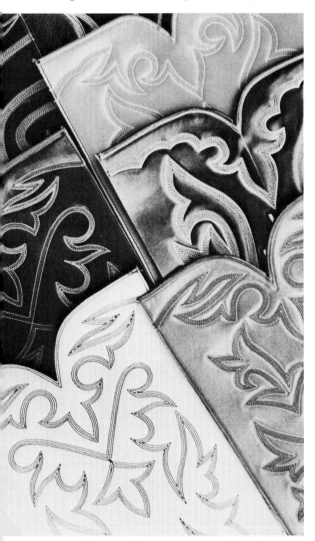

offer and comes with special measuring instructions for people who don't fit into standard sizes. This is not unlike systems used by several other bootmakers, but Dave's system is more refined in that he will do the fitting from a model of the customer's foot—the kind of model podiatrists use for their patients, or those made up by orthopedic shops. He uses these "dynamic foot impressions" (made when one's weight is on the foot, as opposed to a static impression made when one is sitting down) to build a customer's last. In a sense this is better than simply measuring clients in a shop, since the mold stays with the bootmaker and can be rechecked. It takes twenty or thirty minutes to make one of these casts, and Dave will do it in his shop for customers who come to him, or he can use a model made up by a podiatrist.

Thus customers can select the shapes and designs and kinds of leather they want and also be assured of a good fit without coming to San Antonio. Dave is careful to point out, though, that as far as he's concerned "a good seventy-five percent of the people can buy stock boots," from a standard last size. He thinks that unless one has a high instep or a very small heel base or bunions, a standard size will be acceptable, although "a custom-made boot is cut different. It has a real nice cut where the heel grips. A factory-made boot is wider, so anyone can get it on and off." In any case, whether customers take simple measurements of their feet or have a mold made  or order a standard size, Dave will put together whatever one wants. He has about one hundred fifty pairs of boots on display in his shop to give customers ideas, or to sell if they happen to fit. He's an old-fashioned bootmaker, but doesn't mind being a modern entrepreneur as well.

# JAMES LEDDY

## *Abilene*

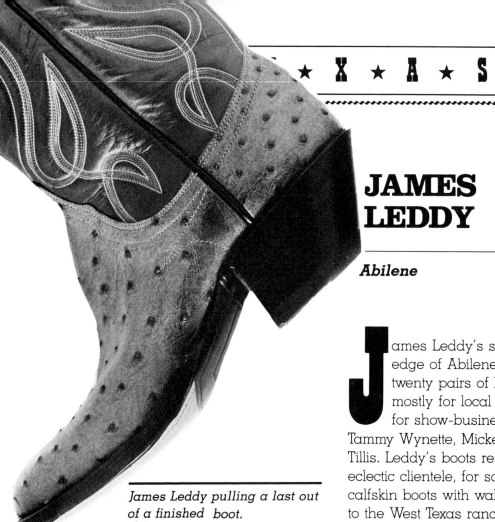

*James Leddy pulling a last out of a finished boot.*

**J**ames Leddy's small shop at the edge of Abilene produces about twenty pairs of boots a week, mostly for local ranchers, but also for show-business people like Tammy Wynette, Mickey Gilley, and Mel Tillis. Leddy's boots reflect that rather eclectic clientele, for some are the sturdy calfskin boots with walking heels common to the West Texas ranchlands and others

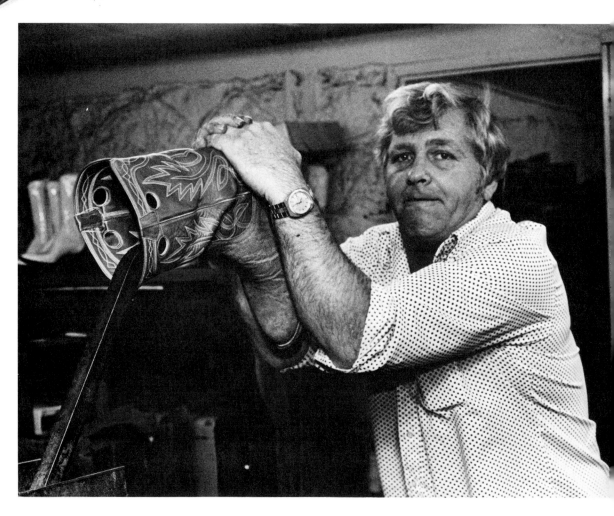

*James Leddy's gray ostrich boots with burgundy tops covered with variegated stitching. See also color plate 39.*

are pink with needle-sharp toes and high-pitched heels.

James Leddy comes from a West Texas bootmaking clan. His uncle was M. L. Leddy, who started the bootmaking business that survives today in the chain of Leddy stores based in San Angelo. His father, Wilson, taught the head bootmaker at Leddy's, Robert Castleberry, to make boots and had his own shop in Tulsa, Oklahoma, which was where James learned to make them, building his first pair there when he was twelve. In 1953 Wilson moved the shop to Abilene, and it now belongs to James. He fits customers and works in the back putting boots together while his wife and daughter-in-law stitch the tops at machines lined up along the wall near the front door, next to boots waiting to be repaired and piles of leather swatches. Two assistants last the boots and build bottoms in a small adjacent building.

Leddy prefers to work with calfskin or kangaroo, but he also makes up boots out of several kinds of exotic skins—lizards and eels and toads and various snakes. The toad skins come from Thailand, and about ten of them are needed to make up a square foot of leather, so the skins have to be pieced together with a zigzag stitch. James made a pair of toad-skin boots for himself and a pair for his wife, but most of his customers don't ask for such eccentric-looking styles. He gets more orders for boots with zippers up the side, which fit tightly around the ankle and provide more support than those that have to be pulled on and off. Performers

who have to stand on stage for several hours a night sometimes like to have them, as do overweight customers. James also makes special "air-conditioned" boots for hot Texas summers—boots with mesh on the vamps and in patterns up the sides. He doesn't have a catalog, because "all my boots are so different. But if somebody sees something they like, they can just send me a picture and I'll make them."

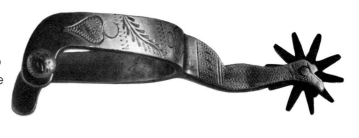

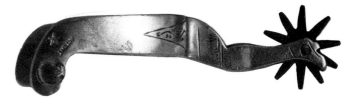

# TEX ROBIN

## *Coleman*

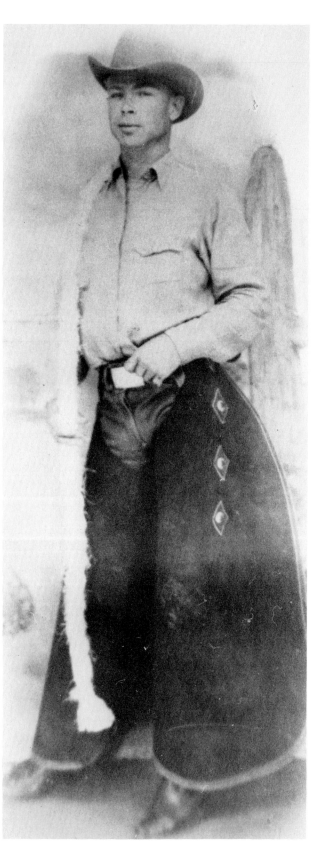

*W. L. Robin in his rodeo gear, 1940.*

Tex Robin started making boots when he was ten, in his father's shop in Throckmorton, a small town between Abilene and Wichita Falls. W. L. Robin, also known as "Tex," was a half-Cherokee, half-Swedish vagabond who rode in a Wild West show in the late Thirties and then set off on the rodeo circuit, where he began to remodel boots for the other bronc riders. They wanted the shank taken out of their boots so that the soles would grip the little ox-bow stirrups on a bucking saddle, and the tops cut down so the boots would come loose when a rider was thrown. After Robin had taken a lot of boots apart and put them back together, he decided to make his own. He worked in shops in small West Texas ranch towns, at the big L. White Boot Company in Fort Worth, and finally in Austin, where, before he died in 1972, he made boots with Charlie Dunn at Buck Steiner's Capitol Saddlery.

His son learned to make a complete boot, although when he was growing up in the Fifties custom bootmakers were usually specialists, either fitters or bottomers. "It was divided up like that. Back then you could find fifteen or twenty migrant boot bottomers or fitters. If you needed some work done you could call two or three guys and they'd come down to work." Today Tex works pretty much alone in his shop in Coleman, a dusty little town on the plains between Abilene and San Angelo. He has a young assistant who does much of the stitching

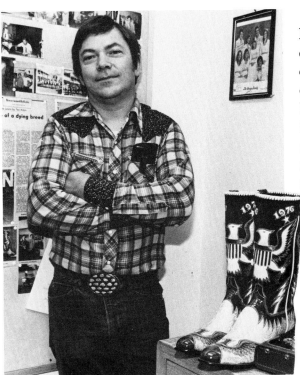

Tex makes about five or six pairs of boots a week, mostly for ranchers, but also for a few clients who come a considerable distance to place their orders—the wife of the chairman of the board of Benton & Bowles in New York, for instance. And not all of Tex's boots are provincially plain: he makes a particularly graceful butterfly inlaid design and does a lot of experimenting with kangaroo overlays on contrasting calfskin. A pair he made for himself has an ostrich-leg

*Tex Robin with his patent-leather and brocade eagle boots made for the American Bicentennial. Details of the toes are shown below.*

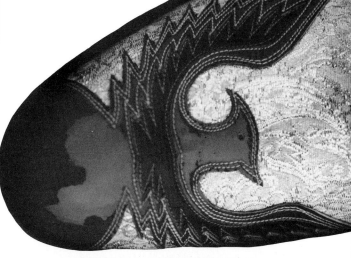

and puts some of the tops together—a "college-graduate bootmaker" from the Boot, Shoe, and Saddle school at Oklahoma State University in Okmulgee.

The elder Robin's reputation was that of a flamboyant, hard-living renegade, who Charlie Dunn remembers could be counted on for a good time. His son is a fundamentalist Baptist family man to whom bootmaking is "a kind of obsession." "I work from eight-thirty until six every day and then I come back and work two or three hours at night. Saturdays. Half a day Sunday. And go to sleep at night dreaming about it." W. L. Robin's boots were multicolored and flashy, reflecting his roots in a world of rodeos and shows. His son likes to experiment with styles and leathers, but his West Texas clients are reluctant to go along with most of his ideas, preferring a simple boot that will hold up. "I like to do inlays and overlays. Different combinations, zigzags, fancy designs, but in this country they just want plain boots. If it was me I'd have them purple."

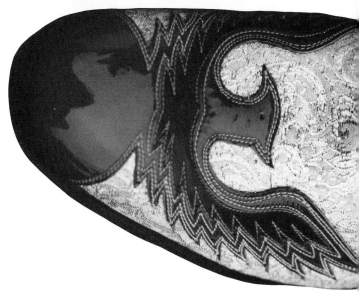

design overlaid on calf that starts at the toe and sweeps up to become the entire tongue. The same ostrich leather is then inlaid on the boot top in a sort of flame pattern and inlaid again into the counter. The vamp overlays are perforated all the way around, the heels are sharply underslung, and the tops deeply scalloped, with white piping. He made his most extravagant pair of boots for the 1976 Bicentennial. They are basically red patent leather, with Tex's own rendering of the Presidential Seal eagle inlaid in blue and white calfskin on the tops. Inlaid stars and streaks of lightning surround the seal, and the eagle design is repeated on the toe in red patent and blue calf over gold brocade, which covers the rest of the vamp.

Tex likes to talk about the abnormal feet he's fitted, and although unlike many bootmakers he does not claim to be able to correct bad feet, he does claim to be able to fit anybody so that they can walk comfortably. "I've never seen anybody

*Tex Robin's ornate counter foxing. The skin on the detail at left is anteater.*

change the shape of their foot by putting it in a boot. The boot molds to the foot. If a person has a high arch you make a boot with a high arch. If he has a flat foot you make a flat-footed boot. If a person has a bunion, though, you can make a boot with room for the bunion and a lot of times it'll go down. . . . I've got two lasts. One has the same arch as a shoe, and I use it on most of my boots for businessmen. The other one is called a cowboy boot last. It's got a ball on the bottom of it where the ball of your foot is that will set up to a two-inch heel. But you have to have an arch to wear it. If you're flat-footed and you put that on it feels like you're standing on top of a broom."

Tex says he would like to be able to make more boots, and talks about getting an assembly line going, but finally he would rather do everything himself and make sure it is done right. "It takes maybe ten years to master the art of bootmaking. You have to be an artist. You can teach somebody else to do the job, but then it's not going to be you. It's just going to be a boot."

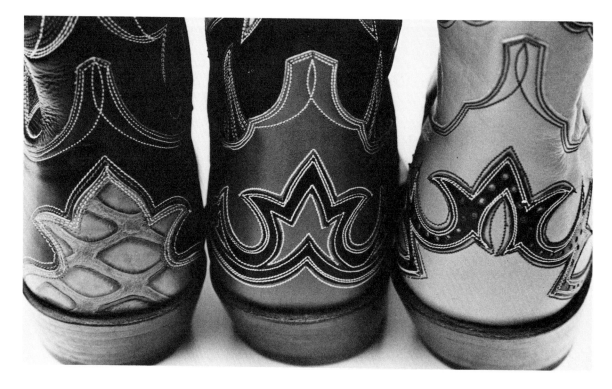

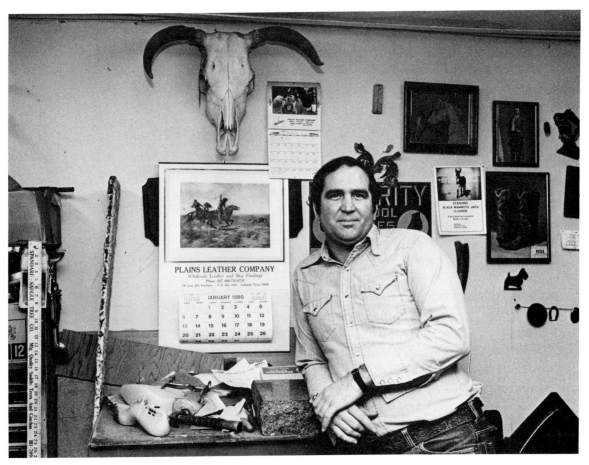

# ALAN BELL

## *Abilene*

Alan Bell's shop is quite literally a one-man operation. His wife doesn't stitch the tops and he has no assistant to whom he is teaching bootmaking, as is the case with most bootmakers who are nominally lone craftsmen. Alan is the number-two bootmaker in town (James Leddy was established in Abilene for many years before Alan got started), the youngest and the most simply equipped. In his little shop in a ramshackle building Bell makes three or four pairs of boots a week for local ranchers, mostly the younger ones who are drawn to a fancy boot, and quite a few customers from farther away—California, Michigan—who have learned of his work. Bell's situation is typical of the hand craftsman in an industrialized world: "My boots start at two hundred and seventy-five dollars, I've got a hundred dollars or so worth of material in them, and it takes me eighteen hours to make them by myself. You've got to put out in volume to make money, but the more hands you have working on that boot, the more you're going to have to sacrifice a little quality."

Alan Bell grew up in Blackwell, a town of about two hundred fifty people just west of Abilene. He was a farm boy, not especially interested in a craft, until one day he took his saddle into Abilene to have his name stamped on the seat. He

was fascinated by the shop there and stayed on for three years learning saddle making and boot repairing. He preferred working with boots, so he persuaded Tex Robin in Coleman to take him on as an assistant. It was Tex who taught him the fine points of the craft.

Alan was a saddle maker for a few years, and is perhaps the only working bootmaker who has mastered the art of hand-tooling. The boots he prizes most are covered with a great swirling-leaf pattern that is tooled into the tops and then repeated over the vamps and back to the counter. Alan had to tool the bottoms freehand while they were on the last because if he'd laid them flat to do the work first the design would have stretched out and been distorted when the leather was wet and pulled over the mold. He keeps the boots nailed down in a Plexiglas display case. They are his favorites, but most of the boots he makes are more conventional, although exotic in the generally conservative context of West

Texas. He puts together a lot of boots with nineteen-inch tops, inlays, toes with wing tips, and triad designs.

Alan Bell is a bit of an anomaly in a business where a big complaint is that it's hard to find new bootmakers, that young people don't want to do the painstaking, detailed work that bootmaking requires. Alan likes it. "I'm going to be around for a long time."

*The toes of Alan Bell's hand-tooled boots. See also color plate 11.*

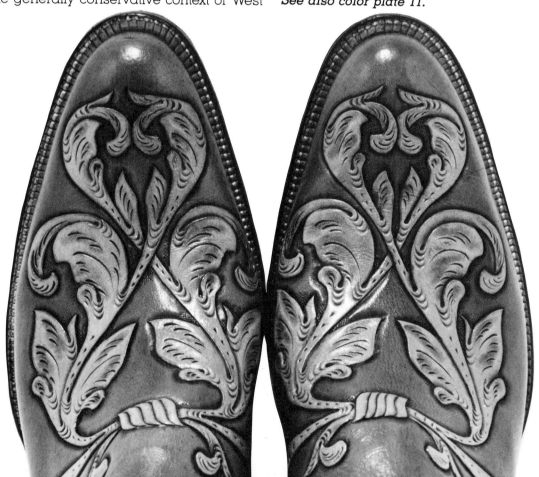

# CARLOS HERNANDEZ, JR.

*Austin*

Few of the Mexican-American craftsmen who for generations made boots for the Luccheses in San Antonio have been able to successfully maintain their own custom boot shops, although many have tried. A happy exception is Carlos Hernandez, Jr.

Carlos Hernandez, Sr., worked for the Lucchese company almost from its inception. In 1940 his son came to work as an apprentice and over the next decade learned every aspect of bootmaking. He had become a skilled bootmaker by 1949, the year Cosimo Lucchese began what was probably the most ambitious custom bootmaking project ever undertaken—the manufacture of a series of intricate, inlaid boots, each pair representing a state of the Union. These boots remain in many ways the finest examples of Texas bootmaking.

The first pairs were executed by Jesus Garcia, the master bootmaker at Lucchese in the late 1940s, but when Garcia left to open his own shop, Carlos Hernandez, Jr., took over. He remembers particularly working on the Texas, Louisiana, and Pennsylvania pairs and recalls that the Pennsylvania boots were especially difficult because of the complexities of that state's flag.

Hernandez left Lucchese in 1959 and started his own shop in San Antonio. Ten years later he returned to the company and remained there until 1974, when he moved to Austin and went to work for the Capitol Saddlery. In 1978 Hernandez opened another shop. The venture is a success, and he now employs a staff of eight, which produces between ten and twelve pairs of boots per week. Recently he has begun to make a few pairs of English riding boots, but his main concern is still finely crafted cowboy boots. Carlos Hernandez, Jr., is adept at all the phases of bootmaking, but he will be remembered most as a gifted top man, one of the best to come out of Cosimo Lucchese's shop, which is to say he has few peers.

*The Pennsylvania boot designed and executed by Carlos Hernandez, Jr., for Lucchese's state-boot series in the late 1940s. Visible here are the multicolored inlays of the Pennsylvania state flag, the state bird, and the tiny letters of the state motto on the top of the boot, with the Liberty Bell inlaid in gold leather on the wing tip.*

# LARRY JACKSON

---

*Walnut Springs*

Larry Jackson's workshop at the rear of his western-wear store is a conventional one-man bootmaking operation—a little less cluttered than most, perhaps, because he hasn't been there too long, and more spacious, for he had the long cinder-block building made for him, with plenty of room to move around. What is peculiar to Jackson's shop are the cages of rattlesnakes sitting in a shady corner off to one side. Larry Jackson makes boots for the ranchers of the Brazos River hill country, tough gear for working cowboys, and his specialty is diamondback

rattlesnake boots. In the store in front, next to the boys' jeans and the Stetson hats, there are rattlesnake hat bands, rattlesnake belts, stuffed rattlesnakes coiled inside clear plastic globes, rattlesnake rattles made into pins.

Jackson learned to make boots at the Nocona factory, where he worked in each of the departments and was finally foreman of the bottomers there. His wife stitched tops. They've been putting together handmade boots in Walnut Springs (pop. 495) since 1976. Jackson makes all kinds of boots—boots with inlaid initials, sharkskin boots with bulldogging heels, plain calfskin riding boots—but his rattlesnake boots stand

---

*Larry Jackson with Sonny Burt, who is holding a Western diamondback rattlesnake.*

*Rattlesnake pieces cover the tops of the vamps and the collars of these boots.*

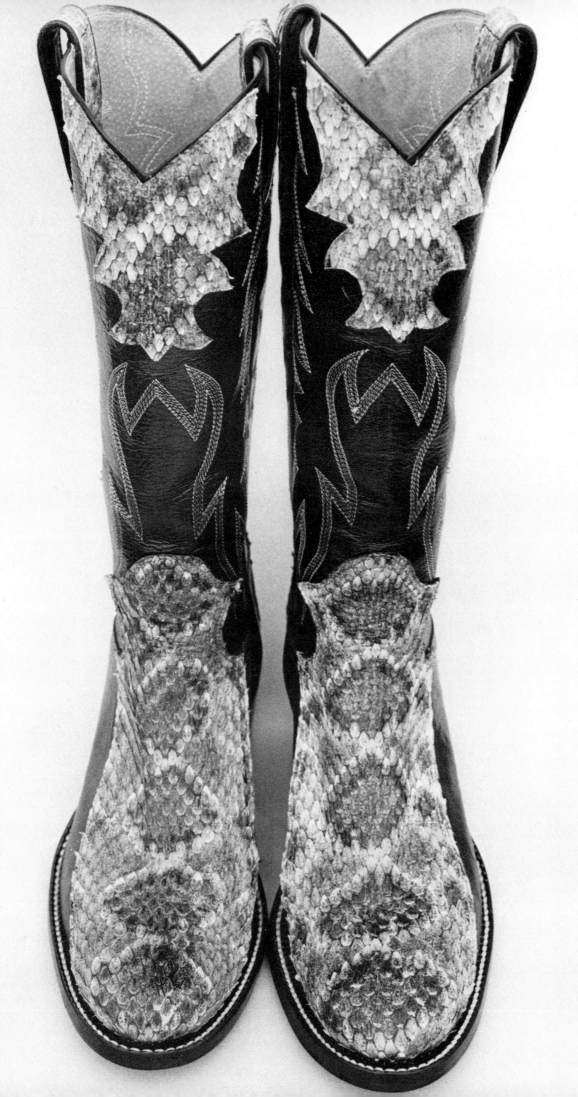

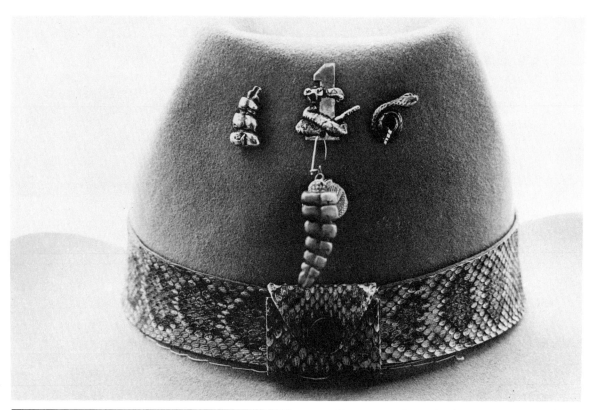

*Sonny Burt's hat, with a rattlesnake hatband and rattlesnake pins.*

out. On some the whole vamp is made in one piece from the skins of huge Florida rattlesnakes; others are pieced together from smaller snakes or made up in triad designs, or the skins are cut into fancy collars and pull pieces, or stripped over the tops in spread-wing patterns.

Rattlesnake is a pretty skin. Western diamondback rattlers, the kind found in central Texas, are usually around four feet long, and the skins when tanned are a yellowish brown, with the diamond patterns formed along the back in a row of dark brown scales outlined with a row of pale yellow scales. There are huge numbers of these snakes in central Texas, and several years ago snake hunts were organized in the country around Walnut Springs to control the number of snakes that had been biting and poisoning cattle and ranchers. At first there was just a big hunt in early March, but snake hunting soon caught on as a sport, and now people stalk snakes year round and swap snake stories in the same way that most rural sportsmen swap fish stories.

With so many snakeskins available, it

might seem that rattlesnake boots would be commonplace in Texas, but tanning the skins properly so they won't crack has always been a problem; in addition, most of the local snakes aren't wide enough to provide a skin that would completely cover the vamp of a boot, and a skin that tends to be fragile anyway would most likely tear if it were pieced together. The man who solved this problem for Larry Jackson is Sonny Burt, an obsessive snake hunter who works on the railroad to make a living and hunts snakes the rest of the time. Sonny is full of snake lore and claims never to have been bitten in his fifteen years of hunting, even though he handles a lot of snakes and kills them with his hands—decapitating them with a hunting knife or injecting them from a hypodermic full of a chloroform solution. He doesn't like to bash them with rocks because it spoils the skin, and often he wants to use the heads.

Sonny buys up most of the skins from the snakes caught in the big hunt in the spring, when hundreds of snakes are put into a pit and "milked" for their venom, which is shipped to research laboratories. The snake-hunting devotees walk among the snakes, selecting the ones they sense they can handle, sure that they can anticipate the snakes' behavior. It's a dangerous sport, but Sonny says one gets used to a snake's personality, and accidents are infrequent, although "Old Apache got bit on the lip, and then a year to the day he got tagged between the eyes when he was demonstrating the Kiss of Death."

Sonny has devised a tanning process that preserves the rattlesnake skins and makes them workable. "Most people around here use alcohol and glycerine, or they just take the skins, salt them, and put them in antifreeze. Puts a little oil back in them. But they won't last. We have a chrome tanning process that keeps a lot of body in the hides. They're pretty thick skins anyway. Then we scale them after they're tanned and there's a little petal left that won't come off." Sonny makes belts and hat bands, and supplies skins to Larry Jackson for boots. The first pair they made was for a friend of Sonny's who works on the railroad. "There's big rocks on the tracks, and diesel fuel, grease, and oil all over the place, and he hasn't hurt his boots a bit."

Opposite page, bottom: *The toes of a pair of boots made out of a huge rattlesnake skin from which the whole vamp was cut.*

Right: *Larry Jackson's shop.*

CUSTOM HAND MADE BOOTS

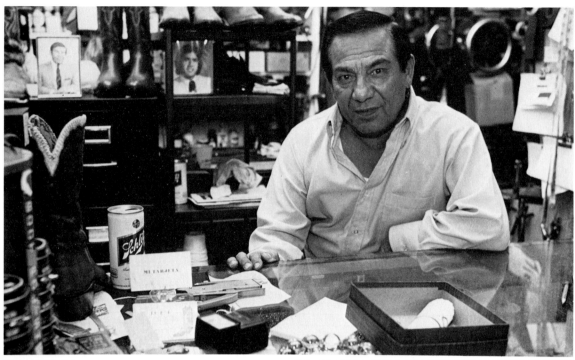

# THE
# GALVANS

*Joe Galvan in his shop.*

### San Antonio

**M**any of the best bootmakers
have been Mexican-Americans,
and this tradition continues. If
Cosimo Lucchese's shop during
the 1930s and 1940s was the
best made-to-measure bootmaking
operation in Texas, a great deal of the
credit must go to the skilled Mexican
craftsmen Lucchese employed—men like
Carlos Hernandez, Jr., Gilbert and Jesus
Garcia, and the former Lucchese
manager, Joe Galvan.

Joe Galvan worked for Cosimo
Lucchese for thirty-five years. He fitted
customers and ran the store, and today
he talks a great deal about his days
there, his affection and respect for
Cosimo. When the Lucchese Boot
Company was sold to Blue Bell, Inc., Joe

Galvan set up a tiny shop in downtown
San Antonio, where he now fits his own
customers and employs many of the
former Lucchese craftsmen. His son Jody

is a partner, and together they produce about five pairs of boots a week.

Joe Galvan is something of a traditionalist. Like other bootmakers of his generation, he is not a great fan of fancy boots, favoring instead the refined Lucchese look and the exotic high-quality leathers that are characteristic of the best custom work. Still, he has saved some extraordinary examples of ornate boots made in the Lucchese shop in the Thirties and Forties. One particularly astonishing pair, designed, according to Galvan, by Carlos Hernandez, Jr., is covered with a panorama of inlaid desert cactuses in bloom, rearing stallions, stars, and multicolored flame wing tips and counters (see color plate 4).

Jody Galvan is, as might be expected, more open to different styles. Still in his early twenties, and still learning the craft, he is enthusiastic and inventive. His clientele includes many customers from the Northeast who are attracted to the elaborate inlay work executed in the Galvans' shop, particularly a subtle pinched flower that is shown in color plates 18 and 19. The resident master of this kind of ornamentation is Pancho Ramirez, known in San Antonio as *La Aguja de Oro*, "The Golden Needle." His climbing vines of budding roses leading to a large flowering rose in the center of the boot top are incomparable.

*Jody Galvan.*

# ELMER TOMLINSON

*Llano*

mer Tomlinson belongs to the old guard of master craftsmen. Like Henry Leopold, Ray Jones, and Charlie Dunn, Tomlinson is best known for the fit of his boots and for their balance and proportion. From his small shop in Llano he turns out about three or four pairs of boots a week. His customers are almost all local ranchers and cowboys, although many oil men from Dallas and Houston have made the trip to be fitted for his boots. A Tomlinson boot is rugged and durable, meant to be worn and worn hard. The bootmaker's art consists of submitting to this practical requirement without compromising the line and look of the boot, and in Elmer Tomlinson's work both of these considerations are gracefully accommodated.

# J. E. TURNIPSEEDE

*Beeville*

d Turnipseede is a contemporary of Charlie Dunn—they worked together in the 1940s—who managed to avoid the life of the itinerant bootmaker. Turnipseede moved to Beeville, in south Texas, where he not only made boots but also opened what is now one of the largest western stores in that part of the state. He describes the kind of boots he makes as "standard," with few inlays or fancy patterns. His clientele is composed of the working ranchers of the region as well as people drawn from both inside and outside Texas who are willing to wait as long as a year for boots by this master craftsman.

# CAPITOL SADDLERY

*Austin*

he Capitol Saddlery has been home to some of the best bootmakers in Texas. Charlie Dunn worked there, as did Carlos Hernandez, Jr. The store is owned by the imposing T. C. "Buck" Steiner, a former rodeo cowboy and something of a local legend. Currently the head bootmaker is Ramon Navarro, who oversees a small staff that turns out about twelve pairs of impeccable boots a week in every imaginable style. Not surprisingly, since the Capitol Saddlery is located in Austin, the shop is called on to execute many fanciful "cosmic cowboy" designs, but it also produces more subdued boot styles for the many working cowboys and ranchers among its customers.

# H★O★W a
# B★O★O★T
# I★S P★U★T
# T★O★G★E★T★H★E★R

A boot is put together in more or less the same sequence whether it is made in a factory or by a bootmaker working alone in his shop. In a factory machines do much of the work, the process is much quicker, and some steps may be omitted. In a small shop a bootmaker may have methods peculiar to him alone. The following explanation of the bootmaking process is a simplified overview that tries to take into account different methods.

**1.** The top pieces and top linings are cut out—the vamp, the counter, and two pieces for the uppers, front and back. In a factory this is done with metal dies in the shape of the different parts (rather like cookie cutters) which a click machine presses into the leather. In a small shop the bootmaker cuts the leather with his knife.

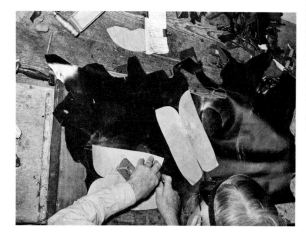

**2.** The vamp piece is wet and stretched over a crimp board and tacked down very tightly until it dries. This gives the bottom of the boot its shape and stretches the leather so that it won't become loose later. All handmade boots are treated in this way, although factories sometimes leave this step out.

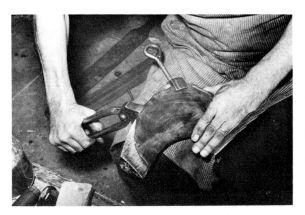

**3.** The lining, the front filler, the back stays are glued onto the top pieces, and the beading around the top edge is attached. Backing is put on the vamps if

the hides are fragile, or if the skins are so small (like those of some tiny lizards) that more than one piece is necessary to make up a complete vamp.

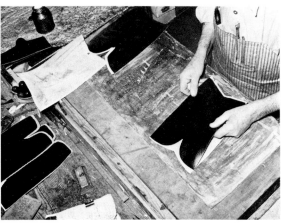

**4.** Paper patterns perforated in the shape of the decorative stitching design are placed on top of the leather, and talc is sprinkled over the patterns. The powder leaves a mark which can be followed by the stitcher after the pattern is removed. In most cases the rows are stitched in the appropriate color and number on a hand-operated sewing machine. In some factories the various patterns are coded on a computer tape from which instructions are given to an automated sewing machine that stitches the designs.

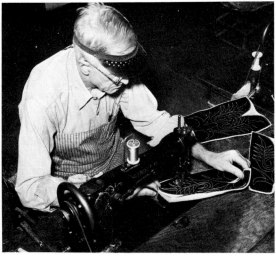

**5.** The vamp and vamp lining are glued and sewn to the front top piece. The hard outside counter and the softer inside counter are sewn to the back top piece.

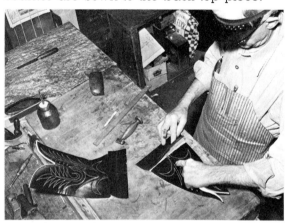

**6.** All excess leather is trimmed off the pieces, and the side-seam welt is attached to the back half of the boot. The front and back sections are now sewn together along the side seams, so that the boot is inside out. The boot is then wet to make it workable, turned right side out, and the side seams are pressed down flat. Slits are cut into the tops and the pull straps are tucked into the slits and sewn in place.

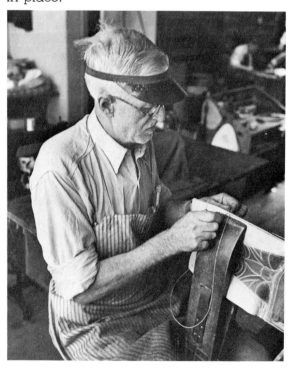

**7.** The insole is nailed to the bottom of the last, and trimmed.

**8.** The boot tops are wet again, pulled over the last, and tacked in place in front. The toe medallion, the front scallop, and the counter have to be carefully lined up at this point.

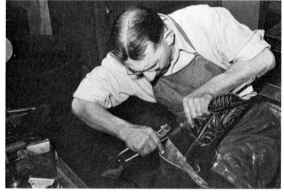

**9.** The rest of the leather is pulled over the sides and nailed into the insole. In a handcrafted process the laster does all this stretching and tacking by hand. In many factories, machines do it—sometimes on dry leather, which makes for a boot that will stretch out after it has been worn.

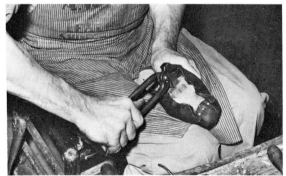

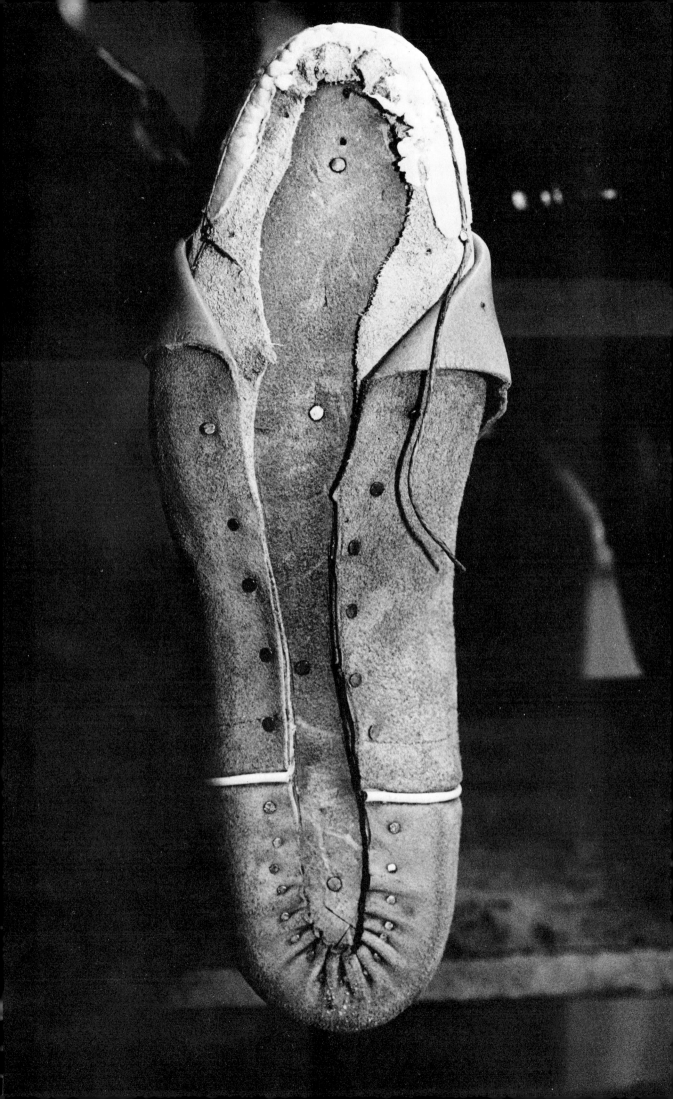

**10.** The leather around the toe is pulled back and the toe box is fitted in between the vamp and the vamp lining. The leather is then pulled back over the vamp and strapped in place until the toe box dries.

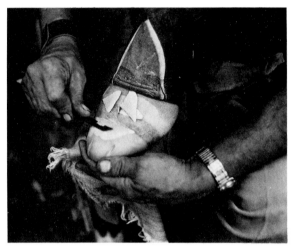

**11.** The straps are removed from around the dried toe box, excess leather is again trimmed off, and the leather welt, or inseam, is sewn onto the vamp, vamp lining, and insole. The welt holds the sole and top together. It takes about an hour and a half to hand-sew a welt, about sixty seconds with a machine.

**12.** The lasting nails are removed from the insole, and a metal shank is placed in the arch. A piece of leather is hammered over the shank to hold it in place.

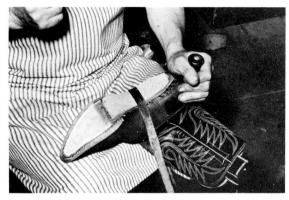

**13.** Glue is laid onto the sole, which is tacked over the insole and shank and pressed to the base of the boot. The sole is trimmed to the shape of the boot base, nails are hammered around the heel area, and the welt and sole are stitched together. Pegs are hammered into the sole along the shank.

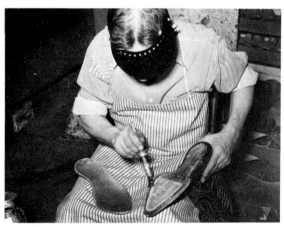

**14.** The sole is trimmed, the pegs are sanded down, the whole bottom is smoothed out, and the heel is nailed in place and shaped.

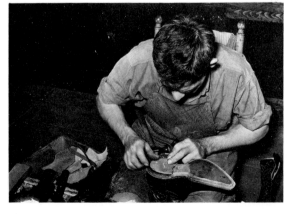

**15.** The lasts are pulled out and the finishing process is begun. A boot tree is inserted to give the boot its final shape. Heels are sanded and inked and burnished. Soles are shined up. Threads are clipped off, heel pads are put in place, the boots are cleaned and shined and waxed.

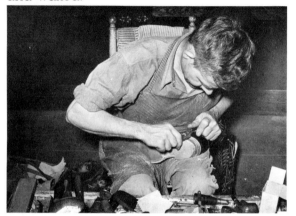

**F**actory workers have very specific jobs. The degree of specialization depends on the size of the assembly line, and obviously someone in a thirty-man plant is going to have more of the boot to take care of than a worker in a factory that employs several hundred people. A bootmaker in a small shop, a shop with less than a dozen people, for instance, has one of three specialties: he is a top man, a bottom man, or a finisher. The top man measures the customer's foot and shapes the last, cuts the leather out, fits the pieces together, and takes care of the decoration. The bottom man puts in the sole, sews on the welt, pulls the vamp over the last, and attaches the heel. The finisher removes the last, is in charge of the final dyeing and the shaping of the boot on a boot tree, the cleaning and waxing.

A factory has hundreds of sophisticated machines, but a small shop has four essential pieces of machinery: a flat-bed sewing machine for putting the decorative stitching on the tops; a machine to lay in

the side-seam welt; a sole stitcher that will sew the outer sole around the welt; a finishing machine for smoothing and polishing the heavy sole and heel. Boots can be put together completely by hand, but even the most "handcrafted" boot will probably have been touched by these four machines.

# C★O★N★S★U★M★E★R G★U★I★D★E

## LEATHER

**B**efore a hide becomes leather it must be tanned. Tanning arrests the natural process of deterioration and produces a material that can be worked with. Prehistoric and primitive peoples preserved pelts with grease or smoke, and until the middle of the nineteenth century a vegetable tanning process was employed. This method used tannin, an astringent vegetable product, and took over a month. Since about 1856, however, chrome tanning, which is based on the use of chrome salts and takes only a few hours, has been the most common method.

At the tannery the hides are first washed and then dehaired in a lime solution. Next they are soaked in the chrome-based chemicals and kneaded with mechanical paddle wheels. At this point the leather is known as "blue stock," though it is in fact colorless. Fats and other chemicals are then added to the hides to soften them, after which they are

ready to be dyed. Leather has no "natural" color after it has been tanned, and it is possible to put any color back into it. Two quite different sorts of dyes are used. A water-soluble aniline dye produces a richer-looking leather, but all the scratches and scars and aberrations of the original hide will show up. Aniline-dyed leather is usually of various shades of brown and has a deep luster. The other type of dye is a kind of pigment finish that is sprayed on. Pigment dye is available in every color imaginable and will cover over defects in the leather. The finish is very much like a paint job, however, and doesn't have the "depth" of aniline-dyed leather. Tanneries can also "augment" the natural grain of the leather, embossing cowhide to resemble ostrich, for instance.

The most common leather used in good cowboy boots is calfskin. It is soft, easy to work with, finely grained, and durable. Most calfskin is imported from Europe because Americans prefer beef to veal and the skins of young animals are rarely available here. European calfskins are better looking because they are not marred by brands or cuts incurred in the rigors of range life. There is in fact only one American tanner of calfskin left.

Cowhide is also a common leather for boots but is inferior to calfskin because it is brittle and coarsely textured. Cowhide is known as "side leather" because it is divided into two large sections from the left and right side of the cow. "Full-grained" leather has a grain side—the side the hair was on—and a flesh side. "Split" skins have been peeled into two pieces from one thick hide, so that one of the pieces won't have a natural grain. These pieces are often rubbed with a rough substance to produce a nap, as for suede. All the parts of a good cowboy boot will be made of

leather of various weights and durability. The pieces used for lining, for instance, should be made of a lightweight cowhide.

The skins of alligators and kangaroos have been popular among bootmakers from rather early on, and for the last twenty years or so "exotic" African, Asian, and South American animal skins have been fashionable. Some of these species have become endangered, and it is no longer possible to obtain their hides. In some cases regulations permit a fixed number of skins to be traded. What follows is a general list of the skins other than calfskin or cowhide that are frequently used by the makers of cowboy boots.

*Alligator* ☆ Has a hard, shiny surface made up of rows of large oval scales.

Crocodile skin.

*Crocodile* ☆ Looks like alligator. Practically the only way to tell the difference between them is to look for a little hole about the size of a pinprick near the top of each scale—if it has such a mark, it is crocodile. Crocodile is heavy, wears well, and is very expensive. Most of it comes from Asia and many species are endangered. Some crocodiles are farmed in Australia.

*Eel* ☆ A lightweight, thin skin with a high sheen. Eel is very fragile and the skins are narrow and must be pieced together and then backed with some kind of lining. It can be dyed in a variety of colors and there are usually streaks running through it. Most eel skins come from Korea.

*Gallapava* ☆ The trade name given the leather made from turkey skins. The species of turkey most common in North America is *Meleagris gallopavo*, hence

Alligator is said to wear very well, but that may be because it is usually worn as a fancy dress boot and doesn't have to endure the abuse of daily wear. It is expensive; most skins are imported from Central and South America, and sales are restricted since many species are considered to be endangered. There are alligator farms in the southern United States, but sales of these hides are also restricted.

*Anteater* ☆ Has a diamond-shaped scale, similar in size to that of an alligator. It is not as heavy a skin as alligator and is soft and flexible to work with and to wear. Most skins come from Africa or Asia. Some species are considered to be endangered.

Anteater skin.

"gallapava." The leather is marked with a pattern somewhat like that of ostrich, although the bumps where the feathers were are not as pronounced and the texture is more even. Gallapava has only recently become available and seems to be somewhat fragile.

*Goatskin* ☆ A fine-textured leather similar to calfskin. The skins of young goats (kids) provide a lustrous leather that was used for years by the Lucchese Boot Company. Most kidskin comes from Morocco or Spain.

*Kangaroo* ☆ Stronger than calfskin but also very soft, with a smooth texture. It wears well, is easy to work with, and is creamy to the touch and beautiful to look at. From Australia.

*Lizard* ☆ There are scores of lizard species, but in general the skins are hard and shiny. Since the lizard population has been extensively plundered, the skins now usually come from younger lizards and the hides are too small to cover a vamp so must be pieced. They are also fragile and should be backed. Alligator lizard from Argentina is the most common, but horn-back, ring, and iguana are also used. Bootmakers get lizard skins from Mexico, North and South America, Asia, and Africa. Some species are endangered.

Alligator-lizard skin.

*Ostrich* ☆ For some years the most prestigious leather for boots. Ostrich skin is very tough yet soft and flexible. It is easy to work with and comfortable to wear. Ostrich has a very grainy texture with a distinctive bump where the quill of the feather has been plucked out. When the leather is dyed this bump becomes darker than the background. Leg or belly ostrich does not have the bump. Ostriches are bred on farms in South Africa, where they are raised primarily for their feathers. The skins, which are much in demand for purses and jackets, are in scarce supply and thus expensive.

*Pigskin* ☆ A tough leather usually made into suede. Pigskin has very pronounced pores and consequently a somewhat

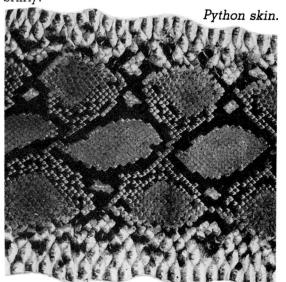

*Anaconda.*

*Snake* ☆ There are many kinds of snakes, imported from nearly everywhere, with minimal restrictions on most species. The most common skin for boots is python, which has small scales that form a blocky diamond pattern. Boa has a more symmetrical, oval design, but the enormous South American anaconda, an aquatic species, is often dyed in solid colors. There are two methods of tanning snakeskin, one which leaves the petal-like scales loose and grainy, the other which makes them lie down and look stiff and shiny.

*Ostrich skin.*

pitted texture. Because it is so tough it is often used for work boots.

*Shark* ☆ A very tough, stiff, hard skin with an erratic grain that can be dyed so that the raised streaks in the grain will be darker than the background.

*Python skin.*

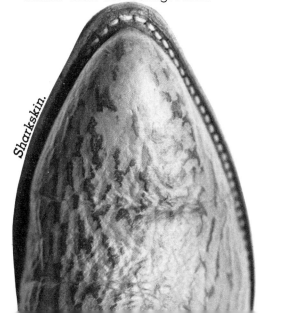

*Sharkskin.*

*Water buffalo* ☆ A tough skin with a rough, sandy grain. Easy to work with and doesn't scuff much. Most water buffalo are bred in captivity in India and Asia, although some hides come from wild African buffalo. Much of what is called water buffalo is in fact grained calf embossed to look like water buffalo.

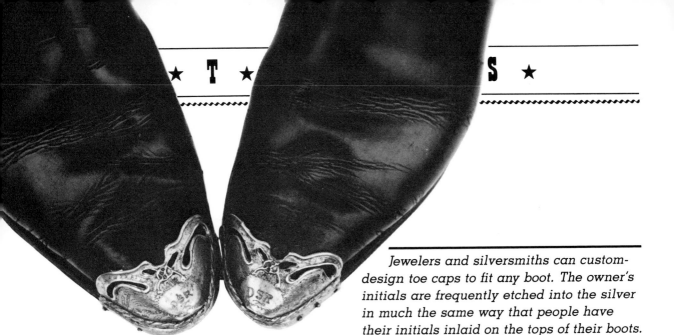

*Jewelers and silversmiths can custom-design toe caps to fit any boot. The owner's initials are frequently etched into the silver in much the same way that people have their initials inlaid on the tops of their boots.*

# WHAT TO LOOK FOR

**B**oots come in different heights and shapes and colors, and are made from a variety of skins, with several different kinds of toes, heels, etc. If nothing you see in local stores pleases you, you can always custom order a pair of boots from a factory or a custom bootmaker. They will cost more, but since you will have these boots for a long time you should get what you want. Keep in mind what they are going to be used for. Some leathers are more durable than others, some are easier to care for. If you are going to repair motorcycles or clean barns you probably don't want to do it in baby-blue kidskin boots with little squared-off toes that scuff easily.

You can tell a lot but not everything by looking at a boot, and to a certain extent you have to trust your bootmaker. You can't tell what kind of lining someone put behind a fragile lizard skin, but if you buy a boot from a good bootmaker you can assume that it was the right one. There *are* some things you can see, though.

Everything but the cap on the heel should be made of leather. The rows of decorative stitching on the tops should be close together and the stitches should be tiny—about twenty stitches per inch. Stitching around inlays should be neat and not leave little points of leather sticking up. There should be one or two rows of wooden pegs running up and down the sole of the boot where the shank is. Wooden pegs don't fall out when a boot gets wet, for they expand and contract with the leather sole itself. Nails get loose in wet weather and the leather around them will eventually rot. The leather on the top of the boot should be of good quality, supple, and pulled tightly over the vamp. If a store has the same style in different sizes you might notice that there are slight variations in colors among different pairs that are ostensibly the same boot. This doesn't mean there is something wrong with the leather but just that good aniline dyes have been used which accentuate the natural variation between hides and bring out the scars and scratches that were there from the beginning.

Cowboy boots are held together with welts. A welt is a sort of inseam that goes around the vamp and keeps the vamp, insole, and outersole together. What you see of a welt is the thick row of stitching on the edge of the sole, running completely around the front of the boot if it is full welted, and from about halfway

between the heel and toe to the same place on the other side of the boot if it is a "ball-to-ball" welt. A welted sole is made from heavier leather than one finds in shoes, and the idea is that a boot is not going to fall apart or wear out like a shoe would. The alternative method of putting a sole on is to cement it and press it to the insole. Bootmakers do this sometimes for women's boots or for boots that are designed for "dress" wear. A cemented sole looks a little sleeker, since it doesn't have stitched edges sticking out, and lighter leather can be used. Lighter leather will of course wear out faster, and there is the possibility that the whole boot could come apart if moisture seeped in, although that is unlikely with modern cement. Some bootmakers have a McKay stitching machine which will stitch the

bottom together from the inside of the boot, so that it is stitched but not welted. In any case, the choice is between a conventional heavy cowboy boot sole and a lighter one. The lighter one won't wear as well, but it might be easier to dance in. On the other hand, if you are used to a thick sole a cemented sole may make you feel like your bare foot has hardly anything between it and the sidewalk.

Right: *Boot pulls and a bootjack.*

*Wooden pegs hold the shank piece in place.*

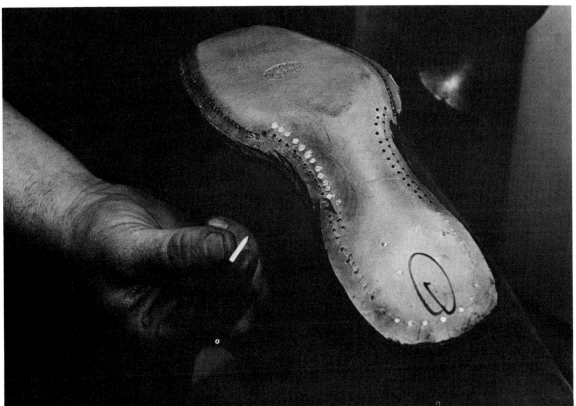

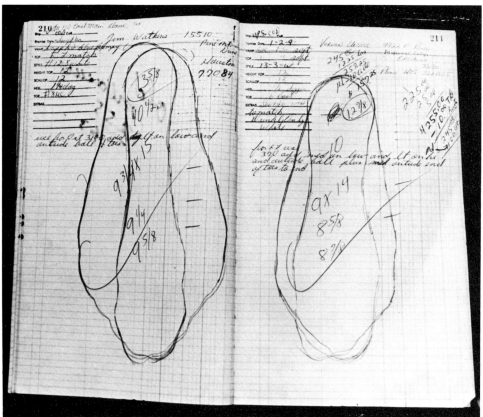

*The sort of log commonly used by boot-makers to record measurements and specifications of boot orders. If the foot has been measured properly here, a good bootmaker should turn out a perfectly fitting boot.*

# PROPER FIT

Purists say that it is impossible to get a proper fit unless one is measured by an expert fitter and boots are then made from lasts carved to match the idiosyncrasies of the feet—all the little tender spots accounted for, bumps and knots accommodated. In a strict sense this is true, but it is also true that unless you have some special problem, like a very high instep or very flat feet, you can probably fit nicely into a standard size. A made-to-measure boot from a good fitter feels like nothing else, and once you find your bootmaker and have a pair made it will be hard to go back to boots off the shelf. But if you don't

feel like waiting several months for your boots or you are two thousand miles from Texas anyway, a good boot store can take care of you.

Boot sizes generally run anywhere from a full size to a half size smaller than shoe sizes. A 7B becomes a 6B, etc. You should try to get the longest, narrowest fit that feels comfortable, because the foot is supported by the sides of the boot, and as you walk your foot will stretch forward and your toes should have space to move in to. If a boot is too wide, it won't hold your foot in place. Your foot will always slip a little in the heel at first, so don't think the boot is too big for that reason. Wear a reasonably thick cotton sock when you try on boots and then always wear the same sort of sock so that you maintain the fit.

Most factory-made boots are going to stretch a little, because often the leather has not been wet and pulled over

crimping boards to take the stretch out before the boot is put together. There is no way to tell by looking whether or not a vamp has been crimped, except that if it has there is often a slight discrepancy between the color of the vamp and that of the counter because the vamp has been stretched out and the counter has not. This is an extremely subtle difference, and it is better to assume that if you are buying a boot off the shelf it will loosen up a little bit with time. And you can have it stretched out immediately by a boot-repair shop if necessary. If you have been measured and fitted by a bootmaker who has made you a last, your boots should fit perfectly at once. If anything, they will go down a little if not worn frequently, and then your foot will have to push them back out again.

It is not a good idea to have the height of heels changed. The contour of the bottom of a boot is designed for a specific heel height, and changing the height throws the balance of the boot off. A bootmaker can make this kind of alteration because he will adjust the whole bottom of the boot. But just having a repair shop switch heels is risky.

# CARE OF YOUR BOOTS

The best thing you can do for boots is to keep them clean. Wipe off loose dust and wash off the dirt that sticks to them. Dust and dirt will settle in creases and eventually cut away at the leather, causing cracks. There are several theories about boot maintenance, but in most cases it is best to clean boots lightly with saddle soap without letting it dry on the boots and without rubbing it in. A soap with an oil base (Murphy's oil soap, for instance) can be used instead and you don't have to worry about its drying. After the boots are cleaned, rub on a coat of a good shoe cream, colored to match the leather. When this is dry the leather can be brushed to a shine. Leather will darken with age and wear, especially if it is saddle soaped, so if you are worried about changes in color it might be better to clean your boots with a creamy cleaner (Meltonian is a good one) instead of saddle soap before you polish them.

Boots should be conditioned occasionally, more often in dry climates or if they have gotten very wet. A conditioner like Lexol should be rubbed in well and left to penetrate the leather before it is polished. Again, this may change the color slightly. Lizards and snakeskins have naturally dry surfaces and should be conditioned often. Sharkskin also needs periodic conditioning to ward off tears. But all leather will dry out if it's not cared for, even if the boots just sit on the shelf.

Don't use silicone products on your boots. Silicone clogs the pores in the leather and a layer will build up and eventually chip off the finish. If you want to waterproof your boots, use an ointment waterproofer like mink oil.

Suede is hard to keep clean. The best thing to do for it is to shampoo it occasionally with a special suede cleaner and then brush it with a stiff suede brush when the boots are dry.

Spots and scuff marks can be removed with a pencil eraser or with a dab of rubber cement spread over the spot and

left to dry. When you rub the cement off, it should take the spot with it.

Don't *ever* put wet boots close to heat to dry. They will shrivel up and be ruined.

If possible, don't wear the same pair of boots on consecutive days. They need to air out.

Boot pulls will make getting into boots easier for people with high insteps, who sometimes have trouble forcing their feet past the tongue of their boots. The same people will probably have trouble getting boots off; if so, they should use a boot-jack rather than pressing down on the counter of one boot with the toe of the other and tugging.

To maintain the proper shape of the boot, it is a good idea to store it with a boot tree to keep the toes from curling up.

If your boots have been made by a custom bootmaker, you should send them back to him if they need to be repaired or restored. If you have factory-made boots and are not near a good repair shop, they can be sent for restoration to Western Boot Service, 1662 Auburn Ravine Road, Auburn, California 95603 (phone: 916-823-3489) or to Houston Shoe Hospital, 5215 Kirby Drive, Houston, Texas 77098 (phone 713-528-6268).

# WHERE TO BUY BOOTS

In the best of all possible worlds, there would be a custom bootmaker for everyone, and everyone would be able to afford custom-made boots and wouldn't mind waiting while they were put together. A last would exist that perfectly matched your foot and your bootmaker would have a vast selection of colored French calfskin and kangaroo and exotic leathers that could be made into whatever suited your fancy. There is an argument, however (which perhaps should not be given too much credence), against even this seemingly ideal situation. It is said that the problem with a made-to-measure boot is that when it is put together you're stuck with it and it might not look like you imagined it would when the skins were hanging on the wall. And then maybe it won't fit. But most people who order custom-made boots have a pretty good idea of what they want, and if the boots don't fit, a good bootmaker will take them back, providing he's the one who took the measurements.

If you can't visit a bootmaker to have your foot measured, and you don't want a garland of pinched leather roses around the top of your boots or an unusual color or style, it is probably just as well that you go to a good boot store and pick out something there, or something that is in a catalog. You can also order boots from a dealer who represents a boot company that accepts custom orders in stock sizes. If you can't get what you want this way, or if you want the attention to detail that comes only with a handmade boot, most custom bootmakers will accept mail orders if you tell them what your standard size is and then have someone carefully measure your foot on the measuring forms they will send.

The following list gives the addresses and phone numbers of the bootmakers included in this book. They will all accept mail orders unless otherwise noted.

Alan Bell
Bell Custom Made Boots
2118 North Treadaway
Abilene 79601
(915) 677-0632
custom bootmaker

Capitol Saddlery
1614 Lavaca
Austin 78701
(512) 478-9309
custom bootmaker; will not
accept mail orders

Dixon Boots
925 Indiana Avenue
Wichita Falls 76301
(817) 766-0422
custom bootmaker

Charlie Dunn
Charlie Dunn Boot Company
222 College Avenue
Austin 78704
custom bootmaker

The Galvans
Joe's Boot and Shoe Repair
109 South Flores
San Antonio 78204
(512) 227-4432
custom bootmakers

Carlos Hernandez, Jr.
Texas Custom Boots
2048 South Lamar Blvd.
Austin 78704
(512) 444-8307
custom bootmaker

Larry Jackson
Jackson Boots and Jeans
Box 175
Walnut Springs 76690
(817) 797-2176
custom bootmaker

Ray Jones
Jones Boot and Saddlery
Box 215
Lampasas 76550
(512) 556-3192
custom bootmaker; takes no
new orders

Justin Boot Company
P.O. Box 548
Fort Worth 76101
(817) 332-4385
wholesale boot manufacturer;
special orders may be placed

through retailers, or custom
orders can be measured at the
Fort Worth plant for a fee

Tony Lama Company
1137 Tony Lama Street
El Paso 79915
(915) 778-8311
wholesale boot manufacturer;
special orders may be placed
through retailers

James Leddy Boots
926 Ambler
Abilene 79601
(915) 677-7811
custom bootmaker

M. L. Leddy & Sons
14 South Chadbourne
San Angelo 76901
(915) 655-9138
custom bootmaker

Henry Leopold
Leopold's Boot Shop
P.O. Box 401572
Garland 75040
(214) 276-8109
custom bootmaker; takes few
new orders

Dave Little
Little's Boot Company
110 Division
San Antonio 78214
custom bootmaker

Lucchese Boot Company
1226 East Houston Street
San Antonio 78205
(512) 226-8147
wholesale boot manufacturer;
special orders in standard last
sizes will be accepted through
retail outlets

Larry Mahan Boot Collection
1141 Larry Mahan Drive
El Paso 79925
(915) 593-1441
wholesale boot manufacturer;
accepts no special orders

Mercer's Boot Shop
224 South Chadbourne
San Angelo 76901
(915) 655-7784
custom bootmaker; prefers not
to take mail orders

The Nocona Boot Company
P.O. Box 599
East Highway 82
Nocona 76255
(817) 825-3321
wholesale boot manufacturer;
special orders will be accepted
through retail dealers and
measurements for custom
orders will be taken at the
Nocona store, for a fee

Olsen-Stelzer Boot and Saddlery
201 South Bridge
P.O. Box 70
Henrietta 76365
(817) 538-4331
custom bootmaker and
wholesaler

Rios of Mercedes
Mercedes 78570
(512) 565-1242
wholesale boot manufacturer;
special orders may be placed
with retailers

Rios Boot Company
P.O. Box 171
Raymondville 78580
(512) 689-2826
custom bootmaker

Tex Robin
115 West 8th Street
Coleman 76834
(915) 625-5556
custom bootmaker

Elmer Tomlinson
Tomlinson Boot Shop
119 East Main
Llano 78643
(915) 247-5441
custom bootmaker

J.E. Turnipseede
Turnipseede's Beeville Boot
    Shop
209 North Washington Street
Beeville 78102
(512) 358-4365
custom bootmaker; will accept
mail orders in standard last
sizes only

Paul Wheeler
4115 Willowbend
Houston 77025
(713) 665-0224
custom bootmaker

*Buck stitching.*

# GLOSSARY

**Beading:** the slender, rounded strip of leather encircling the very top of a boot.

**Buck stitching:** a narrow strip of leather woven in a row through the primary leather as decoration. It is often used around wing tips or counter foxing.

**Bug:** the stitching at the front of a toe medallion, often in the shape of a fleur-de-lis or an insect with wings.

**Click machine:** used in a factory to press down on metal dies to cut out pieces of leather. Works rather like a big, high-speed cookie cutter.

**Collar:** an ornamental band around the top of a boot.

**Conchos:** decorative metal disks.

*Conchos on a decorative tie.*

**Counter:** the leather piece above the heel that is sewn to the vamp, forming the lower part of the boot. Also called a spur piece, since a spur attaches there.

**Crimp board:** a flat piece of wood shaped in the general outline of the profile of a foot, on which the vamps of

*Crimp boards.*

well-made boots are stretched while wet, before they are attached to the rest of the boot, so that they will take on the curve of a foot and lose their stretch before they become parts of a boot.

**_Custom-made, made-to-measure, handmade:_** Custom-made boots are put together to a customer's specifications for color, stitching patterns, heel height, and other features. It is possible to order custom-made boots in standard last sizes from most companies. Made-to-measure boots are custom-made boots fitted to a customer's own last. Handmade boots are made the old-fashioned way, without the aid of machinery, although even the most scrupulous bootmaker does some stitching on a machine.

**_Die:_** a metal pattern used to cut leather into the shape of a vamp, counter, top, etc.

**_Ears:_** pull straps.

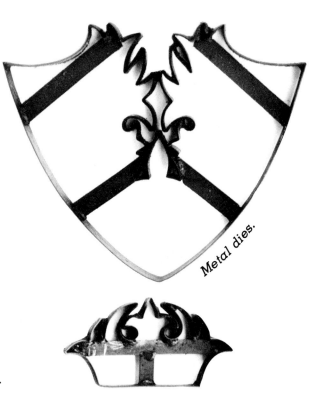

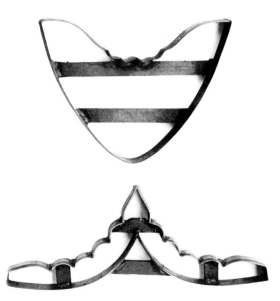

Metal dies.

**_Foxing:_** a piece of leather applied over part of the boot as decoration, usually on the counter or toe.

**_Inlays:_** pieces of leather attached as ornamental designs. They may be overlaid or underlaid; that is, they may be cut into decorative shapes and sewn on top of the primary boot leather, or they may be placed under leather that has

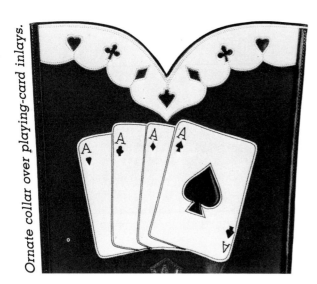

*Ornate collar over playing-card inlays.*

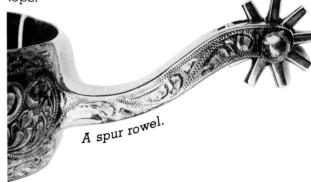

*A spur rowel.*

the boot is pulled on. Until about 1950 they were made of cloth and stuck out above the tops. Now they are almost always leather and fit tightly over the tops.

been cut out into patterns so that the color of the leather underneath forms the design.

**Last:** a model of one's foot, used to shape the lower part of a boot for a proper fit. A standard last in a factory is made out of some kind of plastic molded to a standard size (6½B, 8D, etc.). A made-to-measure last is usually cut from white maple and shaped by adding pieces of leather and gluing and sanding them to match the idiosyncrasies of the foot.

**Medallion:** the stitching on the toe.

**Mule ears:** oversized pull straps that extend all the way down the boot.

*Mule ears.*

**Piping:** the (usually) colored leather running down the side seams.

**Pull holes:** literally, holes at the top of a boot which take the place of pull straps.

**Pull straps:** the leather or cloth straps on the boot tops which are grasped when

**Rowel:** a revolving wheel with points of various degrees or sharpness and length, forming the end of a spur.

**Scallop:** the more or less V-shaped notch at the front and back of a boot top.

**Shank:** a piece of metal used to reinforce the arch. Some bootmakers use a forty-penny bridge nail, hammered flat at

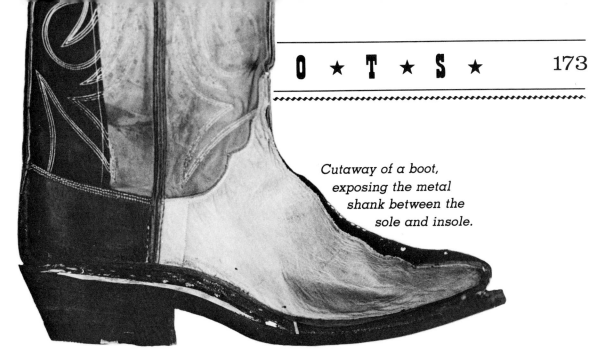

*Cutaway of a boot, exposing the metal shank between the sole and insole.*

both ends, which they claim is the only thing that will absolutely not snap if a cowboy frequently rides standing in his stirrups. Other bootmakers, and factories, use a flat strip of 18-gauge steel.

**Toe box:** the stiff piece of material that is placed into the tip of a boot between the vamp leather and vamp lining to reinforce the toe. Very good boots have a leather toe box which is shaped to the boot and then hardened with cement.

**Tongue:** the part of the vamp that stretches up into the top part of the boot. A western stirrup hits a boot at this point and would cut into the leather if it weren't reinforced by the double thickness of tongue and top.

**Triad:** a kind of boot design in which the top part of the boot has three rather than four primary parts. There is no counter, for the back of the boot comes down to the heel in one piece. The front top section usually comes down to the sole also, and the vamp stops before it reaches the side seam.

**Vamp:** the lower front part of a boot, covering the toes and instep. It attaches to the counter in back.

**Welt:** the strip of leather that serves as an inseam between the sole and the vamp. It is the very heart of the boot, for it holds the front part of the boot together. A full welt extends back to the heel, and a ball-to-ball welt (for "dressier" boots) is stitched from one side of the ball of the foot, around the toe to the other side of the ball.

**Wing tip:** a decorative piece of leather over the toe of the vamp, usually peaked toward the tongue and extending back toward the side seam.

**Wrinkles:** several straight lines of stitching on a toe.

*Lasts.*

*Wing tip.*